# Art and Society

# Art and Society

## Lectures and Essays by William Morris

*Edited and with an Introduction*
*by Gary Zabel*

George's Hill
Boston
1993

Introduction and Biography copyright
© 1993 by Gary Zabel

Published by **George's Hill Publications LTD.**
P.O. Box 59, Medford, Massachusetts 02155

Designed by Gary Zabel. Produced by James Herod.
Set in 11/12 News Serif (a digital version of Times Roman) by
**George's Hill Publications LTD.**, Boston. Printed and bound by
**Book Press, Inc.**, Brattleboro, Vermont.

Available from: **Inland Book Company**, 140 Commerce Street
East Haven, Connecticut 06512, and **Left Bank Distribution**,
4142 Brooklyn Ave NE, Seattle, Washington 98105

This book has a Smythe sewn binding and so can
be opened flat. It is printed on acid-free
paper for long-lasting use.

ISBN 0-9635308-0-1

# ❧ *Contents* ❧

# ❧ *Introduction* ❧

# *The Radical Aesthetics of William Morris*

I T must have been a difficult blow for members of the English ruling class when they lost William Morris, so difficult in fact that it induced in them a curious state of denial. When the established press reported his activities as a radical agitator, it referred to him as Mr. W. Morris, as though he were a different person than William Morris, poet, publisher, designer, and owner of Morris & Company. Even more striking, nine years after his conversion to the revolutionary wing of the working-class movement, a member of Gladstone's cabinet offered him the poet laureateship on Tennyson's death; it was left up to Morris to point out the absurdity involved in the notion of a socialist court poet. In part, such denial, of course, was elicited by the unshakable reputation that Morris had established in a number of the arts well before his political conversion in 1883. How psychologically incongruous it would have been for a wealthy Englishman to recognize Morris as a social insurgent when his own home might have been decorated with furniture, tapestries, and carpets by Morris & Company. In a deeper sense, however, this denial indicates the ease with which a considerable segment of the bourgeoisie has always been able to live with, and even embrace, a purely aesthetic radicalism. After all, Morris had been ranting against 'civilization' and the spirit of 'the age' ever since his arrival as a student at Oxford in 1853, and his identification there with the Romantic poetic tradition as well as the Pre-Raphaelite painters, Burne-Jones and Rossetti. Rejection of the commercialized culture of the Victorian middle class had served as the central thread of his aesthetic efforts from that time on. But it was not until he fused his program of artistic transformation with that of the radical reconstruction of society that Morris presented a problem to his peers—and left us with

the task of understanding the contemporary significance of his revolutionary cultural legacy.

If we exclude some underdeveloped propositions by Marx in the *1844 Manuscripts,* the *Grundrisse,* and other writings, as well as similarly scattered passages by Engels, Morris is the first socialist writer to frame a theory which locates art squarely within the general life process of society. In this respect, he is the earliest representative of an extraordinarily creative tradition, a tradition that includes such central figures as Georg Lukács, Ernst Bloch, Walter Benjamin, Theodor Adorno, and Raymond Williams. In spite of their many differences, these left aestheticians apply themselves to a common theoretical task. The late Renaissance painter's pretention to a status more elevated than that of craftsman, the symbolist concept of *l'art pour l'art* (art for art's sake), the emergence of the museum as a detached cultural space, and the development of a private market in art as a luxury commodity all signal an unprecedented event: the appearance in the modern period of a supposedly 'autonomous' art, a form of artistic practice and associated institutions which claim independence from the ordinary activities of life. Each of the thinkers in the socialist aesthetic tradition cited above attempts both to account for and challenge art's new claim to autonomy by rooting it in the very social process from which it purports to take its distance. Now, Morris' successors elaborate their theories from the perspective of the future-oriented assault on the separation of art from life launched by the European avant-garde of the early twentieth century (whatever their attitude to the avant-garde itself). They project the unification of the aesthetic and workaday dimensions of human existence into a future condition for which there is no earlier model. Morris, however, analyzes the split between art and life from a standpoint prior to its emergence. For him, their unification has the significance of a return to familiar ground rather than a journey into uncharted territory. More precisely, Morris regards the art of the modern epoch from the rear watchtower of the medieval period that precedes it, rather than the forward outpost of the avant-garde that would liquidate it in the name of something entirely new.

In the United States, after the near complete annihilation of the indigenous population, capitalism grew in a sort of hothouse environment purged of any factor that could restrict the expression of its intrinsic social logic. As should be evident to almost

everyone from our vantage point at the end of the twentieth century, with its integrated world market and globally triumphant culture industry, that social logic consists in the extension of the commodity form into all corners of human experience. But in Europe, the capitalist mode of production had to raise itself on a foundation that was riddled with fragments of a more ancient culture, fragments which held open the memory of a type of social and personal existence free from the universal domination of the cash nexus. In the politics of nineteenth and early twentieth century Europe, the appeal of such fragments was often given a reactionary formulation— extending from the 'Feudal Socialism' excoriated by Marx and Engels in *The Communist Manifesto,* to the obsession of the central European right with pre-capitalist *Gemeinschaft* (community) that eventually fed into the fascist movement. Morris' medievalism, however, had no affinity with right-wing Romantic anti-capitalism. What conservatives found compelling about the Middle Ages was its religious irrationalism, its cult of authority, and its hierarchical model of communal organization— and Morris had rejected all of these elements even before becoming a socialist. In spite of his enduring association with the Romantic movement, he was not really a part of the Counter-Enlightenment at all. He believed that the emancipation of humankind from superstition, dependence, and hierarchy, which was the ostensible goal of the revolutionary bourgeoisie, must also be emblazoned upon the banner of the socialist movement, and that only there would it be freed of all class limitations and so attain its true significance. But he was afraid that such emancipation, even in its socialist version, would arrive cut off from the tradition of art, the aspiration toward beauty, and therefore, in Morris' view, the promise of happiness. The danger, then, was that the destruction of aesthetic value which was part and parcel of the bourgeois, utilitarian disenchantment of the world would cling to the realized socialist society so that post-revolutionary life would be free indeed, but devoid of human fulfillment. The goal of Morris' cultural practice was to forestall this possibility by creating a united front between the politics of emancipation and the creation of beauty in art. The Middle Ages provided him with a model for such linkage in the form of a radical conception of the meaning of work.

Like all forms of class society, European feudalism was based upon the extraction of an economic surplus from the labor of the direct producers, but, according to Morris, this exploitative relationship did not reach into the actual conduct of work. The very disdain for labor of the aristocratic upper classes left them content to exact a tribute without involving themselves in the detailed organization or day-to-day management of the labor process. Thus, in spite of the fact that work was incorporated into an overall system of exploitation, Morris claimed that the concrete activity of work in the Middle Ages constituted a sphere of free expression, of the joyful exercise of human powers and sensibilities, of what his mentor John Ruskin called 'wealth of life'. This exuberant freedom was embodied in the self-management of craft labor by the guild organizations. It was also reflected by the evident beauty of ordinary craft objects, a beauty that reached its apogee in the organic spontaneity and finely wrought ornamental detail of Gothic architecture. What is unique about capitalism, even among class societies, is its transformation of human activity, of labor power itself, into a commodity, a transformation that entails the extension of ruling-class domination into the very fabric of the working day. Following Marx, Morris equated this extension with the development of the division of labor which both separates managerial direction of work from its proletarian execution, and fragments production into a series of meaningless partial processes to each of which a particular worker or group of workers is lashed. The result of the dispossession of the worker from his or her own life activity is, on its subjective side, misery and enslavement. On its objective side, it is destruction of the beauty of nature as well as of the built environment. The same process that empties life of happiness drains the world of aesthetic value.

The profound ugliness of capitalism was not difficult to discern in the heyday of the First Industrial Revolution. The depopulation of the English countryside in the service of sheep farming for the international market, the development of mining in Cornwall and Devon as well as the North, the rise of the great manufacturing cities of Birmingham, Manchester, and Leeds, and the concentration of an impoverished and sometimes diseased proletarian population in London had created an overwhelming experience of squalor, blight, and disproportion. Violent technological intrusion into the delicately evolved pat-

terns of the natural and historical worlds was accompanied by the degradation of objects of everyday use, by what even quite conservative Englishmen recognized as the 'triumph of shoddy'. In the classical tradition of Western aesthetics running from Plato through Aquinas to Baumgarten and Kant, beauty is conceived as a complex and harmonious organization of particulars which induces a state of elevated pleasure in the human observer. Given this conception, the grotesque dissonances of capitalist industrialization were bound to provoke an aesthetic rebellion in the name of beauty. However, according to Morris, the degradation of the work process had isolated the art rebellion from any possible popular audience. The works of Romantic poets and Pre-Raphaelite painters in particular embodied genuine aesthetic achievements, but they were forms of expression suspended in a void or, even worse, capable of reaching only those educated individuals whose class depended for its existence on the conversion of ugliness into profit. For Morris, the highest achievements of artistic genius presupposed the creative engagement of very ordinary people. On his reading of art history, the most genuine phase of the Renaissance was actually the final expression of the medieval period with its intact craft traditions. The paintings of a Leonardo or the sculptures of a Michelangelo were capstones of a vast structure erected by innumerable craft workers who did not share their genius, it is true, but who knew what it was to create beauty in grappling with the material world. It was not until the late Renaissance that 'high' art elevated itself above the popular masses, and the capitalist reorganization of the labor process began to create a working class detached from creative endeavor and aesthetic comprehension. Beauty, then, cannot be restored by artists alone. Artistic rebellion is futile so long as it does not join forces with the social and political revolution whose goal is the abolition of toil and its replacement by meaningful work.

Morris' deepest theoretical accomplishment undoubtedly lies in the intimacy with which he links aesthetic renovation, the reorganization of work, and a political model of democratic rule, an intimacy unrivalled in the tradition of socialist aesthetics (with the possible exception of the work of Raymond Williams). Once again, he bases his conception on a paradigm drawn from the Middle Ages, that of the administration of free municipalities or 'communes' by federated craft guilds in the fourteenth cen-

tury. In Morris' account, the rise of the craft guilds to political control of such cities as Ghent, Bruges, Ypres, and Florence was the result of victory by artisans in a sometimes violent class struggle against aristocrats and patrician merchants. The victory of the workmen, the most dramatic instance of which was their military triumph at the battle of Courtray, not only translated the democratic liberties of the ancient tribal societies of Europe into the medium of urban existence; it also inaugurated, in Morris' words, a veritable 'art democracy'. Regulation of their conditions of work by the associated producers had salutary effects for both the craftsmen and their products. On the one hand, it ensured the creation of high quality merchandise by establishing minimal standards of production as well as artisan education; on the other hand, it safeguarded the joyfulness and creative potential of the work process by limiting the working day, establishing a great number of holidays, and prohibiting work under unsafe or onerous conditions. Most importantly, guild regulations prevented the accumulation of capital and the unbridled employment of wage labor by establishing strict rates for wages and limiting the number of journeymen — all of whom were themselves on their way to master status — who could work for each master craftsman. Under such democratically imposed restrictions, beauty was neither extrinsic to working activity nor the province of a special caste of creative geniuses. It was, quite simply, the objective correlate of subjective pleasure in work. Just as, according to Morris, the medieval communes represented an early, though, alas, unstable form of socialist society, so will the socialism of the future assume the shape of new, more culturally sophisticated communes, democratically controlled by the artist-workers who will constitute their free citizenry.

The intimate connection between art, work, and democratic self-management which Morris developed explicitly in the lectures and essays anthologized below, constitutes the implicit theoretical framework of the book for which he is today most widely remembered: *News from Nowhere*. In his novel, Morris broke the prohibition against graven images which the socialist movement was then in the process of adopting as an unquestioned orthodoxy, and created a detailed representation of the kind of society that could be considered a fulfillment of that movement's hope. It is not that he was blind to the legitimate concerns behind socialist anti-utopianism: a rejection of all phil-

anthropic schemes that deny the link between organized class conflict and social renewal, as well as a refusal to preempt the freedom of those generations who will actually engage in constructing the new society. But Morris also understood that people are not puppets operated by anonymous historical forces, that they do not struggle, at least not effectively, for goals that they cannot plausibly envision. Moreover, as an artist he knew that an image of the future capable of motivating action, and even eliciting sacrifices, had to have more than a purely intellectual appeal, that it had to be anchored in the most fundamental texture of people's sensuous and emotional experience. Socialists must deploy the utopian imagination in a struggle for what Antonio Gramsci was later to call 'hegemony', in which their emancipatory vision becomes a deeply rooted schema through which people interpret the details of their everyday lives. And it is not just utopian depiction narrowly conceived that the battle for hegemony demands. The centrality of art to Morris' conception of the socialist idea in general testifies to the full-bodied character of his notion of the human context in which historical projects unfold and allegiances must be won.

What are we to make of Morris' vision nearly one hundred years after his death, more than a decade after the rise of postmodernism in the arts, and a year after the disintegration of the Soviet Union? Certainly, there can be no question of a straightforward return to his formulations after so much has transpired in culture, technology, and politics to alter the landscape within which we must get our bearings. Just think of what's changed. A tortuous experiment claiming to be socialist has ended in failure, appearing to leave the capitalist world system more completely inviolable than in Morris' day. Since the beginning of the twentieth century, Western art has refused to be bound to the norm of beauty that Morris espoused, preferring instead to articulate dissonance, absurdity, and, in its postmodern manifestation, ironic indifference. Technological transformation of the now global work process has proceeded with such vigor that a simple return to craft labor, even with the limited concessions to machine production that Morris does indeed make, is simply no longer a tenable option. Still, in many ways, Morris' lectures and essays on art and society set a standard of emotional engagement, utopian vision (tempered by a tragic recognition of the need for protracted struggle), and decent concern for the suf-

fering and thwarted potential of countless 'ordinary' people that the socialist aesthetic tradition has never again achieved. This standard is rooted in Morris' passionate immersion in a wide variety of forms of work—from writing poetry to cutting engravings to mixing dyes. His own multi-faceted practice as both mental and manual worker imbued him with an understanding of just how fulfilling creative work could be, and just how crippling degraded, meaningless work in fact is. At the end of the twentieth century, with so many disaffected 'post-Marxist' voices counselling abandonment of concern with work and those who must bear its burdens, this is not a bad place for socialists to begin once again.

Gary Zabel
Boston, 1993

# ࣷ *A Note on the Texts* ࣷ

IN choosing material for this anthology, I have selected from among only those lectures and essays that Morris wrote after he joined the Democratic Federation on January 13, 1883. This signified his full conversion to socialist politics, and also marked the beginning of the development of a theory of art on an explicitly socialist foundation. It is true that, in many respects, there is a thematic continuity between Morris' pre-1883 lectures and essays and those reprinted below. The earlier pieces elaborate a critique of the art of the modern period based on an analysis of the industrial degradation of work which is also central to his later writings. Nevertheless, when Morris joined the Democratic Federation, he became a partisan of the revolutionary struggle that it sought to encourage, and adoption of this mantle could not fail to affect his aesthetic formulations. Nothing could guarantee that the working-class movement would make aesthetic reconstruction part of a revolutionary agenda. But, after the beginning of 1883, Morris believed that the rebirth of the arts depended on precisely this hope. It is a hope that the aesthetic concepts developed specifically in his later writings are designed to nurture.

I have arranged the texts chronologically, with one exception. The first selection, 'Art Under Plutocracy', is a lecture that was delivered by Morris on November 11, 1983, several months *after* the next two selections: 'Art and the People: A Socialist's Protest Against Capitalist Brutality; Addressed to the Working Classes' and 'Art, Wealth, and Riches'. It seemed best to begin with 'Art Under Plutocracy' both because of its clear statement of Morris' political and aesthetic positions, and because of the drama that surrounded its delivery. Morris gave the address before the Russell Club at University College Hall, Oxford. The Master of Balliol was in the chair, and Morris' academic mentor, John Ruskin also spoke. Morris took this opportunity to announce that he was 'one of the people called Socialists', and to appeal to his audience for active political support for the Democratic Federation, or at least for financial assistance. The follow-

ing day, *The Times* reported the event with evident disapproval, emphasizing that the Master of Balliol claimed that the loan of the hall would have been refused had the content of Morris' lecture been revealed beforehand. With the address, Morris had demonstrated the real significance of his radicalism, and broken publicly with his class of origin.

Evidence from Morris' calendar suggests that 'Art and the People: A Socialist's Protest Against Capitalist Brutality; Addressed to the Working Classes' was delivered on April 1 or May 3, 1983, but there is no indication of where the reading took place. 'Art, Wealth, and Riches' was delivered on March 6, 1883 at the Manchester Royal Institution before a joint *conversazione* of Manchester societies. 'Art and Socialism' was first delivered on January 1, 1884 before the Leicester Secular Society. 'At a Picture Show, 1884' was delivered at the opening of an Ancoats Recreation Committee art exhibition in Ancoats, Manchester. 'The Aims of Art' was first delivered on March 14, 1886 before the Hammersmith Branch of the Socialist League. 'The Revival of Handicraft' is an essay that was first published in November, 1888 in the 'Fortnightly Review'. 'Gothic Architecture' was first delivered on November 7, 1889 at a meeting sponsored by the Arts and Crafts Exhibition Society in New Gallery on Regent Street, London. 'Art and Industry in the 14th Century' is an essay that was first published in January, 1890 in *Time: a Monthly Magazine*.

The sources for the selections are May Morris, *William Morris: Artist, Writer, Socialist*, 2 vols. (Oxford, 1936); and volumes 22 and 23 of *The Collected Works of William Morris*, ed. May Morris, 24 vols. (London, 1910-1915). The only change that I have made in May Morris' versions of her father's manuscripts is to render spelling consistent in accordance with late nineteenth century standards. I have taken the *Oxford English Dictionary* as my authority in this regard. In identifying dates and places in which the lectures were first delivered and the essays first appeared, I have relied upon the invaluable calendar included as an appendix in *The Unpublished Lectures of William Morris*, ed. Eugene D. Lemire (Detroit, 1969).

A final remark on terminology: Morris uses the expression 'middle class' to refer to the bourgeoisie or owners of the means of production — i.e., the dominant class — in capitalist society, not the traditional petty bourgeoisie of independent shopkeepers

and artisans, and certainly not the 'new middle class' of professionals, managers, and so on, that first appeared in the twentieth century, or the 'middle class' of well-paid wage earners, so popular in American usage.

# ๛ *One* ๛

# *Art Under Plutocracy*

YOU may well think I am not here to criticize any special
school of art or artists, or to plead for any special style, or
to give you any instructions, however general, as to the practice
of the arts. Rather I want to take counsel with you as to what
hindrances may lie in the way towards making art what it should
be, a help and solace to the daily life of all men. Some of you
here may think that the hindrances in the way are none, or few,
and easy to be swept aside. You will say that there is on many
sides much knowledge of the history of art, and plenty of taste
for it, at least among the cultivated classes; that many men of
talent, and some few of genius, practise it with no mean success;
that within the last fifty years there has been something almost
like a fresh renaissance of art, even in directions where such a
change was least to be hoped for. All this is true as far as it goes;
and I can well understand this state of things being a cause of
gratulation amongst those who do not know what the scope of art
really is, and how closely it is bound up with the general condi-
tion of society, and especially with the lives of those who live by
manual labour and whom we call the working classes. For my
part, I cannot help noting that under the apparent satisfaction
with the progress of art of late years there lies in the minds of
most thinking people a feeling of mere despair as to the pros-
pects of art in the future; a despair which seems to me fully
justified if we look at the present condition of art without con-
sidering the causes which have led to it, or the hopes which may
exist for a change in those causes. For, without beating about the
bush, let us consider what the real state of art is. And first I must
ask you to extend the word art beyond those matters which are
consciously works of art, to take in not only painting and sculp-
ture, and architecture, but the shapes and colours of all house-
hold goods, nay, even the arrangement of the fields for tillage

and pasture, the management of towns and of our highways of all kinds; in a word, to extend it to the aspect of all the externals of our life. For I must ask you to believe that every one of the things that goes to make up the surroundings among which we live must be either beautiful or ugly, either elevating or degrading to us, either a torment and burden to the maker of it to make, or a pleasure and a solace to him. How does it fare therefore with our external surroundings in these days? What kind of an account shall we be able to give to those who come after us of our dealings with the earth, which our forefathers handed down to us still beautiful, in spite of all the thousands of years of strife and carelessness and selfishness?

Surely this is no light question to ask ourselves; nor am I afraid that you will think it a mere rhetorical flourish if I say that it is a question that may well seem a solemn one when it is asked here in Oxford, amidst sights and memories which we older men at least regard with nothing short of love. He must be indeed a man of narrow incomplete mind, who, amidst the buildings raised by the hopes of our forefathers, amidst the country which they made so lovely, would venture to say that the beauty of the earth was a matter of little moment. And yet, I say, how have we of these latter days treated the beauty of the earth, or that which we call art?

Perhaps I had best begin by stating what will scarcely be new to you, that art must be broadly divided into two kinds, of which we may call the first Intellectual, and the second Decorative Art, using the words as mere forms of convenience. The first kind addresses itself wholly to our mental needs; the things made by it serve no other purpose but to feed the mind, and, as far as material needs go, might be done without altogether. The second, though so much of it as is art does also appeal to the mind, is always but a part of things which are intended primarily for the service of the body. I must further say that there have been nations and periods which lacked the purely Intellectual art but positively none which lacked the Decorative (or at least some pretence of it); and furthermore, that in all times when the arts were in a healthy condition there was an intimate connexion between the two kinds of art; a connexion so close, that in the times when art flourished most, the higher and lower kinds were divided by no hard and fast lines. The highest intellectual art was meant to please the eye, as the phrase goes, as well as to excite

the emotions and train the intellect. It appealed to all men, and to all the faculties of a man. On the other hand, the humblest of the ornamental art shared in the meaning and emotion of the intellectual; one melted into the other by scarce perceptible gradations; in short, the best artist was a workman still, the humblest workman was an artist. This is not the case now, nor has been for two or three centuries in civilized countries. Intellectual art is separated from Decorative by the sharpest lines of demarcation, not only as to the kind of work produced under those names, but even in the social position of the producers; those who follow the Intellectual arts being all professional men or gentlemen by virtue of their calling, while those who follow the Decorative are workmen earning weekly wages, non-gentlemen in short.

Now, as I have already said, many men of talent and some few of genius are engaged at present in producing works of Intellectual art, paintings and sculpture chiefly. It is nowise my business here or elsewhere to criticize their works; but my subject compels me to say that those who follow the Intellectual arts must be divided into two sections, the first composed of men who would in any age of the world have held a high place in their craft; the second of men who hold their position of gentleman-artist either by the accident of their birth, or by their possessing industry, business habits, or such-like qualities, out of all proportion to their artistic gifts. The work which these latter produce seems to me of little value to the world, though there is a thriving market for it, and their position is neither dignified nor wholesome; yet they are mostly not to be blamed for it personally, since often they have gifts for art, though not great ones, and would probably not have succeeded in any other career. They are, in fact, good decorative workmen spoiled by a system which compels them to ambitious individualist effort, by cutting off from them any opportunity for co-operation with others of greater or less capacity for the production of popular art.

As to the first section of artists, who worthily fill their places and make the world wealthier by their work, it must be said of them that they are very few. These men have won their mastery over their craft by dint of incredible toil, pains, and anxiety, by qualities of mind and strength of will which are bound to produce something of value. Nevertheless they are injured also by the system which insists on individualism and forbids co-opera-

tion. For first, they are cut off from tradition, that wonderful, almost miraculous accumulation of the skill of ages, which men find themselves partakers in without effort on their part. The knowledge of the past and the sympathy with it which the artists of to-day have, they have acquired, on the contrary, by their own most strenuous individual effort; and as that tradition no longer exists to help them in their practice of the art, and they are heavily weighted in the race by having to learn everything from the beginning, each man for himself, so also, and that is worse, the lack of it deprives them of a sympathetic and appreciative audience. Apart from the artists themselves and a few persons who would be also artists but for want of opportunity and for insufficient gifts of hand and eye, there is in the public of to-day no real knowledge of art, and little love for it. Nothing, save at the best certain vague prepossessions, which are but the phantom of that tradition which once bound artist and public together. Therefore the artists are obliged to express themselves, as it were, in a language not understanded of the people. Nor is this their fault. If they were to try, as some think they should, to meet the public half-way and work in such a manner as to satisfy at any cost those vague prepossessions of men ignorant of art, they would be casting aside their special gifts, they would be traitors to the cause of art, which it is their duty and glory to serve. They have no choice save to do their own personal individual work unhelped by the present, stimulated by the past, but shamed by it, and even in a way hampered by it; they must stand apart as possessors of some sacred mystery which, whatever happens, they must at least do their best to guard. It is not to be doubted that both their own lives and their works are injured by this isolation. But the loss of the people; how are we to measure that? That they should have great men living and working amongst them, and be ignorant of the very existence of their work, and incapable of knowing what it means if they could see it!

In the times when art was abundant and healthy, all men were more or less artists; that is to say, the instinct for beauty which is inborn in every complete man had such force that the whole body of craftsmen habitually and without conscious effort made beautiful things, and the audience for the authors of intellectual art was nothing short of the whole people. And so they had each an assured hope of gaining that genuine praise and sympathy which all men who exercise their imagination in expression most

certainly and naturally crave, and the lack of which does certainly injure them in some way; makes them shy, over-sensitive, and narrow, or else cynical and mocking, and in that case well nigh useless. But in these days, I have said and repeat, the whole people is careless and ignorant of art; the inborn instinct for beauty is checked and thwarted at every turn; and the result on the less intellectual or decorative art is that as a spontaneous and popular expression of the instinct for beauty it dost not exist at all.

It is a matter of course that everything made by man's hand is now obviously ugly, unless it is made beautiful by conscious effort; nor does it mend the matter that men have not lost the habit deduced from the times of art, of professing to ornament household goods and the like; for this sham ornament, which has no least intention of giving anyone pleasure, is so base and foolish that the words upholstery and upholsterer have come to have a kind of secondary meaning indicative of the profound contempt which all sensible men have for such twaddle.

This, so far, is what decorative art has come to, and I must break off a while here and ask you to consider what it once was, lest you think over hastily that its degradation is a matter of little moment. Think, I beg you, to go no further back in history, of the stately and careful beauty of S. Sophia at Constantinople, of the golden twilight of S. Mark's at Venice; of the sculptured cliffs of the great French cathedrals, of the quaint and familiar beauty of our own minsters; nay, go through Oxford streets and ponder on what is left us there unscathed by the fury of the thriving shop and the progressive college; or wander some day through some of the out-of-the-way villages and little towns that lie scattered about the country-side within twenty miles of Oxford; and you will surely see that the loss of decorative art is a grievous loss to the world.

Thus then in considering the state of art among us I have been driven to the conclusion that in its co-operative form it is extinct, and only exists in the conscious efforts of men of genius and talent, who themselves are injured, and thwarted, and deprived of due sympathy by the lack of co-operative art.

But furthermore, the repression of the instinct for beauty which has destroyed the Decorative and injured the Intellectual arts has not stopped there in the injury it has done us. I can myself sympathize with a feeling which I suppose is still not

rare, a craving to escape sometimes to mere Nature, not only
from ugliness and squalor, not only from a condition of super-
abundance of art, but even from a condition of art severe and
well ordered, even, say, from such surroundings as the lovely
simplicity of Periclean Athens. I can deeply sympathize with a
weary man finding his account in interest in mere life and com-
munion with external nature, the face of the country, the wind
and weather, and the course of the day, and the lives of animals,
wild and domestic; and man's daily dealings with all this for his
daily bread, and rest, and innocent beast-like pleasure. But the
interest in the mere animal life of man has become impossible to
be indulged in in its fulness by most civilized people. Yet civili-
zation, it seems to me, owes us some compensation for the loss
of this romance, which now only hangs like a dream about the
country life of busy lands. To keep the air pure and the rivers
clean, to take some pains to keep the meadows and tillage as
pleasant as reasonable use will allow them to be; to allow peace-
able citizens freedom to wander where they will, so they do no
hurt to garden or cornfield; nay, even to leave here and there
some piece of waste or mountain sacredly free from fence or
tillage as a memory of man's ruder struggles with nature in his
earlier days: is it too much to ask civilization to be so far
thoughtful of man's pleasure and rest, and to help so far as this
her children to whom she has most often set such heavy tasks of
grinding labour? Surely not an unreasonable asking. But not a
whit of it shall we get under the present system of society. That
loss of the instinct for beauty which has involved us in the loss
of popular art is also busy in depriving us of the only compensa-
tion possible for that loss, by surely and not slowly destroying
the beauty of the very face of the earth. Not only are London and
our other great commercial cities mere masses of sordidness,
filth, and squalor, embroidered with patches of pompous and vul-
gar hideousness, no less revolting to the eye and the mind when
one knows what it means: not only have whole counties of Eng-
land, and the heavens that hang over them, disappeared beneath
a crust of unutterable grime, but the disease, which, to a visitor
coming from the times of art, reason, and order, would seem to
be a love of dirt and ugliness for its own sake, spreads all over
the country, and every little market-town seizes the opportunity
to imitate, as far as it can, the majesty of the hell of London and
Manchester. Need I speak to you of the wretched suburbs that

sprawl all round our fairest and most ancient cities? Must I speak to you of the degradation that has so speedily befallen this city, still the most beautiful of them all; a city which, with its surroundings, would, if we had had a grain of common sense, have been treated like a most precious jewel, whose beauty was to be preserved at any cost? I say at any cost, for it was a possession which did not belong to us, but which we were trustees of for all posterity. I am old enough to know how we have treated that jewel; as if it were any common stone kicking about on the highway, good enough to throw at a dog. When I remember the contrast between the Oxford of to-day and the Oxford which I first saw thirty years ago, I wonder I can face the misery (there is no other word for it) of visiting it, even to have the honour of addressing you to-night. But furthermore, not only are the cities a disgrace to us, and the smaller towns a laughing-stock; not only are the dwellings of man grown inexpressibly base and ugly, but the very cowsheds and cart-stables, nay, the merest piece of necessary farm-engineering, are tarred with the same brush. Even if a tree is cut down or blown down, a worse one, if any, is planted in its stead, and, in short, our civilization is passing like a blight, daily growing heavier and more poisonous, over the whole face of the country, so that every change is sure to be a change for the worse in its outward aspect. So then it comes to this, that not only are the minds of great artists narrowed and their sympathies frozen by their isolation, not only has co-operative art come to a standstill, but the very food on which both the greater and the lesser art subsists is being destroyed; the well of art is poisoned at its spring.

Now I do not wonder that those who think that these evils are from henceforth for ever necessary to the progress of civilization should try to make the best of things, should shut their eyes to all they can, and praise the galvanized life of the art of the present day; but, for my part, I believe that they are not necessary to civilization, but only accompaniments to one phase of it, which will change and pass into something else, like all prior phases have done. I believe also that the essential characteristic of the present state of society is that which has so ruined art, or the pleasure of life; and that this having died out, the inborn love of man for beauty and the desire for expressing it will no longer be repressed, and art will be free. At the same time I not only admit, but declare, and think it most important to declare, that so

long as the system of competition in the production and ex-
change of the means of life goes on, the degradation of the arts
will go on; and if that system is to last for ever, then art is
doomed, and will surely die; that is to say, civilization will die.
I know it is at present the received opinion that the competitive
or 'Devil take the hindmost' system is the last system of econ-
omy which the world will see; that it is perfection, and therefore
finality has been reached in it; and it is doubtless a bold thing to
fly in the face of this opinion, which I am told is held even by
the most learned men. But though I am not learned, I have been
taught that the patriarchal system died out into that of the citizen
and chattel slave, which in its turn gave place to that of the feu-
dal lord and the serf, which, passing through a modified form, in
which the burgher, the gild-craftsman and his journeyman played
their parts, was supplanted by the system of so-called free con-
tract now existing. That all things since the beginning of the
world have been tending to the development of this system I
willingly admit, since it exists; that all the events of history have
taken place for the purpose of making it eternal, the very evolu-
tion of those events forbids me to believe.

For I am 'one of the people called Socialists'; therefore I am
certain that evolution in the economical conditions of life will go
on, whatever shadowy barriers may be drawn across its path by
men whose apparent self-interest binds them, consciously or un-
consciously, to the present, and who are therefore hopeless for
the future. I hold that the condition of competition between man
and man is bestial only, and that of association human; I think
that the change from the undeveloped competition of the Middle
Ages, trammelled as it was by the personal relations of feudality,
and the attempts at association of the gild-craftsmen into the full-
blown *laissez-faire* competition of the nineteenth century, is
bringing to birth out of its own anarchy, and by the very means
by which it seeks to perpetuate that anarchy, a spirit of associa-
tion founded on that antagonism which has produced all former
changes in the condition of men, and which will one day abolish
all classes and take definite and practical form, and substitute
association for competition in all that relates to the production
and exchange of the means of life. I further believe that as that
change will be beneficent in many ways, so especially will it
give an opportunity for the new birth of art, which is now being
crushed to death by the money-bags of competitive commerce.

My reason for this hope for art is founded on what I feel quite sure is a truth, and an important one, namely that all art, even the highest, is influenced by the conditions of labour of the mass of mankind, and that any pretensions which may be made for even the highest intellectual art to be independent of these general conditions are futile and vain; that is to say, that any art which professes to be founded on the special education or refinement of a limited body or class must of necessity be unreal and short-lived. ART IS MAN'S EXPRESSION OF HIS JOY IN LABOUR. If those are not Professor Ruskin's words they embody at least his teaching on this subject. Nor has any truth more important ever been stated; for if pleasure in labour be generally possible, what a strange folly it must be for men to consent to labour without pleasure; and what a hideous injustice it must be for society to compel most men to labour without pleasure! For since all men not dishonest must labour, it becomes a question either of forcing them to lead unhappy lives or allowing them to live unhappily. Now the chief accusation I have to bring against the modern state of society is that it is founded on the art-lacking or unhappy labour of the greater part of men; and all that external degradation of the face of the country of which I have spoken is hateful to me not only because it is a cause of unhappiness to some few of us who still love art, but also and chiefly because it is a token of the unhappy life forced on the great mass of the population by the system of competitive commerce.

The pleasure which ought to go with the making of every piece of handicraft has for its basis the keen interest which every healthy man takes in healthy life, and is compounded, it seems to me, chiefly of three elements; variety, hope of creation, and the self-respect which comes of a sense of usefulness; to which must be added that mysterious bodily pleasure which goes with the deft exercise of the bodily powers. I do not think I need spend many words in trying to prove that these things, if they really and fully accompanied labour, would do much to make it pleasant. As to the pleasures of variety, any of you who have ever made anything, I don't care what, will well remember the pleasure that went with the turning out of the first specimen. What would have become of that pleasure if you had been compelled to go on making it exactly the same for ever? As to the hope of creation, the hope of producing some worthy or even excellent work which without you, the craftsman, would not

have existed at all, a thing which needs you and can have no substitute for you in the making of it—can we any of us fail to understand the pleasure of this? No less easy, surely, is it to see how much the self-respect born of the consciousness of usefulness must sweeten labour. To feel that you have to do a thing not to satisfy the whim of a fool or a set of fools, but because it is really good in itself, that is useful, would surely be a good help to getting through the day's work. As to the unreasoning, sensuous pleasure in handiwork, I believe in good sooth that it has more power of getting rough and strenuous work out of men, even as things go, than most people imagine. At any rate it lies at the bottom of the production of all art, which cannot exist without it even in its feeblest and rudest form.

Now this compound pleasure in handiwork I claim as the birthright of all workmen. I say that if they lack any part of it they will be so far degraded, but that if they lack it altogether they are, so far as their work goes, I will not say slaves, the word would not be strong enough, but machines more or less conscious of their own unhappiness.

I have appealed already to history in aid of my hopes for a change in the system of the conditions of labour. I wish to bring forward now the witness of history that this claim of labour for pleasure rests on a foundation stronger than a mere fantastic dream; what is left of the art of all kinds produced in all periods and countries where hope of progress was alive before the development of the commercial system shows plainly enough to those who have eyes and understanding that pleasure did always in some degree accompany its production. This fact, however difficult it may be to demonstrate in a pedantic way, is abundantly admitted by those who have studied the arts widely; the very phrases so common in criticism that such and such a piece of would-be art is done mechanically, or done without feeling, express accurately enough the general sense of artists of a standard deduced from times of healthy art; for this mechanical and feelingless handiwork did not exist till days comparatively near our own, and it is the condition of labour under plutocratic rule which has allowed it any place at all.

The craftsman of the Middle Ages no doubt often suffered grievous material oppression, yet in spite of the rigid line of separation drawn by the hierarchical system under which he lived between him and his feudal superior, the difference be-

tween them was arbitrary rather than real; there was no such gulf in language, manners, and ideas as divides a cultivated middle-class person of to-day, a 'gentleman', from even a respectable lower-class man; the mental qualities necessary to an artist, intelligence, fancy, imagination, had not then to go through the mill of the competitive market, nor had the rich (or successful competitors) made good their claim to be the sole possessors of mental refinement.

As to the conditions of handiwork in those days, the crafts were drawn together into gilds which indeed divided the occupations of men rigidly enough, and guarded the door to those occupations jealously; but as outside among the gilds there was little competition in the markets, wares being made in the first instance for domestic consumption, and only the overplus of what was wanted at home close to the place of production ever coming into the market or requiring anyone to come and go between the producer and consumer, so inside the gilds there was but little division of labour; a man or youth once accepted as an apprentice to a craft learned it from end to end, and became as a matter of course the master of it; and in the earlier days of the gilds, when the masters were scarcely even small capitalists, there was no grade in the craft save this temporary one. Later on, when the masters became capitalists in a sort, and the apprentices were, like the masters, privileged, the class of journeymen-craftsmen came into existence; but it does not seem that the difference between them and the aristocracy of the gild was anything more than an arbitrary one. In short, during all this period the unit of labour was an intelligent man. Under this system of handiwork no great pressure of speed was put on a man's work, but he was allowed to carry it through leisurely and thoughtfully; it used the whole of a man for the production of a piece of goods, and not small portions of many men; it developed the workman's whole intelligence according to his capacity, instead of concentrating his energy on one-sided dealing with a trifling piece of work; in short, it did not submit the hand and soul of the workman to the necessities of the competitive market, but allowed them freedom for due human development. It was this system, which had not learned the lesson that man was made for commerce, but supposed in its simplicity that commerce was made for man, which produced the art of the Middle Ages, wherein the harmonious co-operation of free intelligence was carried to the furthest point

which has yet been attained, and which alone of all art can claim
to be called Free. The effect of this freedom, and the widespread
or rather universal sense of beauty to which it gave birth, became
obvious enough in the outburst of the expression of splendid and
copious genius which marks the Italian Renaissance. Nor can it
be doubted that this glorious art was the fruit of the five centu-
ries of free popular art which preceded it, and not of the rise of
commercialism which was contemporaneous with it; for the
glory of the Renaissance faded out with strange rapidity as com-
mercial competition developed, so that about the end of the sev-
enteenth century, both in the intellectual and the decorative arts,
the commonplace or body still existed, but the romance or soul
of them was gone. Step by step they had faded and sickened
before the advance of commercialism, now speedily gathering
force throughout civilization. The domestic or architectural arts
were becoming (or become) mere toys for the competitive mar-
ket through which all material wares used by civilized men now
had to pass. Commercialism had by this time well nigh destroyed
the craft-system of labour, in which, as aforesaid, the unit of
labour is a fully instructed craftsman, and had supplanted it by
what I will ask leave to call the workshop-system, wherein, when
complete, division of labour in handiwork is carried to the high-
est point possible, and the unit of manufacture is no longer a
man, but a group of men, each member of which is dependent on
his fellows, and is utterly useless by himself. This system of the
workshop division of labour was perfected during the eighteenth
century by the efforts of the manufacturing classes, stimulated
by the demands of the ever-widening markets; it is still the sys-
tem in some of the smaller and more domestic kinds of manufac-
ture, holding much the same place amongst us as the remains of
the craft-system did in the days when that of the workshop was
still young. Under this system, as I have said, all the romance of
the arts died out, but the commonplace of them flourished still;
for the idea that the essential aim of manufacture is the making
of goods still struggled with a newer idea which has since ob-
tained complete victory, namely, that it is carried on for the sake
of making a profit for the manufacturer on the one hand, and on
the other for the employment of the working classes.

This idea of commerce being an end in itself and not a means
merely, being but half developed in the eighteenth century, the
special period of the workshop-system, some interest could still

be taken in those days in the making of wares. The capitalist-manufacturer of the period had some pride in turning out goods which would do him credit, as the phrase went; he was not willing wholly to sacrifice his pleasure in this kind to the imperious demands of commerce; even his workman, though no longer an artist, that is a free workman, was bound to have skill in his craft, limited though it was to the small fragment of it which he had to toil at day by day for his whole life.

But commerce went on growing, stimulated still more by the opening up of new markets, and pushed on the invention of men, till their ingenuity produced the machines which we have now got to look upon as necessities of manufacture, and which have brought about a system the very opposite to the ancient craft-system; that system was fixed and conservative of methods; there was no real difference in the method of making a piece of goods between the time of Pliny and the time of Sir Thomas More; the method of manufacture, on the contrary, in the present time, alters not merely from decade to decade, but from year to year; this fact has naturally helped the victory of this machine-system, the system of the Factory, where the machine-like workmen of the workshop period are supplanted by actual machines, of which the operatives (as they are now called) are but a portion, and a portion gradually diminishing both in importance and numbers. This system is still short of its full development, therefore to a certain extent the workshop-system is being carried on side by side with it, but it is being speedily and steadily crushed out by it; and when the process is complete, the skilled workman will no longer exist, and his place will be filled by machines directed by a few highly trained and very intelligent experts, and tended by a multitude of people, men, women, and children, of whom neither skill nor intelligence is required.

This system, I repeat, is as near as may be the opposite of that which produced the popular art which led up to that splendid outburst of art in the days of the Italian Renaissance which even cultivated men will sometimes deign to notice now-a-days; it has therefore produced the opposite of what the old craft-system produced, the death of art and not its birth; in other words the degradation of the external surroundings of life, or simply and plainly unhappiness. Through all society spreads that curse of unhappiness: from the poor wretches, the news of whom we middle-class people are just now receiving with such naïf wonder

and horror: from those poor people whom nature forces to strive against hope, and to expend all the divine energy of man in competing for something less than a dog's lodging and a dog's food, from them up to the cultivated and refined person, well lodged, well fed, well clothed, expensively educated, but lacking all interest in life except, it may be, the cultivation of unhappiness as a fine art.

Something must be wrong then in art, or the happiness of life is sickening in the house of civilization. What has caused the sickness? Machine-labour will you say? Well, I have seen quoted a passage from one of the ancient Sicilian poets rejoicing in the fashioning of a water-mill, and exulting in labour being set free from the toil of the hand-quern in consequence; and that surely would be a type of a man's natural hope when foreseeing the invention of labour-saving machinery as 'tis called; natural surely, since though I have said that the labour of which art can form a part should be accompanied by pleasure, no one could deny that there is some necessary labour even which is not pleasant in itself, and plenty of unnecessary labour which is merely painful. If machinery had been used for minimizing such labour, the utmost ingenuity would scarcely have been wasted on it; but is that the case in any way? Look round the world, and you must agree with John Stuart Mill in his doubt whether all the machinery of modern times has lightened the daily work of one labourer. And why have our natural hopes been so disappointed? Surely because in these latter days, in which as a matter of fact machinery has been invented, it was by no means invented with the aim of saving the pain of labour. The phrase labour-saving machinery is elliptical, and means machinery which saves the cost of labour, not the labour itself, which will be expended when saved on tending other machines. For a doctrine which, as I have said, began to be accepted under the workshop-system, is now universally received, even though we are yet short of the complete development of the system of the Factory. Briefly, the doctrine is this, that the essential aim of manufacture is making a profit; that it is frivolous to consider whether the wares when made will be of more or less use to the world so long as any one can be found to buy them at a price which, when the workman engaged in making them has received of necessaries and comforts as little as he can be got to take, will leave something over as a reward to the capitalist who has employed him. This doc-

trine of the sole aim of manufacture (or indeed of life) being the profit of the capitalist and the occupation of the workman, is held, I say, by almost every one; its corollary is, that labour is necessarily unlimited, and that to attempt to limit it is not so much foolish as wicked, whatever misery may be caused to the community by the manufacture and sale of the wares made.

It is this superstition of commerce being an end in itself, of man made for commerce, not commerce for man, of which art has sickened; not of the accidental appliances which that super-stition when put in practice has brought to its aid; machines and railways and the like, which do now verily control us all, might have been controlled by us, if we had not been resolute to seek profit and occupation at the cost of establishing for a time that corrupt and degrading anarchy which has usurped the name of Society. It is my business here to-night and everywhere to foster your discontent with that anarchy and its visible results; for in-deed I think it would be an insult to you to suppose that you are contented with the state of things as they are; contented to see all beauty vanish from our beautiful city, for instance; contented with the squalor of the black country, with the hideousness of London, the wen of all wens, as Cobbett called it; contented with the ugliness and baseness which everywhere surround the life of civilized man; contented, lastly, to be living above that unutter-able and sickening misery of which a few details are once again reaching us as if from some distant unhappy country, of which we could scarcely expect to hear, but which I tell you is the necessary foundation on which our society, our anarchy, rests.

Neither can I doubt that every one here has formed some idea of remedies for these defects in our civilization, as we euphemis-tically call them, even though the ideas be vague; also I know that you are familiar with the precepts of the system of economy, that religion, I may say, which has supplanted the precepts of the old religions on the duty and blessing of giving to the needy; you understand of course that though a friend may give to a friend and both giver and receiver be better for the gift, yet a rich man cannot give to a poor one without both being the worse for it; I suppose because they are not friends. And amidst all this I feel sure, I say, that you all of you have some ideal of a state of things better than that amidst which we live, something, I mean to say, more than the application of temporary palliatives to the enduring defects of our civilization.

Now it seems to me that the ideal of better times which the more advanced in opinion of our own class have formed as possible and hopeful is something like this. There is to be a large class of industrious people not too much refined (or they could not do the rough work wanted of them), who are to live in comfort (not, however, meaning our middle-class comfort), and receive a kind of education (if they can), and not be overworked; that is, not overworked for a working man; his light day's work would be rather heavy for the refined classes. This class is to be the basis of society, and its existence will leave the consciences of the refined class quite free and at rest. From this refined class will come the directors or captains of labour (in other words the usurers), the directors of people's consciences, religious and literary (clergy, philosophers, newspaper-writers), and lastly, if that be thought of at all, the directors of art; these two classes with or without a third, the functions of which are indefinite, will live together with the greatest goodwill, the upper helping the lower without sense of condescension on one side or humiliation on the other; the lower are to be perfectly content with their position, and there is to be no grain of antagonism between the classes: although (even Utopianism of this kind being unable to shake off the idea of the necessity of competition between individuals) the lower class, blessed and respected as it is to be, will have moreover the additional blessing of hope held out to it; the hope of each man rising into the upper class, and leaving the chrysalis of labour behind him; nor, if that matters, is the lower class to lack due political or parliamentary power; all men (or nearly all) being equal before the ballot-box, except so far as they may be bought like other things. That seems to me to be the middle-class liberal ideal of reformed society; all the world turned bourgeois, big and little, peace under the rule of competitive commerce, ease of mind and a good conscience to all and several under the rule of the devil take the hindmost.

Well, for my part I have nothing, positively nothing, to say against it if it can be brought about. Religion, morality, art, literature, science, might for all I know flourish under it and make the world a heaven. But have we not tried it somewhat already? Are not many people jubilant whenever they stand on a public platform over the speedy advent of this good time? It seems to me that the continued and advancing prosperity of the working classes is almost always noted when a political man addresses an

audience on general subjects, when he forgets party politics; nor seldom when he remembers them most. Nor do I wish to take away honour where honour is due; I believe there are many people who deeply believe in the realization of this ideal, while they are not ignorant of how lamentably far things are from it at present; I know that there are men who sacrifice time, money, pleasure, their own prejudices even, to bring it about; men who hate strife and love peace, men hard working, kindly, unambitious. What have they done? How much nearer are they to the ideal of the bourgeois commonwealth than they were at the time of the Reform Bill, or the time of the repeal of the Corn Laws? Well, thus much nearer to a great change perhaps, that there is a chink in the armour of self-satisfaction; a suspicion that perhaps it is not the accidents of the system of competitive commerce which have to be abolished, but the system itself; but as to approaching the ideal of that system reformed into humanity and decency, they are about so much nearer to it as a man is nearer to the moon when he stands on a hayrick. I don't want to make too much of the matter of money-wages apart from the ghastly contrast between the rich and the poor which is the essence of our system; yet remember that poverty driven below a certain limit means degradation and slavery pure and simple. Now I have seen a statement made by one of the hopeful men of the rich middle class that the average yearly income of an English working man's household is one hundred pounds. I don't believe the figures because I am sure that they are swollen by wages paid in times of inflation, and ignore the precarious position of most working men; but quite apart from that, do not, I beg you, take refuge behind averages; for at least they are swelled by the high wages paid to special classes of workmen in special places, and in the manufacturing districts by the mothers of families working in factories, to my mind a most abominable custom, and by other matters of the like kind, which the average-makers leave you to find out for yourselves. But even that is not the point of the matter. For my part the enormous average of one hundred pounds a year to so many millions of toiling people, while many thousands who do not toil think themselves poor with ten times the income, does not comfort me for the fact of a thousand strong men waiting at the dock gates down at Poplar the greater part of a working-day, on the chance of some of them being taken on at wretched wages, or for the ordinary wage of a farm labourer over

a great part of England being ten shillings per week, and that
considered ruinous by the farmers also: if averages will content
us while such things as this go on, why stop at the working
classes? Why not take in everybody, from the Duke of Westmin-
ster downwards, and then raise a hymn of rejoicing over the in-
come of the English people?

I say let us be done with averages and look at lives and their
sufferings, and try to realize them: for indeed what I want you to
note is this; that though you may realize a part of the bourgeois
or radical ideal, there is and for ever will be under the competi-
tive system a skeleton in the cupboard. We may, nay, we have
managed to create a great mass of middling well-to-do people,
hovering on the verge of the middle classes, prosperous artisans,
small tradesmen, and the like; and I must say parenthetically that
in spite of all their innate good qualities the class does little
credit to our civilization; for though they live in a kind of swin-
ish comfort as far as food is concerned, they are ill housed, ill
educated, crushed by grovelling superstitions, lacking reasonable
pleasures, utterly devoid of any sense of beauty. But let that
pass. For aught I know we may very much increase the propor-
tionate numbers of this class without making any serious change
in our system, but under all that still lies and will lie another
class which we shall never get rid of as long as we are under the
tyranny of the devil take the hindmost; that class is the Class of
Victims. Now above all things I want us not to forget them (as
indeed we are not likely to for some weeks to come), or to con-
sole ourselves by averages for the fact that the riches of the rich
and the comfort of the well-to-do are founded on that terrible
mass of undignified, unrewarded, useless misery, concerning
which we have of late been hearing a little, a very little; after all
we do know that is a fact, and we can only console ourselves by
hoping that we may, if we are watchful and diligent (which we
very seldom are), we may greatly diminish the amount of it. I ask
you, is such a hope as that worthy of our boasted civilization
with its perfected creeds, its high morality, its sounding political
maxims? Will you think it monstrous that some people have con-
ceived another hope, and see before them the ideal of a society
in which there should be no classes permanently degraded for the
benefit of the commonweal? For one thing I would have you
remember, that this lowest class of utter poverty lies like a gulf
before the whole of the working classes, who in spite of all av-

erages live a precarious life; the failure in the game of life which entails on a rich man an unambitious retirement, and on a well-to-do man a life of dependence and laborious shifts, drags a working man down into that hell of irredeemable degradation. I hope there are but few, at least here, who can comfort their consciences by saying that the working classes bring this degradation on themselves by their own unthrift and recklessness. Some do, no doubt, stoic philosophers of the higher type not being much commoner among day-labourers than among the well-to-do and rich; but we know very well how sorely the mass of the poor strive, practising such thrift as is in itself a degradation to man, in whose very nature it is to love mirth and pleasure, and how in spite of all that they fall into the gulf. What! are we going to deny that when we see all round us in our own class cases of men failing in life by no fault of their own; nay, many of the failers worthier and more useful than those that succeed: as might indeed be looked for in the state of war which we call the system of unlimited competition, where the best campaigning-luggage a man can carry is a hard heart and no scruples? For indeed the fulfilment of that liberal ideal of the reform of our present system into a state of moderate class supremacy is impossible, because that system is after all nothing but a continuous implacable war; the war once ended, commerce, as we now understand the word, comes to an end, and the mountains of wares which are either useless in themselves or only useful to slaves and slaveowners are no longer made, and once again art will be used to determine what things are useful and what useless to be made; since nothing should be made which does not give pleasure to the maker and the user, and that pleasure of making must produce art in the hands of the workman. So will art be used to discriminate between the waste and the usefulness of labour; whereas at present the waste of labour is, as I have said above, a matter never considered at all; so long as a man toils he is supposed to be useful, no matter what he toils at.

I tell you the very essence of competitive commerce is waste; the waste that comes of the anarchy of war. Do not be deceived by the outside appearance of order in our plutocratic society. It fares with it as it does with the older forms of war, that there is an outside look of quiet wonderful order about it; how neat and comforting the steady march of the regiment; how quiet and respectable the sergeants look; how clean the polished cannon;

neat as a new pin are the storehouses of murder; the books of
adjutant and sergeant as innocent-looking as may be; nay, the
very orders for destruction and plunder are given with a quiet
precision which seems the very token of a good conscience; this
is the mask that lies before the ruined cornfield and the burning
cottage, the mangled bodies, the untimely death of worthy men,
the desolated home. All this, the results of the order and sobriety
which is the face which civilized soldiering turns towards us
stay-at-homes, we have been told often and eloquently enough to
consider; often enough we have been shown the wrong side of
the glories of war, nor can we be shown it too often or too elo-
quently. Yet I say even such a mask is worn by competitive com-
merce, with its respectable prim order, its talk of peace and the
blessings of intercommunication of countries and the like; and
all the while its whole energy, its whole organized precision is
employed in one thing, the wrenching the means of living from
others; while outside that everything must do as it may, whoever
is the worse or the better for it; as in the war of fire and steel, all
other aims must be crushed out before that one object. It is worse
than the older war in one respect at least, that whereas that was
intermittent, this is continuous and unresting, and its leaders and
captains are never tired of declaring that it must last as long as
the world, and is the end-all and be-all of the creation of man and
of his home. Of such the words are said:

> *For them alone do seethe*
> *A thousand men in troubles wide and dark;*
> *Half ignorant they turn an easy wheel*
> *That sets sharp racks at work to pinch and peel.*

What can overthrow this terrible organization so strong in it-
self, so rooted in the self-interest, stupidity, and cowardice of
strenuous narrow-minded men; so strong in itself and so much
fortified against attack by the surrounding anarchy which it has
bred? Nothing but discontent with that anarchy, and an order
which in its turn will arise from it, nay, is arising from it; an
order once a part of the internal organization of that which it is
doomed to destroy. For the fuller development of industrialism
from the ancient crafts through the workshop-system into the
system of the factory and the machine, while it has taken from
the workmen all pleasure in their labour, or hope of distinction

and excellence in it, has welded them into a great class, and has by its very oppression and compulsion of the monotony of life driven them into feeling the solidarity of their interests and the antagonism of those interests to those of the capitalist class; they are all through civilization feeling the necessity of their rising as a class. As I have said, it is impossible for them to coalesce with the middle classes to produce the universal reign of moderate bourgeois society which some have dreamed of; because however many of them may rise out of their class, these become at once part of the middle class, owners of capital, even though it be in a small way, and exploiters of labour; and there is still left behind a lower class which in its own turn drags down to it the unsuccessful in the struggle; a process which is being accelerated in these latter days by the rapid growth of the great factories and stores, which are extinguishing the remains of the small workshops served by the men who may hope to become small masters, and also the smaller of the tradesman class. Thus then, feeling that it is impossible for them to rise as a class, while competition naturally, and as a necessity for its existence, keeps them down, they have begun to look to association as their natural tendency, just as competition is looked to by the capitalists; in them the hope has arisen, if nowhere else, of finally making an end of class degradation.

It is in the belief that this hope is spreading to the middle classes that I stand before you now, pleading for its acceptance by you, in the certainty that in its fulfilment alone lies the other hope for the new birth of Art and the attainment by the middle classes of true refinement, the lack of which at present is so grievously betokened by the sordidness and baseness of all the external surroundings of our lives, even those of us who are rich. I know there are some to whom this possibility of getting rid of class degradation may come, not as a hope, but as a fear. These may comfort themselves by thinking that this Socialist matter is a hollow scare, in England at least; that the proletariat have no hope, and therefore will lie quiet in this country, where the rapid and nearly complete development of commercialism has crushed the power of combination out of the lower classes; where the very combinations, the Trades Unions, founded for the advancement of the working class as a class, have already become conservative and obstructive bodies, wielded by the middle-class politicians for party purposes; where the proportion of the town

and manufacturing districts to the country is so great that the inhabitants, no longer recruited by the peasantry but become townsmen bred of townsmen, are yearly deteriorating in physique; where lastly education is so backward.

It may be that in England the mass of the working classes has no hope; that it will not be hard to keep them down for a while, possibly a long while. The hope that this may be so I will say plainly is a dastard's hope, for it is founded on the chance of their degradation. I say such an expectation is that of slave-holders or the hangers-on of slave-holders. I believe, however, that hope is growing among the working classes even in England; at any rate you may be sure of one thing, that there is at least discontent. Can any of us doubt that, since there is unjust suffering? Or which of us would be contented with ten shillings a week to keep our households with, or to dwell in unutterable filth and have to pay the price of good lodging for it? Do you doubt that if we had any time for it amidst our struggle to live we should look into the title of those who kept us there, themselves rich and comfortable, under the pretext that it was necessary to society? I tell you there is plenty of discontent, and I call on all those who think there is something better than making money for the sake of making it to help in educating that discontent into hope, that is into the demand for the new birth of society; and I do this not because I am afraid of it, but because I myself am discontented and long for justice.

Yet, if any of you are afraid of the discontent which is abroad, in its present shape, I cannot say that you have no reason to be. I am representing reconstructive Socialism before you; but there are other people who call themselves Socialists whose aim is not reconstruction, but destruction; people who think that the present state of things is horrible and unbearable (as in very truth it is), and that there is nothing for it but to shake society by constant blows given at any sacrifice, so that it may at last totter and fall. May it not be worth while, think you, to combat such a doctrine by supplying discontent with hope of change that involves reconstruction? Meanwhile, be sure that, though the day of change may be long delayed, it will come at last. The middle classes will one day become conscious of the discontent of the proletariat; before that some will have renounced their class and cast in their lot with the working men, influenced by love of justice or insight into facts. For the rest, they will, when their conscience is awak-

ened, have two choices before them; they must either cast aside their morality, of which though three parts are cant, the other is sincere, or they must give way. In either case I do believe that the change will come, and that nothing will seriously retard that new birth; yet I well know that the middle class may do much to give a peaceable or a violent character to the education of discontent which must precede it. Hinder it, and who knows what violence you may be driven into, even to the renunciation of the morality of which we middle-class men are so proud; advance it, strive single-heartedly that truth may prevail, and what need you fear? At any rate not your own violence, not your own tyranny?

Again I say things have gone too far, and the pretence at least of a love of justice is too common among us, for the middle classes to attempt to keep the proletariat in its condition of slavery to capital, as soon as they stir seriously in the matter, except at the cost of complete degradation to themselves, the middle class, whatever else may happen. I cannot help hoping that there are some here who are already in dread of the shadow of that degradation of consciously sustaining an injustice, and are eager to escape from that half-ignorant tyranny of which Keats tells, and which is, sooth to say, the common condition of rich people. To those I have a last word or two to say in begging them to renounce their class pretensions and cast in their lot with the working men. It may be that some of them are kept from actively furthering the cause which they believe in by that dread of organization, by that unpracticality in a word, which, as it is very common in England generally, is more common among highly cultivated people, and, if you will forgive the word, most common in our ancient universities. Since I am a member of a Socialist propaganda I earnestly beg those of you who agree with me to help us actively, with your time and your talents if you can, but if not, at least with your money, as you can. Do not hold aloof from us, since you agree with us, because we have not attained that delicacy of manners, that refinement of language, nay, even that prudent and careful wisdom of action which the long oppression of competitive commerce has crushed out of us.

Art is long and life is short; let us at least do something before we die. We seek perfection, but can find no perfect means to bring it about; let it be enough for us if we can unite with those whose aims are right, and their means honest and feasible. I tell you if we wait for perfection in association in these days of com-

bat we shall die before we can do anything. Help us now, you whom the fortune of your birth has helped to make wise and refined; and as you help us in our work-a-day business toward the success of the cause, instil into us your superior wisdom, your superior refinement, and you in your turn may be helped by the courage and hope of those who are not so completely wise and refined. Remember we have but one weapon against that terrible organization of selfishness which we attack, and that weapon is Union. Yes, and it should be obvious union, which we can be conscious of as we mix with others who are hostile or indifferent to the cause; organized brotherhood is that which must break the spell of anarchical Plutocracy. One man with an idea in his head is in danger of being considered a madman; two men with the same idea in common may be foolish, but can hardly be mad; ten men sharing an idea begin to act, a hundred draw attention as fanatics, a thousand and society begins to tremble, a hundred thousand and there is war abroad, and the cause has victories tangible and real; and why only a hundred thousand? Why not a hundred million and peace upon the earth? You and I who agree together, it is we who have to answer that question.

## ❧ *Two* ❧

# *Art and the People: A Socialist's Protest Against Capitalist Brutality; Addressed to the Working Classes*

Fellow citizens,

I WISH to say a few plain words to you on the subject of art; and since I address myself chiefly to those who are called the working classes, I know well that the plainer those words are the better, since now for many years, for centuries, the working classes have scarcely been partakers in art of any kind, and the phraseology of men learned in the fine arts will be strange to you. For centuries this slavery has been added to the rest of the oppression under which you lie, that you have been forbidden to have any share in the intelligent production of beautiful things.

Indeed, I think it will be news to many of you who toil to live that you may live to toil, that there either is or has been or can be any connexion between Art and the People. It may seem to you, I can well imagine, that art is concerned only in making luxurious toys for rich and idle persons, and that all the working classes have to do with it, is that some of them can earn their poor wages by working at it as machines work, without knowing or caring what they are doing; while now and then on holidays those of them that chance to think of it and who live in London may stray into the National Gallery or the British Museum, and see the carefully hoarded works of past ages, and get from them such good as men can get who look on a book in an antiquated dialect of their language without an interpreter between them and the past.

And yet there is a phrase which of late has been much in the mouths of those who have been thought to be interested in the welfare of the Fine Arts; they have talked much of Popular Art: what does that mean?

The words Popular Art, or Art of the People, have a meaning you may be sure; the thing which they mean has really existed, or you would have little to look at when you stray into the National Gallery and the British Museum: the Art of the People has in many places and in many times solaced and sustained the people amidst their griefs and troubles.

And a great gift such an art seems to me; an art made intelligently by the whole body of those who live by their labour: instinct with their thoughts and aspirations, moving whither they are moving, changing as they change, the genuine expression of their sense of the beauty and mystery of life: an art born of their joy and outliving their sorrow, though tinged by it: an art leaving to future ages living witness of the existence of deft hands and eager minds not too proud to tell us of their imperfect thoughts and their glimpses of insight into wonders and terrors, as they passed amid the hurry of their daily work through the sunshine and the shadow of their lives.

This, I say, is the Art of the People, and on this is founded all Art which is worth anything. I do not believe that Art worthy of the name can long exist, unless it rests on such a foundation: or if it can, if it really be that there can be an art practised by and for a few well-to-do and rich people, and founded on the slavery of the many, I for one will have nought to do with it: to me it will be contemptible and dishonourable, a rag of luxury and folly.

And yet, I must tell you that I am an artist: art is that by which I live; it feeds me body and soul, and without it the world would be empty to me: judge therefore how I must love and long for the Art of the People! For with me it comes to this, that I cannot live with any approach to happiness without art forming part of my life, and I know that my only chance of my having any real share in art, is that it shall be the Art of the People: nay more, I know that what art yet remains to us from the time when man had some pleasure in his labour, is lessening day by day, and that unless some change comes which will give all people a share in art, there will soon be no art at all left in the world. Judge therefore, I say, how I must love the Art of the People!

And one thing I must tell you before I go further, that this art is not a mere dream of something which might have been; as I have said it has in many times and places solaced the lives of toiling men; and this I have noticed of the times and places where it has flourished, that it has always been in advance of the apparent progress of the times that produced it. I have been astonished when I have looked into the popular art of past ages to find work so refined and elegant done in times so rude and rough: work bearing so many tokens of quick wit and invention done in times so ignorant and superstitious: works showing so many signs of freedom of thought and pleasure in life and external nature in days which seem to us to have been so full of oppression, gloom and turmoil; all these, mind you, qualities of hand and soul which could not have been produced to the order of rich men; for such qualities are spontaneous and cannot be bought with money or compelled by power: in short, it is not easy to exaggerate the contrast between the beauty and thoughtfulness of the handicrafts of certain periods, and the folly and disgrace of their history as otherwise told. Can we wonder at this? That written history of 'Kings and Scoundrels'* is made up of the deeds of the greedy few ruling arbitrarily; while the history of art is made up of the deeds of the patient many living naturally.

The History of Art! what is that history indeed but the history of the World, since it alone tells us of the deeds of the people, and what they thought of and hoped for? through this and this alone can we look upon times past as they really were and see them alive.

And our own times, the days in which we live, how will those come to know the story of our lives from day to day? Well, when we are gone, and the 19th century has become a mere part of the past history of the world, people will still I suppose study history through the remains and records of popular art, as they do now:

---

* 'There also shall we be free from the troubling of kings and scoundrels' are the memorable words used by the freemen of Norway when they left their country at the end of the tenth century to find freedom amidst the terrible wastes of Iceland: but for them the history and mythology of the North would have been forgotten.

but when they come to these days and seek for evidence in their handiwork of the lives of those who lived by their labour, they will be baulked and have to stop short: they will perhaps find evidence of what the upper and middle classes thought working men were like left them in literature, chiefly novels; they will have record more or less trustworthy of their efforts towards political and social advancement; they will know that they made and used certain machines, and that they drew such and such wages: they will in short know something of the people as a political and commercial machine; but of the real story of their lives and the daily labour which was so great a part of them they will know nothing; a blank space will be the history of the popular art of the 19th century.

To make sure that you do not misunderstand me, I will state in the plainest words possible what seems to me to be the condition of Art in civilized countries, and in what proportions such art as there is, is shared amongst the various classes of the community.

Now the fine arts must be divided into two classes or kinds: the first what we may call the intellectual Arts, represented by painting and sculpture, address themselves wholly to the mind of man; they have no necessary connexion with any articles of material use, I mean. It is conceivable that a community might have all bodily necessaries, comforts, luxuries even, and not know what painting and sculpture meant: but besides these strictly intellectual Arts, there is a large body of art (or the pretence of it) which forms part of the matters of our daily life; our houses, our furniture, our utensils for eating and drinking, and our clothes are ornamented by this lesser kind of art, which cannot be dissociated from the things which we use every day: and this is commonly called decorative or ornamental art. I must further explain that while nations and times (though not many) have lacked the purely intellectual art, no nation or time has ever consented to do without the ornamental art; and lastly I must tell you that in all times when the Arts were in a healthy condition there was an intimate connexion between these two kinds of art; nay moreover that in those times when art flourished most, the higher and the lower kinds of art were divided from one another by no hard and fast lines; the highest of the intellectual art had ornamental character in it and appealed to all men, and to all the faculties of a man; while the humblest of the ornamental art shared in the

meaning and deep feeling of the intellectual; one melted into the other by scarce perceptible gradations: or to put it into other words, the best artist was a workman, the humblest workman was an artist.

Well, let us see how it fares with art to-day: those who practise the purely intellectual arts, and who are technically called 'artists' are all by virtue of their occupation conventionally of the class of gentlemen, and many of them are men of education from their youth up: it is nowise my business here or elsewhere to criticize the works of these men; but I think I may be allowed to say that they are really subdivided into two classes, the first composed of men who would in any age of the world have held a high place in their art; the second composed of men who hold their present position of gentlemen-artists either by the accident of their birth, or by their possessing industry, business habits or such-like qualities out of all proportion to their artistic gifts. The work which these latter produce seems to me of little value to the world (though there is a thriving market for it), and their position is neither dignified nor wholesome; yet they are mostly not to be personally blamed for it, since oftenest they have some gifts for art though not great ones, and would probably not have succeeded in any other career; they are in fact good decorative workmen spoiled by a system which urges them to worldly ambition; in times when popular art was flourishing, and when one man was apprenticed to an artist, just as another was to a carpenter, they would have found their level, and in various ways done useful though unambitious work.

Again as to that first class of artists, who worthily fill their place and make the world wealthier by their work, they are very few, and have won their mastery over their craft by dint of incredible toil, painstaking and anxiety: yet in spite of that, or perhaps because of it, they cannot help looking back with longing eyes toward the past times of art when less labour produced greater results: for whatever knowledge they may have of the older art, and its methods of work, they are cut off from *tradition,* that wonderful almost magical accumulation of the skill of ages, which men find themselves sharers in almost without effort on their part, and by which their toil of learning is so very much diminished.

Furthermore these great artists, as they only hold on to the past artificially and by effort, so also, and that is worse, they fail

to touch widely those who are living in the present: for as a body
the whole public, Upper, Middle and Lower classes, is ignorant
of art: apart from the artists themselves and those very few per-
sons who have special gifts of sympathy with them, there is no
real knowledge of what art means; nothing at the best save cer-
tain vague prepossessions, which are but the phantoms of that
Tradition I have spoken of, which once bound artist and public
together. Therefore the artists are obliged to express themselves,
as it were, in a language 'not understanded of the people': nor is
this their fault; if they were to try, as some think they should, to
meet the public half-way, and work in such a manner as to sat-
isfy only those prepossessions of men ignorant of art, they would
be casting aside their special gifts, and would become traitors to
that cause of art which it is their duty and glory to serve: they
have no choice save to do their own personal work without any
hope of being understood as things now are; to stand apart as
possessors of some sacred mystery, which, whatever happens,
they must at least do their best to guard: and by this isolation
their loss is great; great both to their own minds and to the work
they produce; and as to our loss, the loss of the public, it is not
easy to measure: for, you see, it comes to this, if we are to con-
sider the distribution of the great and elevating intellectual pleas-
ure of the enjoyment of the higher arts, that only a very few
among the most cultivated classes can share in it.

But if it fares thus with that side of the arts which, depending
on individual genius, is only acted on indirectly by bad social
conditions, what is likely to be the state of that other side of the
fine arts which is commonly called decorative art; art which (or
the pretence of which) is to be found on nearly every piece of
goods which is offered for sale? How is it likely to be with this
art which above all other depends on the co-operation of men
with each other?

Well I suppose there are many people who have not realized
the fact that such an art exists, or who have heard that it ever did
exist; and few indeed are those who consider that this great body
of art, which has in times past had such a hold on the world, can
now be worth the exercise of the thoughts of serious people.

Such as these arts now are, this is the way in which they are
carried on; they are made by three sets of people, I won't say
working together, but rather jostling along together: the first link
in the chain is the capitalist called the manufacturer, a ridiculous

misnomer since the word ought to mean a man who makes things with his hands: well he is by virtue of his position conventionally a gentleman, and often enough has received a liberal education; but in spite of any education he may have received it is rarely indeed that he takes any interest in the craft he is supposed to direct, and rarer still that he troubles himself on the quality of any ornament, i.e., art, which may be in it for its own sake: nay, if he be personally inclined to do so his position would soon put a stopper on his wishes: he has been created to 'make a profit' as 'tis called, i.e., to accumulate money which he has not earned, and which most people suppose tumbles mysteriously from the sky as a heaven-sent blessing on capital; but which some of us, who have not been content to accept the miracle, believe really comes of the earnings of those who do labour with their hands, and are called in the jargon of to-day 'operatives' not manufacturers. A good deal more could be said of the manufacturer and his position, but at present I must consider him only as the first link of the chain in the production of popular art (so called) and from that point of view all I need say of him is that he is and is compelled to be quite careless of what art there may profess to be in the wares he gets made. It will illustrate this side of the subject if you think how many rich men there are who profess (no doubt honestly) to be deeply interested in art and literature; who read poems and such-like books, who further the establishment of museums, who buy pictures for great sums of money, and who nevertheless are actually engaged in pushing on the degradation of art, because they are in a position which forces on them the accumulation of money as an imperative duty, not to be set aside by any consideration: which money if they but knew it, is not theirs, but has been forced by the screw of competition out of the earnings of those who are, to speak bluntly, their slaves.

The second link in the chain of the system by which industrial art is produced, is the body of men who go between capital and labour, as managers, foremen, and the like; as far as the ornamenting of wares is concerned they are represented by the designer, who is usually educated technically but seldom liberally: in the few cases in which gentlemen-artists are employed in this intermediate position, they know little or nothing of the way in which the wares are made and have next to no communication with the workman; but whatever the social position of the designer may be as a factor in the production of art, he is bound by

the same necessity as the capitalist to consider first of all the 'making a profit', and is also in most cases only a superior slave to the operative-slave, and competes for a bare existence like the latter.

As for the workman, the third link in the chain, I need not waste many words on his share in the production of art; when he has anything to do save to tend an automatic machine, he has nevertheless no control over the design of the art, or even over the way in which it is to be carried out; he is only responsible for turning out his work rigidly to pattern, is in fact a machine and nothing better.

Now at present I will not ask you workmen whether you are content to spend your working hours fulfilling the office of cog-wheels and cranks, but I will simply assert that under the system I have been speaking of it is impossible to turn out art: you must take an artist's word for that.

Let us look at the system again and summarize its beautiful arrangements: I am supposing it, mind you, to be a system for the production of art as it verily professes to be in some degree in all cases, while sometimes it is supposed to be employed making wares which are pure works of art. This in short is the system: at the head is a man who is absolutely master of the production, who is forced by his position not to heed whether what he produces is good or bad so long as it sells at a profit: his will is carried one step further by subordinates who have to take care that the wares shall sell at a profit and of nothing else; and finally the 'hands' who accomplish the will of the 'captain of labour' have one thing only to do, to make their labour profit-able—to their master.

What place can art have in such a system? How much can people care about art who will put up with the products of such a system?

But indeed whatever may be thought of the matter by a public quite ignorant of art, the plain truth is that the system does not intend to produce either art or anything else which might add to the pleasure of life or its dignity: making a profit out of the lives of the great masses of the working man is its sole aim.

Therefore the sad truth is that there is no popular art to-day, no art which represents the feelings and aspirations of the people at large, as for example the buildings of the Middle Ages repre-

sented the feelings and aspirations of the people, gentle and simple, lay and clerk, of that period.

This then is the condition of the fine arts under the rule of Plutocracy: on the one side there remains of the higher intellectual art, the work of poets, painters, and the like, a very small remnant struggling amidst a thicket of pretence and imposture: this remnant is lofty in aim and is not without special skill of its own; but it is quite unregarded by, indeed unknown to the people in general, and is but ill understood even among the cultivated classes by all but a very few.

On the other side of what used to be popular art there remains but a ghastly pretence of ornament which is nothing but a commercial imposture, or at best but a foolish survival of a half-remembered habit.

That I say is all the art we have left us; we in the heyday of civilization, we who, as many people confidently believe, have at last perfected our social system, and arranged for it to endure for ever in that perfect form.

Popular art is a thing the world once had and has now lost: is the loss grievous or trivial?

I answer first by another question: Is it right that the most of civilized men, all town-dwellers at least, should be deprived of the sight of beautiful things? is it right that they should, except on rare occasions, have to look on mere squalid ugliness?

I do not think we can seriously argue that question: consider what it means; loss of the sense of beauty. Indeed you may say that people will get used to it and will not feel it: alas! that is too true of this loss as of others. Think then what follows! We shall no longer for one thing be able to understand the meaning of the poets and great writers of the world; their language will be dead to us. What would be left to us indeed of all that makes life worth living? What! shall man go on generation after generation gaining fresh command over the powers of nature, gaining more and more luxurious appliances for the comfort of the body, yet generation after generation losing some portion of his natural senses: that is, of his life and soul? Think of a race of men whose eyes are only of use to serve them to carry their food to their mouths without spilling it!

It is no idle fear that this may befal us; nay there are plenty of such men already; and they may well say that if we are to live amidst of London as it is or amidst the squalor of the manufac-

turing districts without any hope of bettering the state of things, if not for ourselves, yet at least for our sons or our sons' sons, they may well say in this hopeless case that they are happier than those who have still kept their manlike senses: that it is better to be born blind.

A strange conclusion to come to if we must! a strange outcome of the progress of the race, if that be so:

That nature should have led us on through her ever varying moods and seasons of loveliness to desire beauty, and then that our own greed and cowardice should spoil all for us, even nature herself in the long run: if indeed it be true as I hear all kinds of people asserting that it is, that the inevitable destiny of the race of man will compel him to cover the whole of the civilized world with places like London or Manchester.

As for me I will say plainly that I can conceive of no greater downfall to the hopes of civilization than the fulfilment of this so-called inevitable destiny would be: a society replete with all material comforts but shorn of man's intellectual pleasures: in such cold words has one to speak of the reduction of the world to something far below a huge swine-stye; the grossest state of savagery which the world has known would be better than that, for there was hope in it; but no hope in the future which the present system, the rule of plutocracy, would bring us to.

So I say that if the beauty which once surrounded the daily life of man is to pass away for ever, the mere loss of that beauty, of the reasonable pleasure of the eyes, would be a grievous loss to the world: nay such a loss would be a sign that either our ideas of the progress of the race were but a fond dream from the first, or that progress has reached its height and is now going down hill: that the decrepitude of the race of man is beginning.

Where lies the hope with which we must answer this terrible fear?

To my mind it is wrapped up in the answer to be made to yet another question which I must now ask: Is it right that all men who make anything should be deprived of the pleasure of making beautiful things intelligently? Or, to put it in other words, is it right that only a very few men should have pleasure in their daily work?

I can easily suppose that it seems strange to most of you to hear that there can be pleasure in labour: and truly to most men now-a-days, even to most of those who are not strictly of the

working classes there is no pleasure in it; yet there are still a few men left whose life is spent in creating beauty for the sake of the beauty, that is to say that their work may give pleasure to themselves and others. Now consider such work, think of the pleasure that lies in a great piece of intellectual art, a picture, a poem or a piece of music; the pleasure and elevation of soul which you receive from it as you look or read or listen: think of this I say, and I believe it will be as inconceivable to you as it is to me that such work can be done without pleasure, that what it has rejoiced you so to receive has been no joy, nothing but weariness for the author, the inventor, to give.

People talk of the inspiration of a great author or a great artist; not without reason I think; for to my mind that inspiration means the hope and the fruition of pleasure which fills a man as he receives from the minds of those who came before him to give to his fellows now living and to those that shall live.

Now further I assert that some portion of this pleasure of creation is felt by every man who duly makes anything for the benefit of mankind: in which sentence you see there lie two important claims for labour: the first that such labour must be *duly* done; the second that it must be done for the benefit of the commonwealth.

It must be duly done; there must be in it some of the keen interest which every healthy man takes in healthy life; and in order that there may be such interest, it must have in it variety and hope besides that mysterious bodily pleasure which goes with the deft exercise of the bodily powers: the variety and hope that should go with all labour are intimately connected with each other: for the hope means hope of excellence, the hope of doing something different from day to day; nay in the end, of doing something which no other man but the workman has yet thought of in some respects at least: a piece of work so done, you understand, is a work of art, and he who does it is an artist, and only so done can any work that has any endurance in it be done duly.

But also not only must the work be done duly, but it must be done for the benefit of the commonwealth: when done it must be worth the trouble and labour spent on it, and when this claim is satisfied there is added self-respect to the hope and variety which I have just claimed as due to worthy labour: so that the pleasure which an artist, that is a free workman, feels in his labour, is made up of these three things, variety, hope of excellence and

self-respect: and the feelings of those who receive his work with due sympathy may be expressed by the corresponding words, surprise, pleasure and gratitude: and, believe me, the knowledge that one's work will be so received is a reward which the greatest man cannot afford to fall short of, and which the humblest cannot be deprived of without suffering grievous wrong.

But the workman of to-day is not free: he is during his working hours at least the slave of a system of labour which does not in the least concern itself with his pleasure in the work: instead of the incitement of the hope of excellence and the amusement of variety, it uses one goad to labour, the fear of ruin and starvation: it says in plain terms: 'Do this work which blind chance has apportioned to you, or else go to the workhouse or die'.

Who can wonder that all work which can be ill done is ill done now-a-days? it would be a more reasonable hope to expect to find figs on thistles than to find art growing from such a system.

For, moreover, those who have to work under the compulsion of competitive commerce cannot comfort themselves by thinking that suffer as they may they are suffering for the benefit of the commonweal. The system of competition which enslaves them has no such end in view as that: it is but the hollowest pretence which professes to think that the greater part of the wares made by modern commerce are of any use to the world; a professor of that system will, if he says what he thinks, admit that speedily enough: ask him the end of commerce, and he will tell you, to find occupation for people, to carry on the life of society.

But I will translate his speech and tell you what it means: just this is the end of competitive commerce, the getting people to live and breed in order that they may toil to go on living and breeding and by their toil produce a profit for certain people who call themselves masters: other things may be good, says this gospel, but this thing is necessary, that workmen should live and breed to produce a profit for their masters: this makes the true greatness of a country, this is prosperity, this is civilization.

Well, whatever names you may call it by, and I could find different names from these, it is for this we have given up art at least: and I who know what art means am not content with the sacrifice. But you, working men, of whom I am to my measureless grief compelled to say that you do not know what art means,

I ask you to consider what has been sacrificed along with art and as a part of it.

I have said that an artist, or free workman, works amused by variety, cheered by hope of success and excellence, and elevated by the sense of giving worthy gifts to the world: how then does the slave of commerce work? Does variety amuse him? What! with the pattern before him with the invention of which he had nothing to do, which he will vary at his peril: day by day and day by day the same dull task, his only solace to think of something else while it is going on? Good for him and us if his thought is of why he is a slave.

Does the hope of excellence cheer him? nay he is not asked, not allowed even, to excell: to turn the crank oftener than his comrade, that is his excellence: good for him and for us if he refuses to do so. Or lastly, is he elevated by the thought that he is giving worthy gifts to the world? What, when he scarcely knows what he is doing; or if he does know, knows only too well what sort of a gift his master (not he) is offering to the world— wares made to sell — let the buyer find out what they are! let the 'hand' take care he don't put too much work in them, 'for the margin of profit is narrow'!

The hope of the workman! what respectable hope has he save by constant toil and by dismal thrift, the misery and unmanliness of which I as an artist, and as one who enjoys life, can at least guess at, by toil and thrift to cast aside his craft and climb up the ladder into the class of petty capitalists; where he in his turn will make a profit from other men's labour, from other men's necessities and despair? That is the hope held out to him as the glory of the gospel of supply and demand, or in plainer English, the gospel of Devil take the hindmost: for you know climbing up the ladder means pulling two or three others off the rungs.

No, the work itself, the exercise of the craft (a word which in our older tongue means power) offers no hope and no pleasure to the workman. Yet note by far the greater part of your waking hours are your working hours, that the remnant of your lives is but made up of rests to enable you to go on toiling: under the present plutocratic system therefore the greater part of your lives will be passed in shuffling off a wearisome burden day by day, which day by day you must take up again. Is this a life for men to lead? Can we believe that it is necessary that the vast majority of men should live such a life? Is it necessary, that is, for most

men, to lead an unhappy life lit by no gleam of self-respect, cheered by one hope only, the hope of shifting the burden of unhappiness on to some one else's shoulders? Such is the life to which plutocracy condemns you.

So therefore my position comes to this; that art once common to the whole people has by the action of competitive commerce been taken from all but the more cultivated part of the well-to-do classes, and that as regards art this injustice is gradually putting an end to all art even amongst this limited class: while as regards the life of the people in general, it has not only starved it of beauty, but has also made almost all labour unhappy; that is to say, has cast a burden of unhappiness on the lives of the great mass of the people.

This evil I will not call the greatest of all the evils which the careless pursuit of so-called civilization has brought on the world, but will rather say that it does in itself include all the evils born of that fearful recklessness. What then is the remedy for it? I have just now denied that it was necessary that man's labour should be unhappy: but I say most solemnly that this unhappy labour *is* necessary to the existence of the present system of competitive commerce, on which modern society rests: I say that the whole structure of modern society rests on its power to compel the mass of the people to work unhappily on pain of death by starvation.

Unless this is changed utterly we may as well fold our hands, and let things go as they will; that is the plain truth: if you ask me, will not the change be gradual? I must say, yes, indeed; since it *must* come about by the change of opinion in men's minds; it is of course that whatever action takes place must spring from opinion—from hope let us say. Yes, it will be gradual; but do not let us deceive ourselves, it must be complete and without compromise: one thing has to be aimed at and one alone: the reconstruction of Society on such a basis that from thenceforth it will be impossible for any man to make his private profit from the compulsion of other men's labour: that it will be impossible for a man to labour duly without benefiting himself and all other men.

Pretty much the reverse of this is at present the rule in the productions of labour: when a piece of work is to be put in hand, the question asked of himself by the capitalist is this: Will it sell at a profit to me? And the fuller meaning of that question is

developed by these two further questions: Can money be screwed out of the general public for it? That is the question, and the second is: How much over the actual cost of production can I get for myself? or in other words: How much can I cut off for myself from the product of each workman's daily labour?

Or will you have the two questions in plainer English still? technical words are not wanted here: these are the questions: How much can I take by stealth from the public? how much can I take by force from the workman?

These are the two pillars of England's greatness; supply and demand are the words used to cloak their native hideousness, and men are hoodwinked by fine words.

But under the condition of things which I beg you to try to bring about, two questions would have to be asked when anyone was about producing anything: first, will the thing produced be useful to the world? second, will the making of it give healthy and pleasurable occupation to the makers?

If both these questions cannot be answered in the affirmative, then the work should not be done at all; the product of it will either not be wealth positively, or it will not be wealth relatively to the practical life of man: that is, it will either be worthless or the price for it will be too high: for instance it may be desirable to polish steel forks highly; but if the work shortens men's lives the price for the polishing is too high, and we ought to do without it.

At first sight it does not seem a great demand to make on human wisdom to get it to assert that no work should be done which is not useful when done and not degrading to do: but look around the world and think how the application of such a maxim would alter the face of it! I say that the vast majority of workers are under the present system engaged in doing nothing with frightful toil: nay there is a side to modern labour which is worse even than that: the greater number of people are poor, their household goods, scanty as they are, they must have at the lowest possible price, and their poverty creates the demand for wares which ought to have no value at all, and which would have none if there were not slaves of poverty who must be provided with such things as slaves alone will put up with: the poor must live on poison since nothing else is cheap enough for them: they live on poison and 'get used to it', as people phrase it; that is, they

are forced to perpetuate the degradation of a part of the community, to spread it, to deepen it.

So you see people are kept poor that cheap wares may be made, and being poor cheap wares are a necessity for them, and that necessity can only be supplied by the cheap wages (or poverty), which are necessary to allow riches to accumulate in a few hands.

And now when I say that this is the reason why there is no popular art now, surely the absence of beauty from the ordinary life of civilized man looks a more serious thing than many people who have thought and written on economical matters would allow: for that absence of art from the matters of daily life is the badge of slavery: people who are poor can have no art; for art cannot be produced without thought, without freedom from sordid anxiety, above all without leisure: and do you suppose that wares the very soul of which is such qualities as these can compete in the market with wares that have been screwed out of the necessity of the poor; that are born from the high pressure of machines tended by men who have no more time for thought than the eager unremitting *pursuit* of those tireless machines for ten hours a day may leave them?

No; popular art cannot live under the full development of competitive commerce; the revolt against unhuman work which is necessary for its existence would destroy the exploiting system of the capitalists, which appears by this time to be rapidly approaching perfection: nor without popular art can the art of the rich and cultivated long exist; what is now left of it is but a reflex of the days before commercialism began; while it was yet hanging in the balance, whether the days in which a man might be allowed to enjoy the fruits of his own labour were to come without our going through the terrible mill which the gospel of free contract has provided for us.

As far as the mass of people is concerned art is gone or all but gone from the daily life of man in civilized countries, and I say that is no mere accident but a necessary consequence of the rule of plutocratic anarchy: some branches of human invention can live under that tyranny: it allows learned men to seek out the secrets of nature and to subdue her forces because these matters can be turned to the advantage of the profit-market. But in art, the romance of each day's life, there is nothing 'practical' that is convertible into money, so long as it is real: all plutocracy can

do is to degrade it into an hypocrisy, a sham of real feeling and insight, a set of counters for the picture-dealers; it can do that and in the end kill it, but it cannot use it.

Yes, art is not far from actual death and beauty is fading out of the land before the poison of riches. Green and beautiful places are still left in the countryside of England, but the hand of decay is on them; the life of man is poor and slavish there, and his dwellings, the sure token of the life led in them, which were once sound, trim, and beautiful, are giving place to miserable abortions which it is a pain and grief to look at; mere scrapings from the heaps of filth where you working men live and which we call great cities.

And those terrible and frightful places; this horror we call London, or those worse because filthier hells the manufacturing districts — if ever the world escapes from the nightmare of riches and poverty which now oppresses us, will people from the midst of order and peace be able to understand what they were like?

And if we choose to consider the matter and face what must be the future unless this living death of Commercialism is swept away, do we not know what it must come to, supposing that national ruin does not overtake us? no rest, no beauty, no leisure anywhere: all England become like the heart of Lancashire is now: a breeding-stye for flesh and blood machines for the production of the profit of capital: machines, yes, but men also who, dimly perhaps, but miserably certainly, will be conscious of their own degradation.

Yes, it may be that Commercialism will find for us plenty of food and clothes and house-room, comforts even or luxuries; for us, I say, for most of us. It may be that, though it must have a body of abject poverty to serve it, it will produce so many rich men, and so many well-to-do men down to the class of the well fed prosperous artisan, that the class of the *poor* slaves will not be very numerous and will be powerless: that I know is the ideal of a large body of so-called advanced thinkers; and they may realize it, though I do not think they will, as I fervently hope they will not: for art, or the beauty of life, would be wholly lacking to all these classes, rich, middle-class, and poor; they would pass a wretched bestial degraded existence, and the hope of the progress of the race would have perished.

What is to save us from this misery, this hell? What but a Social Revolution which shall take away from men at once the

power and the temptation of accumulating riches or in other
words of keeping a body of slaves to do their dirty work for
them: a Revolution which by abolishing men's power of making
a profit from their fellows' labour will abolish all classes: not the
mere arbitrary distinction between lord and commoner, gentle-
man and worker, but the real and dreadful distinction between
rich man and poor, between the cultivated and the ignorant, be-
tween the refined and the brutal, which now exists, and is the
foundation of plutocratic society.

I know as surely as I know that I breathe, that this Social
Revolution would give to each and all of us a fair share of the
good and evil of life: we should have our fair share of trouble-
some work and no more than our fair share: for we should not
then be set to work for the sake of working: there would no
longer be any need to cumber the world with mountains of use-
less wares: no need to weary ourselves with making either the
idiotic toys of the rich, or the miserable rags of the poor, which
form now by far the greater part of the baggage of commerce.

In all our work would be hope, and the greater part of it would
be a labour of love, given freely and happily to the commonweal,
as the commonweal would freely and ungrudgingly supply our
needs for us: the hours of such work would to most of us be the
happiest, but mere rest, time for thought, or dreaming even,
would not be lacking to us, nor in any wise be grudged to us.

Then we should have nature beautiful around us again, for
surely then no disgrace of foulness in air or water would be suf-
fered, nor would it in anywise need to be, with science set free
from the huckster's fetters: and remember once more it is not
mere carelessness of beauty as we are now, the serving of our
real needs, that has turned half England into a foul and greasy
cinderheap, but the insatiable compulsion of commerce on us to
make an extra profit from labour we know not for what or for
whom.

Doubt it not that from all this art would spring art in all
forms, great and glorious, full of hope with eyes always turned
towards perfection.

Is it a dream? If so then let us give up all striving for pro-
gress: do not let us worry ourselves about politics, but stand by
and grin as one knave pushes the other out of the saddle; for one
or another will be much the same to us: let us eat and drink for
to-morrow we die — or better still let us die to-day.

It is no dream but a cause; men and women have died for it, not in the ancient days but in our own time: they lie in prison for it, work in mines, are exiled, are ruined for it: believe me when such things are suffered for dreams, the dreams come true at last.

But how is the change to be brought about?

The minds and hearts of men must be set on bringing it about; that is clear; no noise of people puffing themselves will do it, no mere electioneering dodges, no mere clattering of fine phrases amongst those who perfectly well agree with each other; it must come from the hearts of men who are resolved on it. Yet do not mistake my meaning; I have heard several people say: This is a thing which must be the gradual birth of opinion; therefore we, though we think the change necessary, must take no active measures to bring it about, but let it grow spontaneously.

Friends, such words may have the appearance of philosophical wisdom and forbearance and tolerance, but I fear their meaning is, *I durst not though I would.*

What other sign can there be of the growth of spontaneous opinion save eager and *active* attempts to spread that opinion? is the opinion never to result in action? and if ever when? if 'tis too early to-day, will it be late enough to-morrow? Alas! for some of us it will be too late; for every minute while we speak our fellows and friends are living in degradation and dying in despair.

I say it is the plain duty of those who believe in the necessity of social revolution, quite irrespectively of any date they may give to the event, first to express their own discontent and hope when and where they can, striving to impress it on others; secondly to learn from books and from living people who are willing, or I will say, *who can be made,* to teach them, in as much detail as possible what are the ends and the hopes of Social Revolution; and thirdly to join any body of men which is honestly striving to give means of expression to that discontent and hope, and to teach people the details of the aim of Constructive Revolution. You will understand that although I have numbered these duties first, second, and third, they must be all set about together: you can neither express your discontent nor learn what hopes there are of making it fruitful without union with others who have those aims in view.

And mind you by union I mean a very serious matter: I mean sacrifice to the Cause of leisure, pleasure and money each according to his means: I mean sacrifice of individual whims and

vanity, of individual misgivings, even though they may be founded on reason, as to the means which the organizing body may be forced to use: remember without organization the cause *is* but a vague dream, which may lead to revolt, to violence and disorder, but which will be speedily repressed by those who are blindly interested in sustaining the present anarchical tyranny which is misnamed Society: remember also that no organization is possible without the sacrifices I have been speaking of; without obedience to the necessities of the Cause.

Educate, Agitate, Organize; these words the motto of our Federation do most completely express what is necessary to be done by those who have any hope in the future of the People.

To feel the wrongs which oppress ourselves and our fellows, to learn what remedies there are for them, to declare openly the wrongs and remedies and to band together to make that declaration effective: how can those who wish to call themselves free and honest do less than this?

And the consequences that may come of our action? What can they be in the long run save peace and order? You who fear revolt, you who fear revolution, think what blind revolt and aimless revolution may mean; shake off at least enough of your cowardice and sloth to consider what must be the consequences of blind repression, of aimless upholding of a state of Society where side by side with refinement and cultivation dwell brutality and ignorance; and in which this dreadful contrast is not an accident but a necessity of the existence of your boasted civilized society.

I tell you civilization will begin on the day when we determine that Riches and Poverty shall disappear into one commonweal of happy people. I tell you that civilization, long talked of, much boasted of, never yet attained, will begin on the day when the organization of the claims of labour is strong enough to force on society the acceptation of those claims: when the necessary and inevitable revolution, the child of all the long centuries of history, which while we speak is being born out of the corruption of the organized anarchy which it is doomed to destroy, when that revolution shall take definite and orderly form, and sweep away for ever the two great foes of humanity, riches and poverty.

It is for you working men to attain this end: learn what you have to claim and unite to claim it: who or what can resist you then?

# Art, Wealth, and Riches

ART, Wealth, and Riches are the words I have written at the head of this paper. Some of you may think that the two latter words, wealth and riches, are tautologous; but I cannot admit it. In truth there are no real synonyms in any language, I mean unless in the case of words borrowed from another tongue; and in the early days of our own language no one would have thought of using the word rich as a synonym for wealthy. He would have understood a wealthy man to mean one who had plentiful livelihood, and a rich man one who had great dominion over his fellow-men. Alexander the Rich, Canute the Rich, Alfred the Rich; these are familiar words enough in the early literature of the North; the adjective would scarcely be used except of a great king or chief, a man pre-eminent above other kings and chiefs. Now, without being a stickler for etymological accuracy, I must say that I think there are cases where modern languages have lost power by confusing two words into one meaning, and that this is one of them. I shall ask your leave therefore to use the words wealth and riches somewhat in the way in which our forefathers did, and to understand wealth as signifying the means of living a decent life, and riches the means for exercising dominion over other people. Thus understood the words are widely different to my mind; yet, indeed, if you say that the difference is but one of degree I must needs admit it; just so it is between the shepherd's dog and the wolf. Their respective views on the subject of mutton differ only in degree.

Anyhow, I think the following question is an important one: Which shall art belong to, wealth or riches? Whose servant shall she be? or rather, Shall she be the slave of riches, or the friend and helpmate of wealth? Indeed, if I put the question in another form, and ask: Is art to be limited to a narrow class who only care for it in a very languid way, or is it to be the solace and

pleasure of the whole people? the question finally comes to this: Are we to have art or the pretence of art? It is like enough that to many or even most of you the question will seem of no practical importance. To most people the present condition of art does seem in the main to be the only condition it could exist in among cultivated people, and they are (in a languid way, as I said) content with its present aims and tendencies. For myself, I am so discontented with the present conditions of art, and the matter seems to me so serious, that I am forced to try to make other people share my discontent, and am this evening risking the committal of a breach of good manners by standing before you, grievance in hand, on an occasion like this, when everybody present, I feel sure, is full of goodwill both towards the arts and towards the public. My only excuse is my belief in the sincerity of your wish to know any serious views that can be taken of a matter so important. So I will say that the question I have asked, whether art is to be the helpmate of wealth or the slave of riches, is of great practical import, if indeed art is important to the human race, which I suppose no one here will gainsay.

Now I will ask those who think art is in a normal and healthy condition to explain the meaning of the enthusiasm (which I am glad to learn the people of Manchester share) shown of late years for the foundation and extension of museums, a great part of whose contents is but fragments of the household goods of past ages. Why do cultivated, sober, reasonable people, not lacking in a due sense of the value of money, give large sums for scraps of figured cloth, pieces of roughly made pottery, worm-eaten carving, or battered metal work, and treasure them up in expensive public buildings under the official guardianship of learned experts? Well, we all know that these things are supposed to teach us something; they are educational. The type of all our museums, that at South Kensington, is distinctly an educational establishment. Nor is what they are supposed to teach us mere dead history; these things are studied carefully and laboriously by men who intend making their living by the art of design. Ask any expert of any school of opinion as to art what he thinks of the desirability of those who are to make designs for the ornamental part of industrial art studying from these remains of past ages, and he will be certain to answer you that such study is indispensable to a designer. So you see this is what it comes to. It is not to the best works of our own time that a student is sent; no mas-

ter or expert could honestly tell him that that would do him good, but to the mere wreckage of a bygone art, things which, when they were new, could be bought for the most part in every shop and market-place.Well, need one ask what sort of a figure the wreckage of our ornamental art would cut in a museum of the twenty-fourth century? The plain truth is that people who have studied these matters know that these remnants of the past give tokens of an art which fashioned goods not only better than we do now, but different in kind, and better because they are different in kind, and were made in quite other ways than we make such things.

Before we ask why they were so much better, and why they differ in kind and not merely in degree of goodness, I want you to note specially once more that they were common wares, bought and sold in any market. I want you to note that, in spite of the tyranny and violence of the days when they were fashioned, the beauty of which they formed a part surrounded all life; that then, at all events, art was the helpmate of wealth and not the slave of riches. True it is that then as now rich men spent great sums of money in ornament of all kinds, and no doubt the lower classes were wretchedly poor (as they are now); nevertheless, the art that rich men got differed only in abundance and splendour of material from what other people could compass. The thing to remember is that then everything which was made by man's hand was more or less beautiful.

Contrast that with the state of art at present, and then say if my unmannerly discontent is not somewhat justified. So far from everything that is made by man being beautiful, almost all ordinary wares that are made by civilized man are shabbily and pretentiously ugly; made so (it would almost seem) by perverse intent rather than by accident, when we consider how pleasant and tempting to the inventive mind and the skilful hand are many of the processes of manufacture. Take for example the familiar art of glass-making. I have been in a glass-house, and seen the workmen in the process of their work bring the molten glass into the most elegant and delicious forms. There were points of the manufacture when, if the vessel they were making had been taken straight to the annealing house, the result would have been something which would have rivalled the choicest pieces of Venetian glass; but that could not be, they had to take their callipers and moulds and reduce the fantastic elegance of the living metal

to the due marketable ugliness and vulgarity of some shape, designed most likely by a man who did not in the least know or care how glass was made; and the experience is common enough in other arts. I repeat that all manufactured goods are now divided into two classes; one class vulgar and ugly, though often pretentious enough, with work on it which it is a mockery to call ornamental, but which probably has some wretched remains of tradition still clinging to it; that is for poor people, for the uncultivated. The other class, made for some of the rich, intends to be beautiful, is carefully and elaborately designed, but usually fails of its intent partly because it is cast loose from tradition, partly because there is no co-operation in it between the designer and the handicraftsman. Thus is our wealth injured, our wealth, the means of living a decent life, and no one is the gainer; for while on the one hand the lower classes have no real art of any kind about their houses, and have instead to put up with shabby and ghastly pretences of it which quite destroy their capacity for appreciating real art when they come across it in museums and picture-galleries, so on the other hand not all the superfluous money of the rich can buy what they profess to want; the only real art they can have is that which is made by unassisted individual genius, the laborious and painful work of men of rare attainments and special culture, who, cumbered as they are by unromantic life and hideous surroundings, do in spite of all manage now and then to break through the hindrances and produce noble works of art, which only a very few people even pretend to understand or be moved by. This art rich people can buy and possess sometimes, but necessarily there is little enough of it; and if there were tenfold what there is, I repeat it would not move the people one jot, for they are deadened to all art by the hideousness and squalor that surround them. Nor can I honestly say that the lack is wholly on their side, for the great artists I have been speaking of are what they are in virtue of their being men of very peculiar and especial gifts, and are mostly steeped in thoughts of history, wrapped up in contemplation of the beauty of past times. If they were not so constituted, I say, they would not in the teeth of all the difficulties in their way be able to produce beauty at all. But note the result. Everyday life rejects and neglects them; they cannot choose but let it go its way, and wrap themselves up in dreams of Greece and Italy. The days of Pericles and the days of Dante are the days through which they

move, and the England of our own day with its millions of eager struggling people neither helps nor is helped by them: yet it may be they bide their time of usefulness, and in days to come will not be forgotten. Let us hope so.

That, I say, is the condition of art amongst us. Lest you doubt it, or think I exaggerate, let me ask you to note how it fares with that art which is above all others co-operative: the art of architecture, to wit. Now, none know better than I do what a vast amount of talent and knowledge there is amongst the first-rate designers of buildings now-a-days; and here and there all about the country one sees the buildings they have planned, and is rejoiced by them. Yet little enough does that help us in these days when, if a man leaves England for a few years, he finds when he comes back half a county of bricks and mortar added to London. Can the greatest optimists say that the style of building in that half county has improved meanwhile? Is it not true, on the contrary, that it goes on getting worse, if that be possible? the last house built being always the vulgarest and ugliest, till one is beginning now to think with regret of the days of Gower Street, and to look with some complacency on the queer little boxes of brown brick which stand with their trim gardens choked up amongst new squares and terraces in the suburbs of London? It is a matter of course that almost every new house shall be quite disgracefully and degradingly ugly, and if by chance we come across a new house that shows any signs of thoughtfulness in design and planning we are quite astonished, and want to know who built it, who owns it, who designed it, and all about it from beginning to end; whereas when architecture was alive every house built was more or less beautiful. The phrase which called the styles of the Middle Ages Ecclesiastical Architecture has been long set aside by increased knowledge, and we know now that in that time cottage and cathedral were built in the same style and had the same kind of ornaments about them; size and, in some cases, material were the only differences between the humble and the majestic building. And it will not be till this sort of beauty is beginning to be once more in our towns, that there will be a real school of architecture; till every little chandler's shop in our suburbs, every shed run up for mere convenience, is made without effort fit for its purpose and beautiful at one and the same time. Now just think what a contrast that makes with our present way of housing ourselves. It is not easy to imagine

the beauty of a town all of whose houses are beautiful, at least unless you have seen (say) Rouen or Oxford thirty years ago. But what a strange state art must be in when we either won't or can't take any trouble to make our houses fit for reasonable human beings to live in! Cannot, I suppose: for once again, except in the rarest cases, rich men's houses are no better than common ones. Excuse an example of this, I beg you. I have lately seen Bournemouth, the watering place south-west of the New Forest. It is a district (scarcely a town) of rich men's houses. There was every inducement there to make them decent, for the place, with its sandy hills and pine-trees, gave really a remarkable site. It would not have taken so very much to have made it romantic. Well, there stand these rich men's houses among the pine-trees and gardens, and not even the pine-trees and gardens can make them tolerable. They are (you must pardon me the word) simply blackguardly, and while I speak they are going on building them by the mile.

And now why cannot we amend all this? Why cannot we have, for instance, simple and beautiful dwellings fit for cultivated, well mannered men and women, and not for ignorant, purse-proud digesting-machines? You may say because we don't wish for them, and that is true enough; but that only removes the question a step further, and we must ask: why don't we care about art? Why has civilized society in all that relates to the beauty of man's handiwork degenerated from the time of the barbarous, superstitious, unpeaceful Middle Ages? That is indeed a serious question to ask, involving questions still more serious, and the mere mention of which you may resent if I should be forced to speak of them.

I said that the relics of past art which we are driven to study now-a-days are of a work which was not merely better than what we do now, but differed in kind from it. Now this difference in kind explains our shortcomings so far, and leaves us only one more question to ask: How shall we remedy the fault? For the kind of the handiwork of former times down to at least the time of the Renaissance was intelligent work, whereas ours is unintelligent work, or the work of slaves; surely this is enough to account for the worsening of art, for it means the disappearance of popular art from civilization. Popular art, that is, the art which is made by the co-operation of many minds and hands varying in kind and degree of talent, but all doing their part in due subordi-

nation to a great whole, without any one losing his individuality — the loss of such an art is surely great, nay, inestimable. But hitherto I have only been speaking of the lack of popular art being a grievous loss as a part of wealth; I have been considering the loss of the thing itself, the loss of the humanizing influence which the daily sight of beautiful handiwork brings to bear upon people; but now, when we are considering the way in which that handiwork was done, and the way in which it is done, the matter becomes more serious still. For I say unhesitatingly that the intelligent work which produced real art was pleasant to do, was human work, not over burdensome or degrading; whereas the unintelligent work which produces sham art, is irksome to do, it is unhuman work, burdensome and degrading; so that it is but right and proper that it should turn out nothing but ugly things. And the immediate cause of this degrading labour which oppresses so large a part of our people is the system of the organization of labour, which is the chief instrument of the great power of modern Europe, competitive commerce. That system has quite changed the way of working in all matters that can be considered as art, and the change is a very much greater one than people know of or think of. In times past these handicrafts were done on a small, almost a domestic, scale by knots of workmen who mostly belonged to organized gilds, and were taught their work soundly, however limited their education was in other respects. There was little division of labour among them; the grades between master and man were not many; a man knew his work from end to end, and felt responsible for every stage of its progress. Such work was necessarily slow to do and expensive to buy; neither was it always finished to the nail; but it was always intelligent work; there was a man's mind in it always, and abundant tokens of human hopes and fears, the sum of which makes life for all of us.

Now think of any kind of manufacture which you are conversant with, and note how differently it is done now-a-days; almost certainly the workmen are collected in huge factories, in which labour is divided and subdivided, till a workman is perfectly helpless in his craft if he finds himself without those above to feed his work, and those below to be fed by it. There is a regular hierarchy of masters over him; foreman, manager, clerk, and capitalist, every one of whom is more important than he who does the work. Not only is he not asked to put his individuality

into his share of the work, but he is not allowed to. He is but part of a machine, and has but one unvarying set of tasks to do; and when he has once learned these, the more regularly and with the less thought he does them, the more valuable he is. The work turned out by this system is speedily done, and cheap to buy. No wonder, considering the marvellous perfection of the organization of labour that turns it out, and the energy with which it is carried through. Also, it has a certain high finish, and what I should call shop-counter look, quite peculiar to the wares of this century; but it is of necessity utterly unintelligent, and has no sign of humanity on it; not even so much as to show weariness here and there, which would imply that one part of it was pleasanter to do than another. Whatever art or semblance of art is on it has been doled out with due commercial care, and applied by a machine, human or otherwise, with exactly the same amount of interest in the doing it as went to the non-artistic parts of the work. Again I say that if such work were otherwise than ugly and despicable to look at one's sense of justice would be shocked; for the labour which went to the making of it was thankless and unpleasurable, little more than a mere oppression on the workman.

Must this sort of work last for ever? As long as it lasts the mass of the people can have no share in art; the only handicraftsmen who are free are the artists, as we call them to-day, and even they are hindered and oppressed by the oppression of their fellows. Yet I know that this machine-organized labour is necessary to competitive commerce; that is to say, to the present constitution of society; and probably most of you think that speculation on a root and branch change in that is mere idle dreaming. I cannot help it; I can only say that that change must come, or at least be on the way, before art can be made to touch the mass of the people. To some that may seem an unimportant matter. One must charitably hope that such people are blind on the side of art, which I imagine is by no means an uncommon thing; and that blindness will entirely prevent them from understanding what I have been saying as to the pleasure which a good workman takes in his handiwork. But all those who know what art means will agree with me in asserting that pleasure is a necessary companion to the making of everything that can be called a work of art. To those, then, I appeal and ask them to consider if it is fair and just that only a few among the millions of civilization shall be

partakers in a pleasure which is the surest and most constant of all pleasures, the unfailing solace of misfortune, happy and honourable work. Let us face the truth, and admit that a society which allows little other human and undegrading pleasure to the greater part of its toilers save the pleasure that comes of rest after the torment of weary work—that such a society should not be stable if it is; that it is but natural that such a society should be honeycombed with corruption and sick with oft-repeated sordid crimes.

Anyhow, dream or not as we may about the chances of a better kind of life which shall include a fair share of art for most people, it is no dream, but a certainty, that change is going on around us, though whitherward the change is leading us may be a matter of dispute. Most people though, I suppose, will be inclined to think that everything tends to favour the fullest development of competitive commerce and the utmost perfection of the system of labour which it depends upon. I think that is likely enough, and that things will go on quicker and quicker till the last perfection of blind commercial war has been reached; and then? May the change come with as little violence and suffering as may be!

It is the business of all of us to do our best to that end of preparing for change, and so softening the shock of it; to leave as little as possible that must be destroyed to be destroyed suddenly and by violence of some sort or other. And in no direction, it seems to me, can we do more useful work in forestalling destructive revolution than in being beforehand with it in trying to fill up the gap that separates class from class. Here is a point surely where competitive commerce has disappointed our hopes; she has been ready enough to attack the privilege of feudality, and successful enough in doing it, but in levelling the distinctions between upper and middle classes, between gentleman and commoner, she has stopped as if enough had been done: for, alas, most men will be glad enough to level down to themselves, and then hold their hands obstinately enough. But note what stopping short here will do for us. It seems to me more than doubtful, if we go no further, whether we had better have gone as far; for the feudal and hierarchical system under which the old gild brethren whose work I have been praising lived, and which undoubtedly had something to do with the intelligence and single-heartedness of their work: this system, while it divided men

rigorously into castes, did not actually busy itself to degrade them by forcing on them violent contrasts of cultivation and ignorance. The difference between lord and commoner, noble and burgher, was purely arbitrary; but how does it fare now with the distinction between class and class? Is it not the sad fact that the difference is no longer arbitrary but real? Down to a certain class, that of the educated gentleman, as he is called, there is indeed equality of manners and bearing, and if the commoners still choose to humble themselves and play the flunkey, that is their own affair; but below that class there is, as it were, the stroke of a knife, and gentlemen and non-gentlemen divide the world.

Just think of the significance of one fact; that here in England in the nineteenth century, among all the shouts of progress that have been raised for many years, the greater number of people are doomed by the accident of their birth to misplace their aitches; that there are two languages talked in England: gentleman's English and workman's English. I do not care who gainsays it, I say that this is barbarous and dangerous; and it goes step by step with the lack of art which the same classes are forced into; it is a token, in short, of that vulgarity, to use a hateful word, which was not in existence before modern times and the blossoming of competitive commerce.

Nor, on the other hand, does modern class-division really fall much short of the caste system of the Middle Ages. It is pretty much as exclusive as that was. Excuse an example: I was talking with a lady friend of mine the other day who was puzzled as to what to do with her growing son, and we discussed the possibility of his taking to one the crafts, trades as we call them now: say cabinetmaking. Now neither of us was much cumbered with social prejudices, both of us had a wholesome horror of increasing the army of London clerks, yet we were obliged to admit that unless a lad were of strong character and could take the step with his own eyes open and face the consequences on his own account, the thing could not be done; it would be making him either a sort of sloppy amateur or an involuntary martyr to principle. Well really after that we do not seem to have quite cast off even the mere mediæval superstition founded, I take it, on the exclusiveness of Roman landlordism (for our Gothic forefathers were quite free from the twaddle), that handiwork is a degrading occupation. At first sight the thing seems so monstrous that one

almost expects to wake up from a confused dream and find one-self in the reign of Henry the Eighth, with the whole paraphernalia in full blossom, from the divine right of kings downwards. Why in the name of patience should a carpenter be a worse gentleman than a lawyer? His craft is a much more useful one, much harder to learn, and at the very worst, even in these days, much pleasanter; and yet, you see, we gentlemen and ladies durst not set our sons to it unless we have found them to be enthusiasts or philosophers who can accept all consequences and despise the opinion of the world; in which case they will lie under the ban of that terrible adjective, eccentric.

Well, I have thought we might deduce part of this folly from a superstition of past ages, that it was partly a remnant of the accursed tyranny of ancient Rome; but there is another side to the question which puts a somewhat different face upon it. I bethink me that amongst other things the lady said to me: 'You know, I wouldn't mind a lad being a cabinetmaker if he only made "Art" furniture'. Well, there you see! she naturally, as a matter of course, admitted what I have told you this evening is a fact, that even in a craft so intimately connected with fine art as cabinetmaking there could be two classes of goods, one the common one, quite without art; the other exceptional and having a sort of artificial art, so to say, tacked on to it. But furthermore, the thought that was in her mind went tolerably deep into the matter, and cleaves close to our subject; for in fact these crafts are so mechanical as they are now carried on, that they don't exercise the intellectual part of a man; no, scarcely at all; and perhaps after all, in these days, when privilege is on its deathbed, that has something to do with the low estimate that is made of them. You see, supposing a young man to enter the cabinet-maker's craft, for instance (one of the least mechanical, even at present): when he had attained to more than average skill in it, his next ambition would be to better himself, as the phrase goes; that is, either to take to some other occupation thought more gentlemanly, or to become, not a master cabinetmaker, but a capitalist employer of cabinetmakers. Thus the crafts lose their best men because they have not in themselves due reward for excellence. Beyond a certain point you cannot go, and that point is not set high enough. Understand, by reward I don't mean only money wages, but social position, leisure, and above all, the self-respect which comes of our having the opportunity of doing re-

markable and individual work, useful for one's fellows to possess, and pleasant for oneself to do; work which at least deserves thanks, whether it gets them or not. Now, mind you, I know well enough that it is the custom of people when they speak in public to talk largely of the dignity of labour and the esteem in which they hold the working classes, and I suppose while they are speaking they believe what they say; but will their respect for the dignity of labour bear the test I have been speaking of? to wit, will they, can they, being of the upper or middle classes, put their sons to this kind of labour? Do they think that, so doing, they will give their children a good prospect in life? It does not take long to answer that question, and I repeat that I consider it a test question; therefore I say that the crafts are distinctly marked as forming part of a lower class, and that this stupidity is partly the remnant of the prejudices of the hierarchical society of the Middle Ages, but also is partly the result of the reckless pursuit of riches, which is the main aim of competitive commerce. Moreover, this is the worst part of the folly, for the mere superstition would of itself wear away, and not very slowly either, before political and social progress; but the side of it which is fostered by competitive commerce is more enduring, for there is reality about it. The crafts really are degraded, and the classes that form them are only kept sweet by the good blood and innate good sense of the workmen as men out of their working hours, and by their strong political tendencies, which are wittingly or unwittingly at war with competitive commerce, and may, I hope, be trusted slowly to overthrow it. Meanwhile, I believe this degradation of craftsmanship to be necessary to the perfection and progress of competitive commerce: the degradation of craftsmanship, or, in other words, the extinction of art. That is such a heavy accusation to bring against the system, that, crazy as you may think me, I am bound to declare myself in open rebellion against it: against, I admit it, the mightiest power which the world has ever seen. Mighty, indeed, yet mainly to destroy, and therefore I believe short-lived; since all things which are destructive bear their own destruction with them.

And now I want to get back before I finish to my first three words, Art, Wealth, and Riches. I can conceive that many people would be like to say to me: You declare yourself in rebellion against the system which creates wealth for the world. It is just that which I deny; it is the destruction of wealth of which I ac-

cuse competitive commerce. I say that wealth, or the material means for living a decent life, is created in spite of that system, not because of it. To my mind real wealth is of two kinds; the first kind, food, raiment, shelter, and the like; the second, matters of art and knowledge; that is, things good and necessary for the body, and things good and necessary for the mind. Many other things than these is competitive commerce busy about, some of them directly injurious to the life of man, some merely encumbrances to its honourable progress; meanwhile the first of these two kinds of real wealth she largely wastes, the second she largely destroys. She wastes the first by unjust and ill managed distribution of the power of acquiring wealth, which we call shortly money; by urging people to the reckless multiplication of their kind, and by gathering population into unmanageable aggregations to satisfy her ruthless greed, without the least thought of their welfare.

As for the second kind of wealth, mental wealth, in many ways she destroys it; but the two ways which most concern our subject to-night are these: first, the reckless destruction of the natural beauty of the earth, which compels the great mass of the population, in this country at least, to live amidst ugliness and squalor so revolting and disgusting that we could not bear it unless habit had made us used to it; that is to say, unless we were far advanced on the road towards losing some of the highest and happiest qualities which have been given to men. But the second way by which competitive commerce destroys our mental wealth is yet worse: it is by the turning of almost all handicraftsmen into machines; that is to say, compelling them to work which is unintelligent and unhuman, a mere weariness to be borne for the greater part of the day; thus robbing men of the gain and victory which long ages of toil and thought have won from stern hard nature and necessity, man's pleasure and triumph in his daily work.

I tell you it is not wealth which our civilization has created, but riches, with its necessary companion poverty; for riches cannot exist without poverty, or in other words slavery. All rich men must have some one to do their dirty work, from the collecting of their unjust rents to the sifting of their ash heaps. Under the dominion of riches we are masters and slaves instead of fellow-workmen as we should be. If competitive commerce creates wealth, then should England surely be the wealthiest country in

the world, as I suppose some people think it is, and as it is certainly the richest; but what shabbiness is this rich country driven into? I belong, for instance, to a harmless little society whose object is to preserve for the public now living and to come the wealth which England still possesses in historical and beautiful buildings; and I could give you a long and dismal list of buildings which England, with all her riches, has not been able to save from commercial greed in some form or another. 'It's a matter of money' is supposed to be an unanswerable argument in these cases, and indeed we generally find that if we answer it our answer is cast on the winds. Why, to this day in England (in England only, I believe, amongst civilized countries) there is no law to prevent a madman or an ignoramus from pulling down a house which he chooses to call his private property, though it may be one of the treasures of the land for art and history.

Or again, of how many acres of common land has riches robbed the country, even in this century? a treasure irreplaceable, inestimable, in these days of teeming population. Yet where is the man who dares to propose a measure for the reinstatement of the public in its rights in this matter? How often, once more, have railway companies been allowed for the benefit of the few to rob the public of treasures of beauty that can never be replaced, owing to the cowardly and anarchical maxims which seem always to be favoured by those who should be our guardians herein; but riches has no bowels except for riches. Or you of this part of the country, what have you done with Lancashire? It does not seem to be above ground. I think you must have been poor indeed to have been compelled to bury it. Were not the brown moors and the meadows, the clear streams and the sunny skies, wealth? Riches has made a strange home for you. Some of you, indeed, can sneak away from it sometimes to Wales, to Scotland, to Italy; some, but very few. I am sorry for you; and for myself too, for that matter, for down by the Thames-side there we are getting rid of the earth as fast as we can also; most of Middlesex, most of Surrey, and huge cantles of Essex and Kent are buried mountains deep under fantastic folly or hideous squalor; and no one has the courage to say: 'Let us seek a remedy while any of our wealth in this kind is left us'.

Or, lastly, if all these things may seem light matters to some of you, grievously heavy as they really are, no one can think lightly of those terrible stories we have been hearing lately of the

housing of poor people in London; indeed and indeed no country which can bear to sit quiet under such grievances has any right to be called wealthy. Yet you know very well that it will be long indeed before any party or any Government will have the courage to face the subject, dangerous as they must needs know it is to shut their eyes to it.

And what is to amend these grievances? You must not press me too close on that point. I believe I am in such a very small minority on these matters that it is enough for me if I find here and there some one who admits the grievances; for my business herein is to spread discontent. I do not think that this is an unimportant office; for, as discontent spreads, the yearning for bettering the state of things spreads with it, and the longing of many people, when it has grown deep and strong, melts away resistance to change in a sure, steady, unaccountable manner. Yet I will, with your leave, tell the chief things which I really want to see changed, in case I have not spoken plainly enough hitherto, and lest I should seem to have nothing to bid you to but destruction, the destruction of a system by some thought to have been made to last for ever. I want, then, all persons to be educated according to their capacity, not according to the amount of money which their parents happen to have. I want all persons to have manners and breeding according to their innate goodness and kindness, and not according to the amount of money which their parents happen to have. As a consequence of these two things I want to be able to talk to any of my countrymen in his own tongue freely, and feeling sure that he will be able to understand my thoughts according to his innate capacity; and I also want to be able to sit at table with a person of any occupation without a feeling of awkwardness and constraint being present between us. I want no one to have any money except as due wages for work done; and, since I feel sure that those who do the most useful work will neither ask nor get the highest wages, I believe that this change will destroy that worship of a man for the sake of his money, which everybody admits is degrading, but which very few indeed can help sharing in. I want those who do the rough work of the world, sailors, miners, ploughmen, and the like, to be treated with consideration and respect, to be paid abundant money-wages, and to have plenty of leisure. I want modern science, which I believe to be capable of overcoming all material difficulties, to turn from such preposterous follies as the inven-

tion of anthracine colours and monster cannon to the invention
of machines for performing such labour as is revolting and de-
structive of self-respect to the men who now have to do it by
hand. I want handicraftsmen proper, that is, those who make
wares, to be in such a position that they may be able to refuse to
make foolish and useless wares, or to make the cheap and nasty
wares which are the mainstay of competitive commerce, and are
indeed slave-wares, made by and for slaves. And in order that the
workmen may be in this position, I want division of labour re-
stricted within reasonable limits, and men taught to think over
their work and take pleasure in it. I also want the wasteful sys-
tem of middlemen restricted, so that workmen may be brought
into contact with the public, who will thus learn something about
their work, and so be able to give them due reward of praise for
excellence.

Furthermore, I want the workmen to share the good fortunes
of the business which they uphold, in due proportion to their skill
and industry, as they must in any case share its bad fortunes. To
which end it would be necessary that those who organize their
labour should be paid no more than due wages for their work,
and should be chosen for their skill and intelligence, and not
because they happen to be the sons of money-bags. Also I want
this, and, if men were living under the conditions I have just
claimed for them, I should get it, that these islands which make
the land we love should no longer be treated as here a cinder-
heap, and there a game preserve, but as the fair green garden of
Northern Europe, which no man on any pretence should be al-
lowed to befoul or disfigure. Under all these conditions I should
certainly get the last want accomplished which I am now going
to name. I want all the works of man's hand to be beautiful,
rising in fair and honourable gradation from the simplest house-
hold goods to the stately public building, adorned with the handi-
work of the greatest masters of expression which that real new
birth and the dayspring of hope come back will bring forth for
us.

These are the foundations of my Utopia, a city in which riches
and poverty will have been conquered by wealth; and however
crazy you may think my aspirations for it, one thing at least I am
sure of, that henceforward it will be no use looking for popular
art except in such an Utopia, or at least on the road thither; a
road which, in my belief, leads to peace and civilization, as the

road away from it leads to discontent, corruption, tyranny, and confusion. Yet it may be we are more nearly on the road to it than many people think; and however that may be, I am cheered somewhat by thinking that the very small minority to which I belong is being helped by every one who is of goodwill in social matters. Every one who is pushing forward education helps us; for education, which seems such a small power to classes which have been used to some share of it for generations, when it reaches those who have grievances which they ought not to bear spreads deep discontent among them, and teaches them what to do to make their discontent fruitful. Every one who is striving to extinguish poverty is helping us; for one of the greatest causes of the dearth of popular art and the oppression of joyless labour is the necessity that is imposed on modern civilization for making miserable wares for miserable people, for the slaves of competitive commerce. All who assert public rights against private greed are helping us; every foil given to common-stealers, or railway-Philistines, or smoke-nuisance-breeders, is a victory scored to us. Every one who tries to keep alive traditions of art by gathering together relics of the art of bygone times, still more if he is so lucky as to be able to lead people by his own works to look through Manchester smoke and squalor to fair scenes of unspoiled nature or deeds of past history, is helping us. Every one who tries to bridge the gap between the classes, by helping the opening of museums and galleries and gardens and other pleasures which can be shared by all, is helping us. Every one who tries to stir up intelligence in their work in workmen, and more especially every one who gives them hope in their work and a sense of self-respect and responsibility to the public in it, by such means as industrial partnerships and the like, is helping the cause most thoroughly.

These, and such as these, are our helpers, and give us a kind of hope that the time may come when our views and aspirations will no longer be considered rebellious, and when competitive commerce will be lying in the same grave with chattel slavery, with serfdom, and with feudalism. Or rather, certainly the change will come, however long we shall have been dead by then; how, then, can we prevent its coming with violence and injustice that will breed other grievances in time, to be met by fresh discontent? Once again, how good it were to destroy all that must be destroyed gradually and with a good grace!

Here in England, we have a fair house full of many good things, but cumbered also with pestilential rubbish. What duty can be more pressing than to carry out the rubbish piecemeal and burn it outside, lest some day there be no way of getting rid of it but by burning it up inside with the goods and house and all?

# ᐧ *Four* ᐧ

# *Art and Socialism*

M Y friends, I want you to look into the relation of Art to Commerce, using the latter word to express what is generally meant by it; namely, that system of competition in the market which is indeed the only form which most people now-a-days suppose that Commerce can take. Now whereas there have been times in the world's history when Art held the supremacy over Commerce; when Art was a good deal, and Commerce, as we understand the word, was a very little; so now on the contrary it will be admitted by all, I fancy, that Commerce has become of very great importance and Art of very little. I say this will be generally admitted, but different persons will hold very different opinions not only as to whether this is well or ill, but even as to what it really means when we say that Commerce has become of supreme importance and that Art has sunk into an unimportant matter.

Allow me to give you my opinion of the meaning of it: which will lead me on to ask you to consider what remedies should be applied for curing the evils that exist in the relations between Art and Commerce. Now to speak plainly it seems to me that the supremacy of Commerce (as we understand the word) is an evil, and a very serious one; and I should call it an unmixed evil but for the strange continuity of life which runs through all historical events, and by means of which the very evils of such and such a period tend to abolish themselves. For to my mind it means this: that the world of modern civilization in its haste to gain a very inequitably divided material prosperity has entirely suppressed popular Art; or in other words that the greater part of the people have no share in Art, which as things now are must be kept in the hands of a few rich or well-to-do people, who we may fairly say need it less and not more than the laborious workers. Nor is that all the evil, nor the worst of it; for the cause of this famine

of Art is that whilst people work throughout the civilized world as laboriously as ever they did, they have lost, in losing an Art which was done by and for the people, the natural solace of that labour; a solace which they once had, and always should have; the opportunity of expressing their own thoughts to their fellows by means of that very labour, by means of that daily work which nature or long custom, a second nature, does indeed require of them, but without meaning that it should be an unrewarded and repulsive burden. But, through a strange blindness and error in the civilization of these latter days, the world's work, almost all of it, the work some share of which should have been the helpful companion of every man, has become even such a burden, which every man, if he could, would shake off. I have said that people work no less laboriously than they ever did; but I should have said that they work more laboriously. The wonderful machines which in the hands of just and foreseeing men would have been used to minimize repulsive labour and to give pleasure, or in other words added life, to the human race, have been so used on the contrary that they have driven all men into mere frantic haste and hurry, thereby destroying pleasure, that is life, on all hands: they have, instead of lightening the labour of the workmen, intensified it, and thereby added more weariness yet to the burden which the poor have to carry.

Nor can it be pleaded for the system of modern civilization that the mere material or bodily gains of it balance the loss of pleasure which it has brought upon the world; for as I hinted before those gains have been so unfairly divided that the contrast between rich and poor has been fearfully intensified, so that in all civilized countries, but most of all in England, the terrible spectacle is exhibited of two peoples living street by street and door by door, people of the same blood, the same tongue, and at least nominally living under the same laws, but yet one civilized and the other uncivilized. All this I say is the result of the system that has trampled down Art, and exalted Commerce into a sacred religion; and it would seem is ready, with the ghastly stupidity which is its principal characteristic, to mock the Roman satirist for his noble warning by taking it in inverse meaning, and now bids us all for the sake of life to destroy the reasons for living.

And now in the teeth of this stupid tyranny I put forward a claim on behalf of labour enslaved by Commerce, which I know no thinking man can deny is reasonable, but which if acted on

would involve such a change as would defeat Commerce; that is, would put Association instead of Competition, Social Order instead of Individualist Anarchy. Yet I have looked at this claim by the light of history and my own conscience, and it seems to me so looked at to be a most just claim, and that resistance to it means nothing short of a denial of the hope of civilization. This then is the claim: *It is right and necessary that all men should have work to do which shall be worth doing, and be of itself pleasant to do; and which should be done under such conditions as would make it neither over-wearisome nor over-anxious.* Turn that claim about as I may, think of it as long as I can, I cannot find that it is an exorbitant claim; yet again I say if Society would or could admit it, the face of the world would be changed; discontent and strife and dishonesty would be ended. To feel that we were doing work useful to others and pleasant to ourselves, and that such work and its due reward could not fail us! What serious harm could happen to us then? And the price to be paid for so making the world happy is Revolution: Socialism instead of *Laissez faire.*

How can we of the middle classes help to bring such a state of things about; a state of things as nearly as possible the reverse of the present state of things? The reverse; no less than that. For first, THE WORK MUST BE WORTH DOING: think what a change that would make in the world! I tell you I feel dazed at the thought of the immensity of work which is undergone for the making of useless things. It would be an instructive day's work for any one of us who is strong enough to walk through two or three of the principal streets of London on a week-day, and take accurate note of everything in the shop windows which is embarrassing or superfluous to the daily life of a serious man. Nay, the most of these things no one, serious or unserious, wants at all; only a foolish habit makes even the lightest-minded of us suppose that he wants them, and to many people even of those who buy them they are obvious encumbrances to real work, thought, and pleasure. But I beg you to think of the enormous mass of men who are occupied with this miserable trumpery, from the engineers who have had to make the machines for making them, down to the hapless clerks who sit daylong year after year in the horrible dens wherein the wholesale exchange of them is transacted, and the shopmen who, not daring to call their souls their own, retail them amidst numberless insults which they must not

resent, to the idle public which doesn't want them, but buys them
to be bored by them and sick to death of them. I am talking of
the merely useless things; but there are other matters not merely
useless, but actively destructive and poisonous, which command
a good price in the market; for instance, adulterated food and
drink. Vast is the number of slaves whom competitive Com-
merce employs in turning out infamies such as these. But quite
apart from them there is an enormous mass of labour which is
just merely wasted; many thousands of men and women making
Nothing with terrible and inhuman toil which deadens the soul
and shortens mere animal life itself.

All these are the slaves of what is called luxury, which in the
modern sense of the word comprises a mass of sham wealth, the
invention of competitive Commerce, and enslaves not only the
poor people who are compelled to work at its production, but
also the foolish and not over happy people who buy it to harass
themselves with its encumbrance. Now if we are to have popular
Art, or indeed Art of any kind, we must at once and for all be
done with this luxury; it is the supplanter, the changeling of Art;
so much so that by those who know of nothing better it has even
been taken for Art, the divine solace of human labour, the ro-
mance of each day's hard practice of the difficult art of living.
But I say Art cannot live beside it, nor self-respect in any class
of life. Effeminacy and brutality are its companions on the right
hand and the left. This, first of all, we of the well-to-do classes
must get rid of if we are serious in desiring the new birth of Art:
and if not then corruption is digging a terrible pit of perdition for
society, from which indeed the new birth may come, but surely
from amidst of terror, violence, and misery. Indeed if it were but
ridding ourselves, the well-to-do people, of this mountain of rub-
bish, that would be something worth doing: things which every-
body knows are of no use; the very capitalists know well that
there is no genuine healthy demand for them, and they are com-
pelled to foist them off on the public by stirring up a strange
feverish desire for petty excitement, the outward token of which
is known by the conventional name of fashion, a strange monster
born of the vacancy of the lives of rich people, and the eagerness
of competitive Commerce to make the most of the huge crowd
of workmen whom it breeds as unregarded instruments for what
is called the making of money.

Do not think it a little matter to resist this monster of folly; to think for yourselves what you yourselves really desire, will not only make men and women of you so far, but may also set you thinking of the due desires of other people, since you will soon find when you get to know a work of Art, that slavish work is undesirable. And here furthermore is at least a little sign whereby to distinguish between a rag of fashion and a work of art: whereas the toys of fashion when the first gloss is worn off them do become obviously worthless even to the frivolous, a work of art, be it never so humble, is long-lived; we never tire of it; as long as a scrap hangs together it is valuable and instructive to each new generation. All works of art in short have the property of becoming venerable amidst decay; and reason good, for from the first there was a soul in them, the thought of man, which will be visible in them so long as the body exists in which they were implanted.

And that last sentence brings me to considering the other side of the necessity for labour only occupying itself in making goods that are worth making. Hitherto we have been thinking of it only from the user's point of view; even so looked at it was surely important enough; yet from the other side, as to the producer, it is far more important still. For I say again that in buying these things

'Tis the lives of men you buy!

Will you from mere folly and thoughtlessness make yourselves partakers of the guilt of those who compel their fellow men to labour uselessly? For when I said it was necessary for all things made to be worth making, I set up that claim chiefly on behalf of Labour; since the waste of making useless things grieves the workman doubly. As part of the public he is forced into buying them, and the more part of his miserable wages is squeezed out of him by an universal kind of truck system; as one of the producers he is forced into making them, and so into losing the very foundations of that pleasure in daily work which I claim as his birthright; he is compelled to labour joylessly at making the poison which the truck system compels him to buy. So that the huge mass of men who are compelled by folly and greed to make harmful and useless things are sacrificed to Society. I say that this would be terrible and unendurable even

though they were sacrificed to the good of Society, if that were possible; but if they are sacrificed not for the welfare of Society but for its whims, to add to its degradation, what do luxury and fashion look like then? On one side ruinous and wearisome waste leading through corruption to corruption on to complete cynicism at last, and the disintegration of all Society; and on the other side implacable oppression destructive of all pleasure and hope in life, and leading — whitherward?

Here then is one thing for us of the middle classes to do before we can clear the ground for the new birth of Art, before we can clear our own consciences of the guilt of enslaving men by their labour. One thing; and if we could do it perhaps that one thing would be enough, and all other healthy changes would follow it: but can we do it? Can we escape from the corruption of Society which threatens us? Can the middle classes regenerate themselves? At first sight one would say that a body of people so powerful, who have built up the gigantic edifice of modern Commerce, whose science, invention, and energy have subdued the forces of nature to serve their everyday purposes, and who guide the organization that keeps these natural powers in subjection in a way almost miraculous; at first sight one would say surely such a mighty mass of wealthy men could do anything they please. And yet I doubt it: their own creation, the Commerce they are so proud of, has become their master; and all we of the well-to-do classes, some of us with triumphant glee, some with dull satisfaction, and some with sadness of heart, are compelled to admit not that Commerce was made for man, but that man was made for Commerce.

On all sides we are forced to admit it. There are of the English middle class to-day, for instance, men of the highest aspirations towards Art, and of the strongest will; men who are most deeply convinced of the necessity to civilization of surrounding men's lives with beauty; and many lesser men, thousands for what I know, refined and cultivated, follow them and praise their opinions. But both the leaders and the led are incapable of saving so much as half-a-dozen commons from the grasp of inexorable Commerce: they are as helpless in spite of their culture and their genius as if they were just so many overworked shoemakers. Less lucky than King Midas, our green fields and clear waters, nay, the very air we breathe, are turned not to gold (which might please some of us for an hour maybe) but to dirt; and to speak

plainly we know full well that under the present gospel of Capital not only there is no hope of bettering it, but that things grow worse year by year, day by day. Let us eat and drink, for to-morrow we die, choked by filth.

Or let me give you a direct example of the slavery to competitive Commerce, in which we hapless folk of the middle classes live. I have exhorted you to the putting away of luxury, to the stripping yourselves of useless encumbrances, to the simplification of life, and I believe that there are not a few of you that heartily agree with me on that point. Well, I have long thought that one of the most revolting circumstances that cling to our present class-system, is the relation between us of the well-to-do and our domestic servants: we and our servants live together under one roof, but are little better than strangers to each other, in spite of the good nature and good feeling that often exists on both sides: nay, strangers is a mild word; though we are of the same blood, bound by the same laws, we live together like people of different tribes. Now think how this works on the job of getting through the ordinary day's work of a household, and whether our lives can be simplified while such a system lasts. To go no further, you who are housekeepers know full well (as I myself do, since I have learned the useful art of cooking a dinner) how it would simplify the day's work, if the chief meals could be eaten in common; if there had not got to be double meals, one upstairs, another downstairs. And again, surely we of this educational century cannot be ignorant of what an education it would be for the less refined members of a household to meet on common easy terms the more refined once a day at least; to note the elegant manners of well bred ladies, to give and take in talk with learned and travelled men, with men of action and imagination: believe me, that would beat elementary education.

Furthermore this matter cleaves close to our subject of Art: for note, as a token of this stupidity of our sham civilization, what foolish rabbit-warrens our well-to-do houses are obliged to be; instead of being planned in the rational ancient way which was used from the time of Homer to past the time of Chaucer, a big hall, to wit, with a few chambers tacked on to it for sleeping or sulking in. No wonder our houses are cramped and ignoble when the lives lived in them are cramped and ignoble also. Well, and why don't we who have thought of this, as I am sure many of us have, change this mean and shabby custom, simplifying our

lives thereby and educating our friends, to whose toil we owe so many comforts? Why do not you and I set about doing this to-morrow? Because we cannot; because our servants wouldn't have it, knowing, as we know, that both parties would be made miserable by it. The civilization of the nineteenth century forbids us to share the refinement of a household among its members! So you see, if we middle-class people belong to a powerful folk, and in good sooth we do, we are but playing a part played in many a tale of the world's history: we are great but hapless; we are important dignified people, but bored to death; we have bought our power at the price of our liberty and our pleasure. So I say in answer to the question: Can we put luxury from us and live simple and decent lives? Yes, when we are free from the slavery of Capitalist-Commerce; but not before.

Surely there are some of you who long to be free; who have been educated and refined, and had your perceptions of beauty and order quickened only that they might be shocked and wounded at every turn by the brutalities of competitive Commerce; who have been so hunted and driven by it that, though you are well-to-do, rich even maybe, you have now nothing to lose from social revolution: love of art, that is to say of the true pleasure of life, has brought you to this, that you must throw in your lot with that of the wage-slave of competitive Commerce; you and he must help each other and have one hope in common, or you at any rate will live and die hopeless and unhelped. You who long to be set free from the oppression of the money-grub-bers hope for the day when you will be compelled to be free!

Meanwhile, if otherwise that oppression has left us scarce any work to do worth doing, one thing at least is left us to strive for, the raising of the standard of life where it is lowest, where it is low: that will put a spoke in the wheel of the triumphant car of competitive Commerce. Nor can I conceive of anything more likely to raise the standard of life than the convincing some thousands of those who live by labour of the necessity of their supporting the second part of the claim I have made for Labour; namely, THAT THEIR WORK SHOULD BE OF ITSELF PLEASANT TO DO. If we could but convince them that such a strange revolution in Labour as this would be of infinite benefit not to them only, but to all men; and that it is so right and natural that for the reverse to be the case, that most men's work should be grievous to them, is a mere monstrosity of these latter days,

which must in the long run bring ruin and confusion on the Society that allows it — if we could but convince them, then indeed there would be chance of the phrase Art of the People being something more than a mere word. At first sight, indeed, it would seem impossible to make men born under the present system of Commerce understand that labour may be a blessing to them: not in the sense in which the phrase is sometimes preached to them by those whose labour is light and easily evaded: not as a necessary task laid by nature on the poor for the benefit of the rich: not as an opiate to dull their sense of right and wrong, to make them sit down quietly under their burdens to the end of time, blessing the squire and his relations: all this they could understand our saying to them easily enough, and sometimes would listen to it I fear with at least a show of complacency, if they thought there were anything to be made out of us thereby. But the true doctrine that labour should be a real tangible blessing in itself to the working man, a pleasure even as sleep and strong drink are to him now: this one might think it hard indeed for him to understand, so different as it is from anything which he has found labour to be.

Nevertheless, though most men's work is only borne as a necessary evil like sickness, my experience as far as it goes is, that whether it be from a certain sacredness in handiwork which does cleave to it even under the worst circumstances, or whether it be that the poor man who is driven by necessity to deal with things which are terribly real, when he thinks at all on such matters, thinks less conventionally than the rich; whatever it may be, my experience so far is that the working man finds it easier to understand the doctrine of the claim of Labour to pleasure in the work itself than the rich or well-to-do man does. Apart from any trivial words of my own, I have been surprised to find, for instance, such a hearty feeling toward John Ruskin among working-class audiences: they can see the prophet in him rather than the fantastic rhetorician, as more superfine audiences do. That is a good omen, I think, for the education of times to come. But we who somehow are so tainted by cynicism, because of our helplessness in the ugly world which surrounds and presses on us, cannot we somehow raise our own hopes at least to the point of thinking that what hope glimmers on the millions of the slaves of Commerce is something better than a mere delusion, the false dawn of a cloudy midnight with which 'tis only the moon that

struggles? Let us call to mind that there yet remain monuments
in the world which show us that all human labour was not always
a grief and a burden to men. Let us think of the mighty and
lovely architecture, for instance, of mediæval Europe: of the
buildings raised before Commerce had put the coping-stone on
the edifice of tyranny by the discovery that fancy, imagination,
sentiment, the joy of creation, and the hope of fair fame, are
marketable articles too precious to be allowed to men who have
not the money to buy them, to mere handicraftsmen and day-la-
bourers. Let us remember there was a time when men had pleas-
ure in their daily work, but yet, as to other matters, hoped for
light and freedom even as they do now: their dim hope grew
brighter, and they watched its seeming fulfilment drawing nearer
and nearer, and gazed so eagerly on it that they did not note how
the ever watchful foe, oppression, had changed his shape and
was stealing from them what they had already gained in the days
when the light of their new hope was but a feeble glimmer: so
they lost the old gain, and for lack of it the new gain was
changed and spoiled for them into something not much better
than loss.

Betwixt the days in which we now live and the end of the
Middle Ages, Europe has gained freedom of thought, increase of
knowledge, and huge talent for dealing with the material forces
of nature; comparative political freedom withal and respect for
the lives of civilized men, and other gains that go with these
things: nevertheless I say deliberately that if the present state of
Society is to endure, she has bought these gains at too high a
price in the loss of the pleasure in daily work which once did
certainly solace the mass of men for their fears and oppressions:
the death of Art was too high a price to pay for the material
prosperity of the middle classes. Grievous indeed it was, that we
could not keep both our hands full, that we were forced to spill
from one while we gathered with the other: yet to my mind it is
more grievous still to be unconscious of the loss; or being dimly
conscious of it to have to force ourselves to forget it and to cry
out that all is well. For, though all is not well, I know that men's
natures are not so changed in three centuries that we can say to
all the thousands of years which went before them: You were
wrong to cherish Art, and now we have found out that all men
need is food and raiment and shelter, with a smattering of knowl-
edge of the material fashion of the universe. Creation is no

longer a need of man's soul, his right hand may forget its cunning, and he be none the worse for it.

Three hundred years, a day in the lapse of ages, have not changed man's nature thus utterly, be sure of that: one day we shall win back Art, that is to say the pleasure of life; win back Art again to our daily labour. Where is the hope then? you may say, Show it us! There lies the hope, where hope of old deceived us. We gave up Art for what we thought was light and freedom, but it was less than light and freedom which we bought: the light showed many things to those of the well-to-do who cared to look for them: the freedom left the well-to-do free enough if they cared to use their freedom; but these were few at the best: to the most of men the light showed them that they need look for hope no more, and the freedom left the most of men free to take at a wretched wage what slave's work lay nearest to them or starve.

There is our hope, I say. If the bargain had been really fair, complete all round, then were there nought else to do but to bury Art, and forget the beauty of life: but now the cause of Art has something else to appeal to; no less than the hope of the people for the happy life which has not yet been granted to them. There is our hope: the cause of Art is the cause of the people. Think of a piece of history, and so hope! Time was when the rule of Rome held the whole world of civilization in its poisonous embrace. To all men, even the best, as you may see in the very Gospels, that rule seemed doomed to last for ever: nor to those who dwelt under it was there any world worth thinking of beyond it. But the days passed and though none saw a shadow of the coming change, it came none the less, like a thief in the night, and the Barbarians, the world which lay outside the rule of Rome, were upon her; and men blind with terror lamented the change and deemed the world undone by the Fury of the North. But even that fury bore with it things long strange to Rome, which once had been the food its glory fed on: hatred of lies, scorn of riches, contempt of death, faith in the fair fame won by steadfast endurance, honourable love of women: all these things the Northern Fury bore with it, as the mountain torrent bears the gold; and so Rome fell and Europe rose, and the hope of the world was born again. To those that have hearts to understand, this tale of the past is a parable of the days to come; of the change in store for us hidden in the breast of the Barbarism of civilization, the Proletariat: and we of the middle class, the strength of the mighty

but monstrous system of competitive Commerce, it behoves us
to clear our souls of greed and cowardice and to face the change
which is now once more on the road; to see the good and the
hope it bears with it amidst all its threats of violence, amidst all
its ugliness, which was not born of itself but of that which it is
doomed to destroy.

Now once more I will say that we well-to-do people, those of
us who love Art, not as a toy, but as a thing necessary to the life
of man, as a token of his freedom and happiness, have for our
best work the raising of the standard of life among the people; or
in other words, establishing the claim I made for Labour, which
I will now put in a different form, that we may try to see what
chiefly hinders us from making that claim good and what are the
enemies to be attacked. Thus then I put the claim again: *Nothing
should be made by man's labour which is not worth making, or
which must be made by labour degrading to the makers.*

Simple as that proposition is, and obviously right as I am sure
it must seem to you, you will find, when you come to consider
the matter, that it is a direct challenge to the death to the present
system of labour in civilized countries. That system, which I
have called competitive Commerce, is distinctly a system of war;
that is, of waste and destruction, or you may call it gambling if
you will; the point of it being that under it whatever a man gains
he gains at the expense of some other man's loss. Such a system
does not and cannot heed whether the matters it makes are worth
making; it does not and cannot heed whether those who make
them are degraded by their work: it heeds one thing and only
one, namely what it calls making a profit; which word has come
to be used so conventionally that I must explain to you what it
really means, to wit, the plunder of the weak by the strong. Now
I say of this system, that it is of its very nature destructive of Art,
that is to say of the happiness of life. Whatever consideration is
shown for the life of the people in these days, whatever is done
which is worth doing, is done in spite of the system and in the
teeth of its maxims; and most true it is that we do all of us tacitly
at least admit that it is opposed to all the highest aspirations of
mankind.

Do we not know, for instance, how those men of genius work
who are the salt of the earth, without whom the corruption of
Society would long ago have become unendurable? The poet, the
artist, the man of science, is it not true that in their fresh and

glorious days, when they are in the heyday of their faith and enthusiasm, they are thwarted at every turn by Commercial War, with its sneering question 'Will it pay'? Is it not true that when they begin to win worldly success, when they become comparatively rich, in spite of ourselves they seem to us tainted by the contact with the commercial world? Need I speak of great schemes that hang about neglected; of things most necessary to be done, and so confessed by all men, that no one can seriously set a hand to because of the lack of money; while if it be a question of creating or stimulating some foolish whim in the public mind, the satisfaction of which will breed a profit, the money will come in by the ton? Nay, you know what an old story it is of the wars bred by Commerce in search of new markets, which not even the most peaceable of statesmen can resist; an old story and still it seems for ever new, and now become a kind of grim joke, at which I would rather not laugh if I could help it, but am even forced to laugh from a soul laden with anger.

And all that mastery over the powers of nature which the last hundred years or less has given us: what has it done for us under this system? In the opinion of John Stuart Mill, it was doubtful if all the mechanical inventions of modern times have done anything to lighten the toil of labour: be sure there is no doubt that they were not made for that end, but to make a profit. Those almost miraculous machines, which if orderly forethought had dealt with them might even now be speedily extinguishing all irksome and unintelligent labour, leaving us free to raise the standard of skill of hand and energy of mind in our workmen, and to produce afresh that loveliness and order which only the hand of man guided by his soul can produce; what have they done for us now? Those machines of which the civilized world is so proud, has it any right to be proud of the use they have been put to by commercial war and waste?

I do not think exultation can have a place here: commercial war has made a profit of these wonders; that is to say it has by their means bred for itself millions of unhappy workers, unintelligent machines as far as their daily work goes, in order to get cheap labour, to keep up its exciting but deadly game for ever. Indeed that labour would have been cheap enough, cheap to the commercial war generals, and deadly dear to the rest of us, but for the seeds of freedom which valiant men of old have sowed amongst us to spring up in our own day into Chartism and Trades

Unionism and Socialism, for the defence of order and a decent
life. Terrible would have been our slavery, and not of the work-
ing classes alone, but for these germs of the change which must
be. Even as it is, by the reckless aggregation of machine-workers
and their adjoints in the great cities and the manufacturing dis-
tricts, it has kept down life amongst us and keeps it down to a
miserably low standard; so low that any standpoint for improve-
ment is hard even to think of. By the means of speedy commu-
nication which it has created, and which should have raised the
standard of life by spreading intelligence from town to country,
and widely creating modest centres of freedom of thought and
habits of culture; by the means of the railways and the like, it
has gathered to itself fresh recruits for the reserve army of com-
peting lack-alls on which its gambling gains so much depend,
stripping the countryside of its population, and extinguishing all
reasonable hope and life in the lesser towns.

Nor can I, an artist, think last or least of the outward effects
which betoken this rule of the wretched anarchy of commercial
war. Think of the spreading sore of London swallowing up with
its loathsomeness field and wood and heath without mercy and
without hope, mocking our feeble efforts to deal even with its
minor evils of smoke-laden sky and befouled river: the black
horror and reckless squalor of our manufacturing districts, so
dreadful to the senses which are unused to them that it is omi-
nous for the future of the race that any man can live among it in
tolerable cheerfulness: nay in the open country itself the thrust-
ing aside by miserable jerry-built brick and slate of the solid grey
dwellings that are still scattered about, fit emblems in their
cheery but beautiful simplicity of the yeomen of the English
field, whose destruction at the hands of the as yet young com-
mercial war was lamented so touchingly by the high-minded
More and the valiant Latimer. Everywhere in short the change
from old to new involves one certainty, whatever else may be
doubtful, a worsening of the aspect of the country.

This is the condition of England: of England the country of
order, peace, and stability, the land of common sense and practi-
cality; the country to which all eyes are turned of those whose
hope is for the continuance and perfection of modern progress.
There are countries in Europe whose aspect is not so ruined out-
wardly, though they may have less of material prosperity, less
widespread middle-class wealth to balance the squalor and dis-

grace I have mentioned: but if they are members of the great commercial whole, through the same mill they have got to go, unless something should happen to turn aside the triumphant march of War Commercial before it reaches the end. That is what three centuries of Commerce have brought that hope to, which sprang up when feudalism began to fall to pieces. What can give us the dayspring of a new hope? What, save general revolt against the tyranny of commercial war? The palliatives over which many worthy people are busying themselves now are useless: because they are but unorganized partial revolts against a vast wide-spreading grasping organization which will, with the unconscious instinct of a plant, meet every attempt at bettering the condition of the people with an attack on a fresh side; new machines, new markets, wholesale emigration, the revival of grovelling superstitions, preachments of thrift to lack-alls, of temperance to the wretched; such things as these will baffle at every turn all partial revolts against the monster we of the middle-classes have created for our own undoing.

I will speak quite plainly on this matter, though I must say an ugly word in the end if I am to say what I think. The one thing to be done is to set people far and wide to think it possible to raise the standard of life. If you think of it, you will see clearly that this means stirring up general discontent. And now to illustrate that I turn back to my blended claim for Art and Labour, that I may deal with the third clause in it: here is the claim again: *It is right and necessary that all men should have work to do: First, Work worth doing; Second, Work of itself pleasant to do; Third, Work done under such conditions as would make it neither over-wearisome nor over-anxious.*

With the first and second clauses, which are very nearly related to each other, I have tried to deal already. They are as it were the soul of the claim for proper labour; the third clause is the body without which that soul cannot exist. I will extend it in this way, which will indeed partly carry us over ground already covered: *No one who is willing to work should ever fear want of such employment as would earn for him all due necessaries of mind and body.* All due necessaries: what are the due necessaries for a good citizen? First, honourable and fitting work: which would involve giving him a chance of gaining capacity for his work by due education; also, as the work must be worth doing and pleasant to do, it will be found necessary to this end that his

position be so assured to him that he cannot be compelled to do useless work, or work in which he cannot take pleasure.

The second necessity is decency of surroundings: including 1. good lodging; 2. ample space; 3. general order and beauty. That is: 1. Our houses must be well built, clean, and healthy; 2. There must be abundant garden space in our towns, and our towns must not eat up the fields and natural features of the country; nay I demand even that there be left waste places and wilds in it, or romance and poetry, that is Art, will die out amongst us. 3. Order and beauty means that not only our houses must be stoutly and properly built, but also that they be ornamented duly: that the fields be not only left for cultivation, but also that they be not spoilt by it any more than a garden is spoilt: no one for instance to be allowed to cut down, for mere profit, trees whose loss would spoil a landscape: neither on any pretext should people be allowed to darken the daylight with smoke, to befoul rivers, or to degrade any spot of earth with squalid litter and brutal wasteful disorder.

The third necessity is leisure. You will understand that in using that word I imply first that all men must work for some portion of the day, and secondly that they have a positive right to claim a respite from that work: the leisure they have a right to claim must be ample enough to allow them full rest of mind and body: a man must have time for serious individual thought, for imagination, for dreaming even, or the race of men will inevitably worsen. Even of the honourable and fitting work of which I have been speaking, which is a whole heaven asunder from the forced work of the capitalist system, a man must not be asked to give more than his fair share; or men will become unequally developed, and there will still be a rotten place in society.

Here then I have given you the conditions under which work worth doing and undegrading to do can be done: under no other conditions can it be done: if the general work of the world is not worth doing and undegrading to do it is a mockery to talk of civilization. Well then, can these conditions be obtained under the present gospel of Capital, which has for its motto 'The devil take the hindmost'? Let us look at our claim again in other words: *In a properly ordered state of Society every man willing to work should be ensured: First, Honourable and fitting work; Second, A healthy and beautiful house; Third, Full leisure for rest of mind and body.*

Now I don't suppose that anybody here will deny that it would be desirable that this claim should be satisfied: but what I want you all to think is that it is necessary that it be satisfied: that unless we try our utmost to satisfy it, we are but part and parcel of a society founded on robbery and injustice, condemned by the laws of the universe to destroy itself by its own efforts to exist for ever. Furthermore, I want you to think that as on the one hand it is possible to satisfy this claim, so on the other hand it is impossible to satisfy it under the present plutocratic system, which will forbid us even any serious attempt to satisfy it: the beginnings of Social Revolution must be the foundations of the rebuilding of the Art of the People, that is to say of the Pleasure of Life. To say ugly words again; do we not know that the greater part of men in civilized societies are dirty, ignorant, brutal, or at best, anxious about their next week's subsistence; that they are in short poor? And we know, when we think of it, that this is unfair. It is an old story of men who have become rich by dishonest and tyrannical means, spending in terror of the future their ill gotten gains liberally and in charity as 'tis called: nor are such people praised; in the old tales 'tis thought that the devil gets them after all. An old story: but I say, 'De te fabula'; of THEE is the story told: THOU art the man! I say that we of the rich and well-to-do classes are daily doing in like wise: unconsciously, or half consciously it may be, we gather wealth by trading on the hard necessity of our fellows, and then we give driblets of it away to those of them who in one way or other cry out loudest to us. Our poor-laws, our hospitals, our charities, organized and unorganized, are but tubs thrown to the whale: blackmail paid to lame-foot justice, that she may not hobble after us too fast.

When will the time come when honest and clear-seeing men will grow sick of all this chaos of waste, this robbing of Peter to pay Paul, which is the essence of commercial war? When shall we band together to replace the system whose motto is 'The devil take the hindmost' with a system whose motto shall be really and without qualification 'One for all and all for one'. Who knows but the time may be at hand, but that we now living may see the beginning of that end which shall extinguish luxury and poverty? when the upper, middle, and lower classes shall have melted into one class, living contentedly a simple and happy life? That is a long sentence to describe the state of things

which I am asking you to help to bring about: the abolition of slavery is a shorter one and means the same thing. You may be tempted to think the end not worth striving for on the one hand, or on the other to suppose, each one of you, that it is so far ahead that nothing serious can be done towards it in our own time, and that you may as well therefore sit quiet and do nothing. Let me remind you how only the other day in the lifetime of the youngest of us many thousand men of our own kindred gave their lives on the battle-field to bring to a happy ending a mere episode in the struggle for the abolition of slavery: they are blessed and happy, for the opportunity came to them, and they seized it and did their best, and the world is the wealthier for it: and if such an opportunity is offered to us shall we thrust it from us that we may sit still in ease of body, in doubt, in disease of soul? These are the days of combat: who can doubt that as he hears all round him the sounds that betoken discontent and hope and fear in high and low, the sounds of awakening courage and awakening conscience? These, I say, are the days of combat, when there is no external peace possible to an honest man; but when for that very reason the internal peace of a good conscience founded on settled convictions is the easier to win, since action for the cause is offered us.

Or will you say that here in this quiet, constitutionally governed country of England there is no opportunity for action offered to us? If we were in gagged Germany, in gagged Austria, in Russia where a word or two might land us in Siberia or the prison or fortress of Peter and Paul; why then, indeed — Ah! my friends, it is but a poor tribute to offer on the tombs of the martyrs of liberty, this refusal to take the torch from their dying hands! Is it not of Goethe it is told, that on hearing one say he was going to America to begin life again, he replied: 'Here is America, or nowhere'? So for my part I say: 'Here is Russia, or nowhere'. To say the governing classes in England are not afraid of freedom of speech, therefore let us abstain from speaking freely, is a strange paradox to me. Let us on the contrary press in through the breach which valiant men have made for us: if we hang back we make their labours, their sufferings, their deaths, of no account. Believe me, we shall be shown that it is all or nothing: or will anyone here tell me that a Russian moujik is in a worse case than a sweating tailor's wage-slave? Do not let us deceive ourselves, the class of victims exists here as in Russia.

There are fewer of them? Maybe; then are they of themselves more helpless, and so have more need of our help.

And how can we of the middle classes, we the capitalists, and our hangers-on, help them? By renouncing our class, and on all occasions when antagonism rises up between the classes casting in our lot with the victims: with those who are condemned at the best to lack of education, refinement, leisure, pleasure, and re-nown; and at the worst to a life lower than that of the most brutal of savages in order that the system of competitive Commerce may endure. There is no other way: and this way, I tell you plainly, will in the long run give us plentiful occasion for self-sacrifice without going to Russia. I feel sure that in this assembly there are some who are steeped in discontent with the miserable anarchy of the century of Commerce: to them I offer a means of renouncing their class by supporting Socialist propaganda in joining the Democratic Federation, which I have the honour of representing before you, and which I believe is the only body in this country which puts forward constructive Socialism as its program.

This to my mind is opportunity enough for those of us who are discontented with the present state of things and long for an opportunity of renunciation; and it is very certain that in accept-ing the opportunity you will have at once to undergo some of the inconveniences of martyrdom, though without gaining its dignity at present. You will at least be mocked and laughed at by those whose mockery is a token of honour to an honest man; but you will, I don't doubt it, be looked on coldly by many excellent people, not all of whom will be quite stupid. You will run the risk of losing position, reputation, money, friends even: losses which are certainly pin-pricks to the serious martyrdom I have spoken of, but which none the less do try the stuff a man is made of; all the more as he can escape them with little other reproach of cowardice than that which his own conscience cries out at him. Nor can I assure you that you will for ever escape scot-free from the attacks of open tyranny. It is true that at present capi-talist society only looks on Socialism in England with dry grins. But remember that the body of people who have for instance ruined India, starved and gagged Ireland, and tortured Egypt, have capacities in them, some ominous signs of which they have lately shown, for openly playing the tyrants' game nearer home. So on all sides I can offer you a position which involves sacri-

fice; a position which will give you your America at home, and make you inwardly sure that you are at least of some use to the cause: and I earnestly beg you, those of you who are convinced of the justice of our cause, not to hang back from active participation in a struggle which, who ever helps or who ever abstains from helping, must beyond all doubt end at last in Victory!

# *At a Picture Show, 1884*

NOW it is clear to me from reading the catalogue of this exhibition that the promoters of it think that the working men, as we call them, of these parts do most seriously need some education in the fine arts, that they need to be told something about them which they do not know, in order that, when they look at pictures or other things professing to be works of art in future, they may be impressed by them in a different way from what they have been used to do: in other words, they want to educate people to look at pictures so that the pictures themselves may educate them afterwards. I agree with the promoters of this exhibition that the working men hereabouts do sorely need this double education, nor do I think that the richer classes would be the worse for it either for that matter; and the admission that this education is needed, that it should be necessary to explain to an ordinary intelligent person what the merits and aims of a picture are, just as one has to translate a piece of writing from a foreign tongue into our own: I say the admission that it is necessary to do this, and that it should be justly thought a good work for men to take trouble to do it without any other reward than what their own consciences may give them, shows that there is something amiss in the condition of the population hereabouts, and to cut the matter short, with the population throughout England, and indeed more or less throughout the civilized world.

I don't know if I make my thought clear to you: let me put it in another way: here on the one hand is a mass of work, done with the utmost care, patience and skill by clever and energetic people, who have devoted their lives to doing it; all of them have been men of special gifts and some of them men of the very greatest capacity, who would have succeeded in almost any career that they might have taken to. That is on the one hand I say, and on the other hand is a mass of laborious and intelligent peo-

ple, who have been brought up in such a way that the mass of work aforesaid is of no value to them, who don't know of its existence, and when by accident they come across any part of it do not understand what it means, till they have been educated into doing so. This is a strange case.

You may say the men who took all this trouble about works of art and gave their lives to making them are dead, they belonged to a past state of society, we have our minds fixed on different aims now. Well to a certain extent that is true, and yet there is another wonder: for there are still men alive who understand what these dead artists meant, who chiefly think of them and their works and the times which produced them; and some of these are themselves engaged with no less energy though perhaps with less success than those dead men in producing works of art to-day: they are neither foolish nor ignorant as a rule, and though some of them may be accused of being dreamers without sympathy for the life of men in the present, that is not a necessary characteristic of them, and we should wrong them if we thought it was general with them.

So you see you have on the one side artists and those who sympathize with them, and on the other the great mass of the people, who scarcely know or rather certainly do not know, what the word art means; these two groups of people so far as their ideas go, the thoughts which pass through their minds, might almost be living in two different worlds, although they are of the same country, the same race, speaking the same tongue.

This separation of the lives of two kinds of people seems to me monstrous and strange: and yet in that very fact of this separation lies a stumbling block in my making myself understood by many of you; for to most of you, I imagine it will not seem either strange or monstrous, no more than one man being a carpenter, and another a lawyer's clerk; I can only say that to me it seems much as if the carpenter, he and his, and the lawyer's clerk had got so perversely developed that the carpenter could see nothing in a tree but so many feet of timber and was blind to the leaves and fruit and blossom of it; as if to the lawyer's clerk a sheep was parchment in the rough, and a goose so many bundles of pens. In other words again, it seems to me that the sense of beauty in the external world, of interest in the life of man as a drama, and the desire of communicating this sense of beauty and interest to our fellows is or ought to be an essential part of the

humanity of man, and that any man or set of men lacking that sense are less than men, and lack a portion of their birthright just as if they were blind or deaf. This proposition if it be true does certainly impose a duty upon us, the duty of guarding jealously this birthright, this gift of humanity; for those who know anything of the arts know for certain that no other pleasure is so sure and so lasting as that which comes of our exercising this gift, sometimes actively as a worker, sometimes as a looker-on only. Ah friends, seeing how many pains there are which are imposed on men's lives, and are not avoidable, surely we were the worst of fools if we did not treasure up those pleasures which are, if we knew it, a natural part of humanity also; especially when they lie so ready to our hands; for in good truth it is in our daily life and our daily work that the chance lies for us to take hold of the pleasure offered to us by art. Again you are astonished at my saying this: but that is just because of that division between artists and other men, which to me seems monstrous, to you natural: you cannot imagine your daily life, still less your daily work, having anything to do with art: somebody else paints a picture which he hopes a rich man will buy, but scarcely dares to hope anybody but a few artists like himself will understand; you look at it, heed more or less what the newspapers say about it, are sometimes perhaps a little amused by it, oftenest not, and go away quite forgetting what kind of thing it was, and by no means yearning to see another like it. Art, as you understand it, you feel you can do pretty well without: well so could I, though I am an artist. And yet, art as it should be you cannot do without, as I think the coming years will show you; as many men even now are beginning to feel—those who do not understand the why and the wherefore of our lack of art with mere despair, those that do understand it with something like exultation at the signs of the times and the new birth which they promise.

In your daily life and daily work, I have said, your chance alone lies of taking hold of art or the pleasure of life, in your becoming all artists: it is only by our all becoming artists that we shall be able to guard that natural birthright. Again you see because of that fatal schism between art and daily life you are astonished, for you think of an artist as a man working at his picture or image day in day out, disconnected with all other life but the carrying through of his piece of uselessness, as you would, if you said what you thought, most probably think it.

That is not what I mean by an artist at all, when I say we must all be artists: I mean that we should all be able to look with reverence and understanding on the aspect of nature and the deeds of man on the earth, that we should take a deep and thoughtful interest in life in short, and not be merely drifted helplessly hither and thither by the force of circumstances, as we too often are.

And if that were our real feeling, if we were really interested in the life of ourselves and our fellowmen, we should take care first, that our daily work was such as was fit for human beings to do, and secondly, that the time when we were not working included something more than mere animal rest, while it provided all due animal pleasure also: that, it seems to me, would be living due human lives, to have fruitful work-time, pleasant rest-time: I am sure you must agree with me there.

And yet, I must say it, how far we are from that now: how little fruitful work we do, how little pleasant rest we enjoy! Many and many a man goes down to the grave without having done one stroke of useful work, and as a consequence (taking the world all round) without having enjoyed one day of pleasant innocent unanxious rest: we waste our working energies in producing nothing or things harmful; we spoil our capacity for enjoyment in terrible wearing anxieties about how we are to live by working hard in doing nothing or less; and as a sad token of our waste and unrest we are speedily making the world, the face of the earth, once so beautiful, hideous, grievous to look on, unfit for man to dwell on. Nay more, all this might be bearable, if we each and all had taken upon us due share of the torment this state of things produces; if we had borne one another's burdens and stood together determined to face it out, and mend it if we could, at the worst to live together bold and kind if we could not live happy. But this we have not done but rather the reverse of it; we have divided the world into rich and poor: we have decreed that, as near as could be, there should be two classes of people, one to toil and suffer, one to spend and enjoy; the poor are to be ill fed, coarsely clad, dirty, wretchedly housed, over-worked, uncertain of their livelihood from day to day, they are to talk coarsely and ungrammatically, to think unconsecutively and illogically, to be uneducated, unrefined, bigoted, ignorant and dishonest; the rich on the other hand are privileged to feed themselves to repletion, to be clad in delicate raiment, to be spotlessly clean at all

hours of the day, to live in gorgeous houses, to do no work or little work and to be paid the more the less they do, to talk daintily a tongue of their own, to be carefully and lengthily educated, to think according to the rules of logic, to have a plausible pretence of knowledge at least, to be over refined, as we call it, that is finikin, or may be vulgar only, to be finally, cynical and corrupt and dishonest: all this is their birth right, and hardly can they escape from it however good their dispositions as individuals may be, just as the poor however kindly and valiant they may be can hardly escape from their curse. If this be the case what wonder that there is this severance between artists and non-artists: the artists have been annexed by the rich and are their hangers on, their lackeys, their toy-makers: what wonder that they can no longer talk a language understanded by the people? that is as I have said a token of the severance between rich and poor; it is proper and right according to the system under which we live that the poor should be obliged to do without art and that the rich should be able to have at least a semblance of it, *because,* as the word goes, *money can buy anything,* which fortunately, my friends, is a lying proverb. For if, as is probable, you are inclined to say that all my words about the rich and the poor is but the ordinary frothy talk of the demagogue, I will add this to it, that as far as I can judge — I who belong to the rich classes — they are not happy either. How should they be? how should a cynical man or class feel happy? a corrupt one feel secure, a dishonest man or class feel at rest? Satisfied they cannot be, so soon as any suspicion creeps in on them that they are cynical, corrupt and dishonest: nor will you working men so soon as you feel that you are ill fed, ill clad, ill housed, overworked, dirty, ignorant, unrefined *because* you belong to a class, cease to feel any content in the wretched scraps of enjoyment of life which are still allowed you; you also will be openly discontented, very openly I hope. No, be sure we are both unhappy, rich and poor, and justly so when we, we children of one mother, have been so led astray, so sported with by circumstance that we can endure the inequalities which underlie those words rich and poor.

And that is why I have been speaking the language of the common demagogue (which is true mind you) in order that I might make you feel, both rich and poor among you, what a gulf gapes between you, and that by some means you might set about trying to bridge it over, to fill it up rather. Indeed both con-

sciously and unconsciously I know you try to do so, and your attempts at it, ineffectual as they are and must be while the present system lasts, do at least testify to your consciousness of there being something wrong: and what I want you to see is that the something wrong is the existence of class distinctions of any kind. I want there to be no more masters and slaves, no more gentlemen and cads (as we used to say at the university), I want us all to be friends, all to be gentlemen, working for the common good, sharing duly the common stock of pleasure and refinement. If this is being a demagogue you must set me down as one: also don't say it is beside the question of an art exhibition; for on this question must depend the answer to the other one whether your art exhibition has any educational value.

What is the use of showing works of art to a class of men, and practically saying to them through a thin veil of verbiage: My contented friends, here are works of art done by famous and clever men, some dead, some living; you, as long as you are workmen, cannot rightly understand them, but this and this is what men privileged to know all about it say about them, and you had better take it for granted; come as often as you can or please to see them, but I don't quite know what good it will do except exciting a little vague wonder in you as you look at them, and therefore I hope a little pleasure. You are told they are beautiful, from which *you* may deduce the fact that you have nothing to do with beauty elsewhere either in your workshops or your homes, for you are workmen, and it is of the nature of workmen to be unrefined and careless of beauty: look and wonder and go your ways with my blessing.

That, I say, must really be the manner of our invitation to the working classes to come to such places as this unless we have in some corner of our minds an intention of changing their condition entirely: but if we have that intention, we can give a different kind of invitation: My friends, my discontented friends, we may say, here you have before you the famous works of men the greater part of them dead by now and living under different conditions of life to ours: you and your fathers and your fathers' fathers have been so oppressed by the folly rather than the malice of man that you cannot fully enter into their spirit, but we who for no merits of our own have been privileged to refinement and knowledge can tell you this about them, that they are the work of men who were not fine gentlemen but workmen like

yourselves: the instincts that enable them to produce these works are latent in your hands and minds if only you had the opportunity to develop them: the qualities of beauty and interest which have made these works the wonder of the world should be present in some way or another in your own daily work and have their influence upon your home life, making it orderly, beautiful, in a word human. Come here often if you please, especially on Sundays when your bodies are rested and your minds with them, and let the sight of these wonders stimulate you to trying to win a worthy life for yourselves and your fellows, a life of men and not of 'operatives'.

That it seems to me is the educational, the hopeful invitation we should give to workmen to come to such places as this: keeping well in mind that though public libraries and museums and picture exhibitions are good, and very good, yet if you are tempted to look upon them as substitutes for decent life in the workshop and the home, if they are to be mere tubs thrown to the whale of poverty, they may become dangerous snares to well meaning, middle-class philanthropists: consider if this must be so: why, I well know the difference when I have been seeing some beautiful and famous place between coming home to a well arranged and simple and beautiful house, and being bundled into some wretched sea-side lodging-house or noisy vulgar hotel: how one's heart sinks in the latter case. And if that is so, think how it must be to a workman who has in him any artistic feeling, who, after spending an hour looking at beautiful works of art in a public place, has to go back again to his close wretched house, a den, no better, buried amidst the miles and miles of vile filth into which the earth of S. Lancashire has been turned: I tell you if he feels anything short of rage at least if not despair, it is because he is used to it, that is his manhood has been crushed out of him: he forgets that he is a man and thinks he has been born to be a machine.

It is now chiefly to those who agree with me in most of what I have been saying, but who can see no way out of it, that I shall address what I have left to say: this condition of things which, evil as you know it to be, you suppose to be as enduring henceforth as the world and incapable of being cured, capable only of being palliated, this condition of things, I say, has grown out of other conditions partly better, partly worse, and is the necessary outcome of them: I must not dwell upon this at length, because

it will form the subject of a discourse that I have been kindly
afforded an opportunity of delivering here to-morrow, so I must
ask you to take that for granted at present, and to believe me
when I say that the changes that have taken place in the relations
of labour to the commonweal have been very great even in our
own history: I must ask you to believe that, gradual as the change
in England has been since the time of Edward III, it has been
complete; that in spite of our counties and cities being called by
the same names, and although not one new parish has been added
to the English parishes since the time of the heptarchy, though
there is a seeming continuity in our history, yet it fares with us
as with the Irishman's knife, the same knife, but with new blades
and a new handle: in morals and aspirations, in manners of work
and life, the English people of to-day are totally different from
what they were in the fifteenth century; 300 years has made them
another people with little sympathy for the virtues, and no under-
standing of the vices of their ancestors.

Let those that will make their moan over that, but I as a living
Englishman will choke down the sad sentiment which I admit it
is natural to feel over the death of the past, so that I may play
my part in the life of the present: that thought about the utter
change that has befallen our country and race, I put before you
not as a matter of regret for the past, but as hope for the future:
I want to point out to you that at no time can you draw a line
athwart the course of history and say thus far and no farther, and
that the change, once more as before, will be complete as well as
gradual. That tremendous edifice of Commercial rule which has
supplanted Feudality is, you may be sure, not the last system
which the world will see: it seems almost a truism to say so; and
yet, you know, there are men and learned ones too, who seem to
think that there are and can be but two systems of life and labour
in the world: the one which now is, which is natural, essential
and for henceforth enduring, though it may contain lamentable
incidents; the other that which has been, which was absurd, arti-
ficial, bound to perish. One was wrong, the other is right: these
learned men can see nothing but past and present; for them the
world has no future. That I am sure must seem impossible to you
when you come to think of it: your only question then will be in
what direction and how will the change come. I must refer you
to what I said before that under the present systems of labour,
our work is wasted and our rest is spoilt; and why? Because it is

a system of war, and therefore necessarily of waste: the parts of the system dovetail into one another, so that no one can escape from the conflict: nation competes against nation, class against class, individual against individual; each of these wars sustains the other and each has its own peculiar waste; only as it is with other war so it is with war commercial, that it is the common soldier that pays for all, in the long run. In commercial war it is on the loss of the manual workman that the whole system is built up, without him there would be nothing to support the war: he is in a peculiar position, for while he has only one commodity to sell, that commodity, labour, is the only one which has the power of increasing wealth, but that commodity he cannot turn to account without the leave of a special class; and the system of war aforesaid compels him by driving him to daily competition with his fellows to getting that leave on very poor terms, namely, that he shall work day long, and that after he has made just so much as shall support him, that is, enable him to go on working and to reproduce his kind, the results of the rest of his day's labour shall be his master's, the man who has bought him for the occasion; which master for his part is in the position of being the privileged monopolist of the hoarded labour of the past in the shape of land, machinery, credit and the like, without the use of which the workman cannot even begin to work.

This is the system of working for profit, which I must ask you to believe me has not always obtained; there have been times and places when people worked not for other people's profit, but for their own livelihood, under which circumstances they regulated their own labour, produced for the market, which was not an extensive one, such goods as were obviously demanded and no more, and at the same time dealt in a simple way with the consumer, so that there was not the same waste between buying and selling which there is now: this was the case in times rude, coarse and ignorant if you will; but rude and coarse and ignorant as they were, they were fruitful of one thing of which we are now barren, art to wit; and the reason was that in spite of their rudeness, coarseness and ignorance, and in spite in good truth of plenteous violence and oppression of the weak by the strong, the workmen did themselves regulate labour, did by means of combination among themselves settle most of the points which might otherwise have been anarchically fought over, and for the rest were when they were at work absolutely masters each man of his

own work: subject only to the demands of the public they were their own employers; or, if you please to put it in another way, the goods they made were made to use, whereas they are now, as you well know, made to sell.

I think it necessary to make these remarks because I assume again that the purpose of this exhibition is to a certain extent at least educational, and that from my point of view I should be defeating that object by misleading you, if in calling attention to the works of past times, I were to allow you to suppose that works of the same quality and kind could be produced under the system which is now the ruling power of civilization: such works as these with all their spontaneous unforced imagination could never have been produced in the copiousness with which they were produced, if apart from the great masters who made them there had not been a vast public who could appreciate them; nor could that public have existed but for the constant unconscious education which was going on in those days by means of the ordinary work of ordinary handicraftsmen: now-a-days, you know, people talk about, and advertise art pottery, art furniture, art fire-grates, and the like, giving us clearly to understand by such words, that it is unusual for pottery, furniture and fire-grates to have anything to do with art, that there is, as I began by saying, a divorce between art and common life. Every object which was made in the days when the pictures from which these engravings were made were painted, was a matter of art and could not help being so: in ordinary matters of daily life the art in a piece of handicraft was not charged for, you understand; why should it be when it was not an additional trouble to the handicraftsman but a solace to his trouble? he could live without being paid extra for it: whereas now-a-days you must pay a man something for the art, because he can, as a rule, do nothing else but the art — he is an extra — like the manners at the village school.

So here you see we are back at the point we began at, that the public does its art, as it does its religion — by deputy: pays a certain number of what I should call art-parsons to perform certain mysteries of civilization which it is pleased to call the fine arts, and stands on one side while they go through their mumbo-jumbo with grievous results to their morals in most cases, and with still more grievous results to the fine arts; which depend on all life being carried on with art; that is the very sustenance and

wellspring of them, the beauty and manliness of daily life. Now I tell you that this kind of thing cannot last: we cannot go on for ever drawing all the food of our pictorial representation, nay even of the ornament of our houses and furniture, from past times: the fact that we do so now is a sign of corruption in the arts; and what must follow corruption save extinction or new birth?

With such reverence I look upon the arts, so clear I am that they have been, since man was man, a part of his very soul, that I know that their extinction is impossible. Where then are we to look for their new birth? To speak plainly I see no sign of it in the life of cultivated civilization to-day, and if I saw any apparent signs in that quarter of what is called Society, I should doubt their reality: it would be a beginning at the wrong end: we must start from the root up to be real. It is from the workman himself that the new birth must come: but how? To speak plainly again, he is to-day a slave, a slave to the great world-market, which holds his master in as tight a grip as it does himself, and which mocks at any feeble effort of either master or man to produce art. From that slavery of the world-market, the mother of lies and theft, of pestilence, war and famine, the worker must free himself if he is ever to take any part again in the enjoyment and production of beauty; and if he does not then beauty will die out of the life of man. The workman must learn to understand that he must have no master, no employer, save himself—himself collectively, that is to say, the commonweal: then once more he will be master of his work and refuse to produce at the command of the gambling-market: he will have no more need to send his son or his brother equipped with all the newest inventions of science to murder half-armed men in distant countries that he may sell another thousand yards of calico: he will think the slaughter of three or four thousand Arabs or negroes a wasteful if not a cruel way of testing the capabilities of the market, and will soberly try to find out what is wanted without resorting to vicarious murder. He will see to it that buying and selling shall mean nothing more intricate and exciting than the exchange of the results of labour without waste; he will not suffer the caprice of a few rich people driving them to crave for useless and harmful luxuries to impose a tax on all usefully industrious persons; and he will find amidst his peaceful and useful work that every stroke he does will benefit both himself and all his neighbours.

This is the root from which all art must spring in the future, whatever has been the case in the past: as it has always when genuine sprung from the lives and labour of the many, it has always been in some degree, and always in exact proportion to its nobility, the token of the freedom of labour: that word, the freedom of labour, is now beginning to mean a something wider and more glorious than it has ever had yet; to mean freedom no longer for a group or a class or a nation but for all men.

True it is that I have for long got to think that in the early days of that freedom art will have a rough time of it; and for long perhaps will have to live a spartan life, forgoing many delicacies which I the weak child of a poorer and less manly time than that which is to come cannot help craving after. But what matter so long as art is alive and healthy? from that spare and spartan life she will rise to greater glories than ever she has attained to yet.

It is in the assured hope of this that I have ventured to hint at what seem to me important truths, most important, even at the risk of offending you by seeming irrelevance. Though the day of that Freedom of Labour from the gambling-market may be distant, be sure it is on the way; nay signs of its approach are even now multiplying around us, and who knows but that even as I speak to you the dawning may be at hand?

## ᔻ *Six* ᔻ

# *The Aims of Art*

IN considering the Aims of Art, that is, why men toilsomely cherish and practise Art, I find myself compelled to generalize from the only specimen of humanity of which I know anything; to wit, myself. Now, when I think of what it is that I desire, I find that I can give it no other name than happiness. I want to be happy while I live; for as for death, I find that, never having experienced it, I have no conception of what it means, and so cannot even bring my mind to bear upon it. I know what it is to live; I cannot even guess what it is to be dead. Well, then, I want to be happy, and even sometimes, say generally, to be merry; and I find it difficult to believe that that is not the universal desire: so that, whatever tends towards that end I cherish with all my best endeavour. Now, when I consider my life further, I find out, or seem to, that it is under the influence of two dominating moods, which for lack of better words I must call the mood of energy and the mood of idleness: these two moods are now one, now the other, always crying out in me to be satisfied. When the mood of energy is upon me, I must be doing something, or I become mopish and unhappy; when the mood of idleness is on me, I find it hard indeed if I cannot rest and let my mind wander over the various pictures, pleasant or terrible, which my own experience or my communing with the thoughts of other men, dead or alive, have fashioned in it; and if circumstances will not allow me to cultivate this mood of idleness, I find I must at the best pass through a period of pain till I can manage to stimulate my mood of energy to take its place and make me happy again. And if I have no means wherewith to rouse up that mood of energy to do its duty in making me happy, and I have to toil while the idle mood is upon me, then am I unhappy indeed, and almost wish myself dead, though I do not know what that means.

Furthermore, I find that while in the mood of idleness memory amuses me, in the mood of energy hope cheers me; which hope is sometimes big and serious, and sometimes trivial, but that without it there is no happy energy. Again, I find that while I can sometimes satisfy this mood by merely exercising it in work that has no result beyond the passing hour—in play, in short—yet that it presently wearies of that and gets languid, the hope therein being too trivial, and sometimes even scarcely real; and that on the whole, to satisfy my master the mood, I must either be making something or making believe to make it.

Well, I believe that all men's lives are compounded of these two moods in various proportions, and that this explains why they have always, with more or less of toil, cherished and practised art.

Why should they have touched it else, and so added to the labour which they could not choose but do in order to live? It must have been done for their pleasure, since it has only been in very elaborate civilizations that a man could get other men to keep him alive merely to produce works of art, whereas all men that have left any signs of their existence behind them have practised art.

I suppose, indeed, that nobody will be inclined to deny that the end proposed by a work of art is always to please the person whose senses are to be made conscious of it. It was done *for* some one who was to be made happier by it; his idle or restful mood was to be amused by it, so that the vacancy which is the besetting evil of that mood might give place to pleased contemplation, dreaming, or what you will; and by this means he would not so soon be driven into his workful or energetic mood: he would have more enjoyment, and better.

The restraining of restlessness, therefore, is clearly one of the essential aims of art, and few things could add to the pleasure of life more than this. There are, to my knowledge, gifted people now alive who have no other vice than this of restlessness, and seemingly no other curse in their lives to make them unhappy: but that is enough; it is 'the little rift within the lute'. Restlessness makes them hapless men and bad citizens.

But granting, as I suppose you all will do, that this is a most important function for art to fulfil, the question next comes, at what price do we obtain it? I have admitted that the practice of art has added to the labour of mankind, though I believe in the

long run it will not do so; but in adding to the labour of man has it added, so far, to his pain? There always have been people who would at once say yes to that question; so that there have been and are two sets of people who dislike and contemn art as an embarrassing folly. Besides the pious ascetics, who look upon it as a worldly entanglement which prevents men from keeping their minds fixed on the chances of their individual happiness or misery in the next world; who, in short, hate art, because they think that it adds to man's earthly happiness—besides these, there are also people who, looking on the struggle of life from the most reasonable point that they know of, contemn the arts because they think that they add to man's slavery by increasing the sum of his painful labour: if this were the case, it would still, to my mind, be a question whether it might not be worth the while to endure the extra pain of labour for the sake of the extra pleasure added to rest; assuming, for the present, equality of condition among men. But it seems to me that it is not the case that the practice of art adds to painful labour; nay more, I believe that, if it did, art would never have arisen at all, would certainly not be discernible, as it is, among peoples in whom only the germs of civilization exist. In other words, I believe that art cannot be the result of external compulsion; the labour which goes to produce it is voluntary, and partly undertaken for the sake of the labour itself, partly for the sake of the hope of producing something which, when done, shall give pleasure to the user of it. Or, again, this extra labour, when it *is* extra, is undertaken with the aim of satisfying that mood of energy by employing it to produce something worth doing, and which, therefore, will keep before the worker a lively hope while he is working; and also by giving it work to do in which there is absolute immediate pleasure. Perhaps it is difficult to explain to the non-artistic capacity that this definite sensuous pleasure is always present in the handiwork of the deft workman when he is working successfully, and that it increases in proportion to the freedom and individuality of the work. Also you must understand that this production of art, and consequent pleasure in work, is not confined to the production of matters which are works of art only, like pictures, statues, and so forth, but has been and should be a part of all labour in some form or other: so only will the claims of the mood of energy be satisfied.

Therefore the Aim of Art is to increase the happiness of men, by giving them beauty and interest of incident to amuse their leisure, and prevent them wearying even of rest, and by giving them hope and bodily pleasure in their work; or, shortly, to make man's work happy and his rest fruitful. Consequently, genuine art is an unmixed blessing to the race of man.

But as the word 'genuine' is a large qualification, I must ask leave to attempt to draw some practical conclusions from this assertion of the Aims of Art, which will, I suppose, or indeed hope, lead us into some controversy on the subject; because it is futile indeed to expect any one to speak about art, except in the most superficial way, without encountering those social problems which all serious men are thinking of; since art is and must be, either in its abundance or its barrenness, in its sincerity or its hollowness, the expression of the society amongst which it exists.

First, then, it is clear to me that, at the present time, those who look widest at things and deepest into them are quite dissatisfied with the present state of the arts, as they are also with the present condition of society. This I say in the teeth of the supposed revivification of art which has taken place of late years: in fact, that very excitement about the arts amongst a part of the cultivated people of to-day does but show on how firm a basis the dissatisfaction above mentioned rests. Forty years ago there was much less talk about art, much less practice of it, than there is now; and that is specially true of the architectural arts, which I shall mostly have to speak about now. People have consciously striven to raise the dead in art since that time, and with some superficial success. Nevertheless, in spite of this conscious effort, I must tell you that England, to a person who can feel and understand beauty, was a less grievous place to live in then than it is now; and we who feel what art means know well, though we do not often dare to say so, that forty years hence it will be a more grievous place to us than it is now if we still follow up the road we are on. Less than forty years ago — about thirty — I first saw the city of Rouen, then still in its outward aspect a piece of the Middle Ages: no words can tell you how its mingled beauty, history, and romance took hold on me; I can only say that, looking back on my past life, I find it was the greatest pleasure I have ever had: and now it is a pleasure which no one can ever have again: it is lost to the world for ever. At that time I was an un-

dergraduate of Oxford. Though not so astounding, so romantic, or at first sight so mediæval as the Norman city, Oxford in those days still kept a great deal of its earlier loveliness: and the memory of its grey streets as they then were has been an abiding influence and pleasure in my life, and would be greater still if I could only forget what they are now — a matter of far more importance than the so-called learning of the place could have been to me in any case, but which, as it was, no one tried to teach me, and I did not try to learn. Since then the guardians of this beauty and romance so fertile of education, though professedly engaged in 'the higher education' (as the futile system of compromises which they follow is nick-named), have ignored it utterly, have made its preservation give way to the pressure of commercial exigencies, and are determined apparently to destroy it altogether. There is another pleasure for the world gone down the wind; here, again, the beauty and romance have been uselessly, causelessly, most foolishly thrown away.

These two cases are given simply because they have been fixed in my mind; they are but types of what is going on everywhere throughout civilization: the world is everywhere growing uglier and more commonplace, in spite of the conscious and very strenuous efforts of a small group of people towards the revival of art, which are so obviously out of joint with the tendency of the age that, while the uncultivated have not even heard of them, the mass of the cultivated look upon them as a joke, and even that they are now beginning to get tired of.

Now, if it be true, as I have asserted, that genuine art is an unmixed blessing to the world, this is a serious matter; for at first sight it seems to show that there will soon be no art at all in the world, which will thus lose an unmixed blessing; it can ill afford to do that, I think.

For art, if it has to die, has worn itself out, and its aim will be a thing forgotten; and its aim was to make work happy and rest fruitful. Is all work to be unhappy, all rest unfruitful, then? Indeed, if art is to perish, that will be the case, unless something is to take its place — something at present unnamed, undreamed of.

I do not think that anything will take the place of art; not that I doubt the ingenuity of man, which seems to be boundless in the direction of making himself unhappy, but because I believe the springs of art in the human mind to be deathless, and also be-

cause it seems to me easy to see the causes of the present obliteration of the arts.

For we civilized people have not given them up consciously, or of our free will; we have been *forced* to give them up. Perhaps I can illustrate that by the detail of the application of machinery to the production of things in which artistic form of some sort is possible. Why does a reasonable man use a machine? Surely to save his labour. There are some things which a machine can do as well as a man's hand, *plus* a tool, can do them. He need not, for instance, grind his corn in a hand-quern; a little trickle of water, a wheel, and a few simple contrivances will do it all perfectly well, and leave him free to smoke his pipe and think, or to carve the handle of his knife. That, so far, is unmixed gain in the use of a machine — always, mind you, supposing equality of condition among men; no art is lost, leisure or time for more pleasurable work is gained. Perhaps a perfectly reasonable and free man would stop there in his dealings with machinery; but such reason and freedom are too much to expect, so let us follow our machine-inventor a step farther. He has to weave plain cloth, and finds doing so dullish on the one hand, and on the other that a power-loom will weave the cloth nearly as well as a hand-loom: so, in order to gain more leisure or time for more pleasurable work, he uses a power-loom, and foregoes the small advantage of the little extra art in the cloth. But so doing, as far as the art is concerned, he has not got a pure gain; he has made a bargain between art and labour, and got a makeshift as a consequence. I do not say that he may not be right in so doing, but that he has lost as well as gained. Now, this is as far as a man who values art and is reasonable would go in the matter of machinery as *long as he was free* — that is, was not *forced* to work for another man's profit; so long as he was living in a society *that had accepted equality of condition*. Carry the machine used for art a step farther, and he becomes an unreasonable man, if he values art and is free. To avoid misunderstanding, I must say that I am thinking of the modern machine, which is as it were alive, and to which the man is auxiliary, and not of the old machine, the improved tool, which is auxiliary to the man, and only works as long as his hand is thinking; though I will remark, that even this elementary form of machine has to be dropped when we come to the higher and more intricate forms of art. Well, as to the machine proper used for art, when it gets to the stage above

dealing with a necessary production that has accidentally some beauty about it, a reasonable man with a feeling for art will only use it when he is *forced* to. If he thinks he would like ornament, for instance, and knows that the machine cannot do it properly, and does not care to spend the time to do it properly, why should he do it at all? He will not diminish his leisure for the sake of making something he does not want unless some man or band of men force him to it; so he will either go without the ornament, or sacrifice some of his leisure to have it genuine. That will be a sign that he wants it very much, and that it will be worth his trouble: in which case, again, his labour on it will not be mere trouble, but will interest and please him by satisfying the needs of his mood of energy.

This, I say, is how a reasonable man would act if he were free from man's compulsion; not being free, he acts very differently. He has long passed the stage at which machines are only used for doing work repulsive to an average man, or for doing what could be as well done by a machine as a man, and he instinctively expects a machine to be invented whenever any product of industry becomes sought after. He is the slave to machinery; the new machine *must* be invented, and when invented he *must*—I will not say use it, but be used by it, whether he likes it or not.

But why is he the slave to machinery? Because he is the slave to the system for whose existence the invention of machinery was necessary.

And now I must drop, or rather have dropped, the assumption of the equality of condition, and remind you that, though in a sense we are all the slaves of machinery, yet that some men are so directly without any metaphor at all, and that these are just those on whom the great body of the arts depends—the workmen. It is necessary for the system which keeps them in their position as an inferior class that they should either be themselves machines or be the servants to machines, in no case having any interest in the work which they turn out. To their employers they are, so far as they are workmen, a part of the machinery of the workshop or the factory; to themselves they are proletarians, human beings working to live that they may live to work: their part of craftsmen, of makers of things by their own free will, is played out.

At the risk of being accused of sentimentality, I will say that since this is so, since the work which produces the things that

should be matters of art is but a burden and a slavery, I exult in this at least, that it cannot produce art; that all it can do lies between stark utilitarianism and idiotic sham.

Or indeed is that merely sentimental? Rather, I think, we who have learned to see the connection between industrial slavery and the degradation of the arts have learned also to hope for a future for those arts; since the day will certainly come when men will shake off the yoke, and refuse to accept the mere artificial compulsion of the gambling-market to waste their lives in ceaseless and hopeless toil; and when it does come, their instincts for beauty and imagination set free along with them, will produce such art as they need; and who can say that it will not as far surpass the art of past ages as that does the poor relics of it left us by the age of commerce?

A word or two on an objection which has often been made to me when I have been talking on this subject. It may be said, and is often, You regret the art of the Middle Ages (as indeed I do), but those who produced it were not free; they were serfs, or gild-craftsmen surrounded by brazen walls of trade restrictions; they had no political rights, and were exploited by their masters, the noble caste, most grievously. Well, I quite admit that the oppression and violence of the Middle Ages had its effect on the art of those days, its shortcomings are traceable to them; they repressed art in certain directions, I do not doubt that; and for that reason I say, that when we shake off the present oppression as we shook off the old, we may expect the art of the days of real freedom to rise above that of those old violent days. But I do say that it was possible then to have social, organic, hopeful progressive art; whereas now such poor scraps of it as are left are the result of individual and wasteful struggle, are retrospective and pessimistic. And this hopeful art was possible amidst all the oppression of those days, because the instruments of that oppression were grossly obvious, and were external to the work of the craftsman. They were laws and customs obviously intended to rob him, and open violence of the highway-robbery kind. In short, industrial production was not the instrument used for robbing the 'lower classes'; it is now the main instrument used in that honourable profession. The mediæval craftsman was free in his work, therefore he made it as amusing to himself as he could; and it was his pleasure and not his pain that made all things beautiful that were made, and lavished treasures of human hope

and thought on everything that man made, from a cathedral to a porridge-pot. Come, let us put it in the way least respectful to the mediæval craftsman, most polite to the modern 'hand': the poor devil of the fourteenth century, his work was of so little value that he was allowed to waste it by the hour in pleasing himself — and others; but our highly-strung mechanic, his minutes are too rich with the burden of perpetual profit for him to be allowed to waste one of them on art; the present system will not allow him — cannot allow him — to produce works of art.

So that there has arisen this strange phenomenon, that there is now a class of ladies and gentlemen, very refined indeed, though not perhaps as well informed as is generally supposed, and of this refined class there are many who do really love beauty and incident — *i.e.*, art, and would make sacrifices to get it; and these are led by artists of great manual skill and high intellect, forming altogether a large body of demand for the article. And yet the supply does not come. Yes, and moreover, this great body of enthusiastic demanders are no mere poor and helpless people, ignorant fisher-peasants, half-mad monks, scatter-brained sansculottes — none of those, in short, the expression of whose needs has shaken the world so often before, and will do yet again. No, they are of the ruling classes, the masters of men, who can live without labour, and have abundant leisure to scheme out the fulfilment of their desires; and yet I say they cannot have the art which they so much long for, though they hunt it about the world so hard, sentimentalizing the sordid lives of the miserable peasants of Italy and the starving proletarians of her towns, now that all the picturesqueness has departed from the poor devils of our own country-side, and of our own slums. Indeed, there is little of reality left them anywhere, and that little is fast fading away before the needs of the manufacturer and his ragged regiment of workers, and before the enthusiasm of the archaeological restorer of the dead past. Soon there will be nothing left except the lying dreams of history, the miserable wreckage of our museums and picture-galleries, and the carefully guarded interiors of our aesthetic drawing-rooms, unreal and foolish, fitting witnesses of the life of corruption that goes on there, so pinched and meagre and cowardly, with its concealment and ignoring, rather than restraint of, natural longings; which does not forbid the greedy indulgence in them if it can but be decently hidden.

The art then is gone, and can no more be 'restored' on its old lines than a mediæval building can be. The rich and refined cannot have it though they would, and though we will believe many of them would. And why? Because those who could give it to the rich are not allowed by the rich to do so. In one word, slavery lies between us and art.

I have said as much as that the aim of art was to destroy the curse of labour by making work the pleasurable satisfaction of our impulse towards energy, and giving to that energy hope of producing something worth its exercise.

Now, therefore, I say, that since we cannot have art by striving after its mere superficial manifestation, since we can have nothing but its sham by so doing, there yet remains for us to see how it would be if we let the shadow take care of itself and try, if we can, to lay hold of the substance. For my part I believe, that if we try to realize the aims of art without much troubling ourselves what the aspect of the art itself shall be, we shall find we shall have what we want at last: whether it is to be called art or not, it will at least be *life*; and, after all, that is what we want. It may lead us into new splendours and beauties of visible art; to architecture with manifolded magnificence free from the curious incompleteness and failings of that which the older times have produced—to painting, uniting to the beauty which mediæval art attained the realism which modern art aims at; to sculpture, uniting the beauty of the Greek and the expression of the Renaissance with some third quality yet undiscovered, so as to give us the images of men and women splendidly alive, yet not disqualified from making, as all true sculpture should, architectural ornament. All this it may do; or, on the other hand, it may lead us into the desert, and art may seem to be dead amidst us; or feebly and uncertainly to be struggling in a world which has utterly forgotten its old glories.

For my part, with art as it now is, I cannot bring myself to think that it much matters which of these dooms awaits it, so long as each bears with it some hope of what is to come; since here, as in other matters, there is no hope save in Revolution. The old art is no longer fertile, no longer yields us anything save elegantly poetical regrets; being barren, it has but to die, and the matter of moment now is, as to how it shall die, whether *with* hope or *without it.*

What is it, for instance, that has destroyed the Rouen, the Oxford of *my* elegant poetic regret? Has it perished for the benefit of the people, either slowly yielding to the growth of intelligent change and new happiness, or has it been, as it were, thunderstricken by the tragedy which mostly accompanies some great new birth? Not so. Neither phalangstere nor dynamite has swept its beauty away, its destroyers have not been either the philanthropist or the Socialist, the co-operator or the anarchist. It has been sold, and at a cheap price indeed: muddled away by the greed and incompetence of fools who do not know what life and pleasure mean, who will neither take them themselves nor let others have them. That is why the death of that beauty wounds us so: no man of sense or feeling would dare to regret such losses if they had been paid for by new life and happiness for the people. But there is the people still as it was before, still facing for its part the monster who destroyed all that beauty, and whose name is Commercial Profit.

I repeat, that every scrap of genuine art will fall by the same hands if the matter only goes on long enough, although a sham art may be left in its place, which may very well be carried on by *dilettanti* fine gentlemen and ladies without any help from below; and, to speak plainly, I fear that this gibbering ghost of the real thing would satisfy a great many of those who now think themselves lovers of art; though it is not difficult to see a long vista of its degradation till it shall become at last a mere laughing-stock; that is to say, if the thing were to go on: I mean, if art were to be for ever the amusement of those whom we now call ladies and gentlemen.

But for my part I do not think it will go on long enough to reach such depths as that; and yet I should be hypocritical if I were to say that I thought that the change in the basis of society, which would enfranchise labour and make men practically equal in condition, would lead us by a short road to the splendid new birth of art which I have mentioned, though I feel quite certain that it would not leave what we now call art untouched, since the aims of that revolution do include the aims of art — *viz.*, abolishing the curse of labour.

I suppose that this is what is likely to happen: that machinery will go on developing, with the purpose of saving men labour, till the mass of the people attain real leisure enough to be able to appreciate the pleasure of life; till, in fact, they have attained

such mastery over Nature that they no longer fear starvation as a penalty for not working more than enough. When they get to that point they will doubtless turn themselves and begin to find out what it is that they really want to do. They would soon find out that the less work they did (the less work unaccompanied by art, I mean), the more desirable a dwelling-place the earth would be; they would accordingly do less and less work, till the mood of energy, of which I began by speaking, urged them on afresh: but by that time Nature, relieved by the relaxation of man's work, would be recovering her ancient beauty and be teaching men the old story of art. And as the Artificial Famine, caused by men working for the profit of a master, and which we now look upon as a matter of course, would have long disappeared, they would be free to do as they chose, and they would set aside their machines in all cases where the work seemed pleasant or desirable for handiwork; till in all crafts where production of beauty was required, the most direct communication between a man's hand and his brain would be sought for. And there would be many occupations also, as the processes of agriculture, in which the voluntary exercise of energy would be thought so delightful, that people would not dream of handing over its pleasure to the jaws of a machine.

In short, men will find out that the men of our days were wrong in first multiplying their needs, and then trying, each man of them, to evade all participation in the means and processes whereby those needs are satisfied; that this kind of division of labour is really only a new and wilful form of arrogant and slothful ignorance, far more injurious to the happiness and contentment of life than the ignorance of the processes of Nature, of what we sometimes call *science,* which men of the earlier days unwittingly lived in.

They will discover, or rediscover rather, that the true secret of happiness *lies in the taking a genuine interest in all the details of daily life,* in elevating them by art instead of handing the performance of them over to unregarded drudges, and ignoring them; and that in cases where it was impossible either so to elevate them and make them interesting, or to lighten them by the use of machinery, so as to make the labour of them trifling, that should be taken as a token that the supposed advantages gained by them were not worth the trouble and had better be given up. All this to my mind would be the outcome of men throwing off

the burden of Artificial Famine, supposing, as I cannot help supposing, that the impulses which have from the first glimmerings of history urged men on to the practice of Art were still at work in them.

Thus and thus only *can* come about the new birth of Art, and I think it *will* come about thus. You may say it is a long process, and so it is; but I can conceive of a longer. I have given you the Socialist or Optimist view of the matter. Now for the Pessimist view.

I can conceive that the revolt against Artificial Famine or Capitalism, which is now on foot, may be vanquished. The result will be that the working class — the slaves of society — will become more and more degraded; that they will not strive against overwhelming force, but, stimulated by that love of life which Nature, always anxious about the perpetuation of the race, has implanted in us, will learn to bear everything — starvation, overwork, dirt, ignorance, brutality. All these things they will bear, as, alas! they bear them too well even now; all this rather than risk sweet life and bitter livelihood, and all sparks of hope and manliness will die out of them.

Nor will their masters be much better off: the earth's surface will be hideous everywhere, save in the uninhabitable desert; Art will utterly perish, as in the manual arts so in literature, which will become, as it is indeed speedily becoming, a mere string of orderly and calculated ineptitudes and passionless ingenuities; Science will grow more and more one-sided, more incomplete, more wordy and useless, till at last she will pile herself up into such a mass of superstition, that beside it the theologies of old time will seem mere reason and enlightenment. All will get lower and lower, till the heroic struggles of the past to realize hope from year to year, from century to century, will be utterly forgotten, and man will be an indescribable being — hopeless, desireless, lifeless.

And will there be deliverance from this even? Maybe: man may, after some terrible cataclysm, learn to strive towards a healthy animalism, may grow from a tolerable animal into a savage, from a savage into a barbarian, and so on; and some thousands of years hence he may be beginning once more those arts which we have now lost, and be carving interlacements like the New Zealanders, or scratching forms of animals on their cleaned blade-bones, like the pre-historic men of the drift.

But in any case, according to the Pessimist view, which looks upon revolt against Artificial Famine as impossible to succeed, we shall wearily trudge the circle again, until some accident, some unforeseen consequence of arrangement, makes an end of us altogether.

That pessimism I do not believe in, nor, on the other hand, do I suppose that it is altogether a matter of our wills as to whether we shall further human progress or human degradation; yet, since there are those who are impelled towards the Socialist or Optimistic side of things, I must conclude that there is some hope of its prevailing, that the strenuous efforts of many individuals imply a force which is thrusting them on. So that I believe that the 'Aims of Art' will be realized, though I know that they cannot be, so long as we groan under the tyranny of Artificial Famine. Once again I warn you against supposing, you who may specially love art, that you will do any good by attempting to revivify art by dealing with its dead exterior. I say it is the *aims of art* that you must seek rather than the *art itself;* and in that search we may find ourselves in a world blank and bare, as the result of our caring at least this much for art, that we will not endure the shams of it.

Anyhow, I ask you to think with me that the worst which can happen to us is to endure tamely the evils that we see; that no trouble or turmoil is so bad as that; that the necessary destruction which reconstruction bears with it must be taken calmly; that everywhere — in State, in Church, in the household — we must be resolute to endure no tyranny, accept no lie, quail before no fear, although they may come before us disguised as piety, duty, or affection, as useful opportunity and good-nature, as prudence or kindness. The world's roughness, falseness, and injustice will bring about their natural consequences, and we and our lives are part of those consequences; but since we inherit also the consequences of old resistance to those curses, let us each look to it to have our fair share of that inheritance also, which, if nothing else come of it, will at least bring to us courage and hope; that is, eager life while we live, which is above all things the Aim of Art.

# *The Revival of Handicraft*

FOR some time past there has been a good deal of interest shown in what is called in our modern slang Art Workmanship, and quite recently there has been a growing feeling that this art workmanship to be of any value must have some of the workman's individuality imparted to it beside whatever of art it may have got from the design of the artist who has planned, but not executed the work. This feeling has gone so far that there is growing up a fashion for demanding handmade goods even when they are not ornamented in any way, as, for instance, woollen and linen cloth spun by hand and woven without power, hand-knitted hosiery, and the like. Nay, it is not uncommon to hear regrets for the hand-labour in the fields, now fast disappearing from even backward districts of civilized countries. The scythe, sickle, and even the flail are lamented over, and many are looking forward with drooping spirits to the time when the hand-plough will be as completely extinct as the quern, and the rattle of the steam-engine will take the place of the whistle of the curly-headed ploughboy through all the length and breadth of the land. People interested, or who suppose that they are interested, in the details of the arts of life feel a desire to revert to methods of handicraft for production in general; and it may therefore be worth considering how far this is a mere reactionary sentiment incapable of realization, and how far it may foreshadow a real coming change in our habits of life as irresistible as the former change which has produced the system of machine-production, the system against which revolt is now attempted.

In this paper I propose to confine the aforesaid consideration as much as I can to the effect of machinery *versus* handicraft upon the arts; using that latter word as widely as possible, so as to include all products of labour which have any claims to be considered beautiful. I say as far as possible: for as all roads lead

to Rome, so the life, habits, and aspirations of all groups and classes of the community are founded on the economical conditions under which the mass of the people live, and it is impossible to exclude socio-political questions from the consideration of aesthetics. Also, although I must avow myself a sharer in the above-mentioned reactionary regrets, I must at the outset disclaim the mere aesthetic point of view which looks upon the ploughman and his bullocks and his plough, the reaper, his work, his wife, and his dinner, as so many elements which compose a pretty tapestry hanging, fit to adorn the study of a contemplative person of cultivation, but which it is not worth while differentiating from each other except in so far as they are related to the beauty and interest of the picture. On the contrary, what I wish for is that the reaper and his wife should have themselves a due share in all the fulness of life; and I can, without any great effort, perceive the justice of their forcing me to bear part of the burden of its deficiencies, so that we may together be forced to attempt to remedy them, and have no very heavy burden to carry between us.

To return to our aesthetics: though a certain part of the cultivated classes of to-day regret the disappearance of handicraft from production, they are quite vague as to how and why it is disappearing, and as to how and why it should or may reappear. For to begin with the general public is grossly ignorant of all the methods and processes of manufacture. This is of course one result of the machine-system we are considering. Almost all goods are made apart from the life of those who use them; we are not responsible for them, our will has had no part in their production, except so far as we form a part of the market on which they can be forced for the profit of the capitalist whose money is employed in producing them. The market assumes that certain wares are wanted; it produces such wares, indeed, but their kind and quality are only adapted to the needs of the public in a very rough fashion, because the public needs are subordinated to the interest of the capitalist masters of the market, and they can force the public to put up with the less desirable article if they choose, as they generally do. The result is that in this direction our boasted individuality is a sham; and persons who wish for anything that deviates ever so little from the beaten path have either to wear away their lives in a wearisome and mostly futile contest with a stupendous organization which disregards

their wishes, or to allow those wishes to be crushed out for the sake of a quiet life.

Let us take a few trivial but undeniable examples. You want a hat, say, like that you wore last year; you go to the hatter's, and find you cannot get it there, and you have no resource but in submission. Money by itself won't buy you the hat you want; it will cost you three months' hard labour and twenty pounds to have an inch added to the brim of your wideawake; for you will have to get hold of a small capitalist (of whom but few are left), and by a series of intrigues and resolute actions which would make material for a three-volume novel, get him to allow you to turn one of his hands into a handicraftsman for the occasion; and a very poor handicraftsman he will be, when all is said. Again, I carry a walking-stick, and like all sensible persons like it to have a good heavy end that will swing out well before me. A year or two ago it became the fashion to pare away all walking-sticks to the shape of attenuated carrots, and I really believe I shortened my life in my attempts at getting a reasonable staff of the kind I was used to, so difficult it was. Again, you want a piece of furniture, which the trade (mark the word, Trade, not Craft!) turns out blotched over with idiotic sham ornament; you wish to dispense with this degradation, and propose it to your upholsterer, who grudgingly assents to it; and you find that you have to pay the price of two pieces of furniture for the privilege of indulging your whim of leaving out the trade finish (I decline to call it ornament) on the one you have got made for you. And this is because it has been made by handicraft instead of machinery. For most people, therefore, there is a prohibitive price put upon the acquirement of the knowledge of methods and processes. We do not know how a piece of goods is made, what the difficulties are that beset its manufacture, what it ought to look like, feel like, smell like, or what it ought to cost apart from the profit of the middleman. We have lost the art of marketing, and with it the due sympathy with the life of the workshop, which would, if it existed, be such a wholesome check on the humbug of party politics.

It is a natural consequence of this ignorance of the methods of making wares, that even those who are in revolt against the tyranny of the excess of division of labour in the occupations of life, and who wish to recur more or less to handicraft, should also be ignorant of what that life of handicraft was when all

wares were made by handicraft. If their revolt is to carry any hope with it, it is necessary that they should know something of this. I must assume that many or perhaps most of my readers are not acquainted with Socialist literature, and that few of them have read the admirable account of the different epochs of production given in Karl Marx' great work entitled 'Capital'. I must ask to be excused, therefore, for stating very briefly what, chiefly owing to Marx, has become a commonplace of Socialism, but is not generally known outside it. There have been three great epochs of production since the beginning of the Middle Ages. During the first or mediæval period all production was individualistic in method; for though the workmen were combined into great associations for protection and the organization of labour, they were so associated as citizens, not as mere workmen. There was little or no division of labour, and what machinery was used was simply of the nature of a multiplied tool, a help to the workman's hand-labour and not a supplanter of it. The workman worked for himself and not for any capitalistic employer, and he was accordingly master of his work and his time; this was the period of pure handicraft. When in the latter half of the sixteenth century the capitalist employer and the so-called free workman began to appear, the workmen were collected into workshops, the old tool-machines were improved, and at last a new invention, the division of labour, found its way into the workshops. The division of labour went on growing throughout the seventeenth century, and was perfected in the eighteenth, when the unit of labour became a group and not a single man; or in other words the workman became a mere part of a machine composed sometimes wholly of human beings and sometimes of human beings plus labour-saving machines, which towards the end of this period were being copiously invented; the fly-shuttle may be taken for an example of these. The latter half of the eighteenth century saw the beginning of the last epoch of production that the world has known, that of the automatic machine which supersedes hand-labour, and turns the workman who was once a handicraftsman helped by tools, and next a part of a machine, into a tender of machines. And as far as we can see, the revolution in this direction as to kind is complete, though as to degree, as pointed out by Mr. David A. Wells last year (1887), the tendency is towards the displacement of ever more and more 'muscular' labour, as Mr. Wells calls it.

This is very briefly the history of the evolution of industry during the last five hundred years; and the question now comes: Are we justified in wishing that handicraft may in its turn supplant machinery? Or it would perhaps be better to put the question in another way: Will the period of machinery evolve itself into a fresh period of machinery more independent of human labour than anything we can conceive of now, or will it develop its contradictory in the shape of a new and improved period of production by handicraft? The second form of the question is the preferable one, because it helps us to give a reasonable answer to what people who have any interest in external beauty will certainly ask: Is the change from handicraft to machinery good or bad? And the answer to that question is to my mind that, as my friend Belfort Bax has put it, statically it is bad, dynamically it is good. As a condition of life, production by machinery is altogether an evil; as an instrument for forcing on us better conditions of life it has been, and for some time yet will be, indispensable.

Having thus tried to clear myself of mere reactionary pessimism, let me attempt to show why statically handicraft is to my mind desirable, and its destruction a degradation of life. Well, first I shall not shrink from saying bluntly that production by machinery necessarily results in utilitarian ugliness in everything which the labour of man deals with, and that this is a serious evil and a degradation of human life. So clearly is this the fact that though few people will venture to deny the latter part of the proposition, yet in their hearts the greater part of cultivated civilized persons do not regard it as an evil, because their degradation has already gone so far that they cannot, in what concerns the sense of seeing, discriminate between beauty and ugliness: their languid assent to the desirableness of beauty is with them only a convention, a superstitious survival from the times when beauty was a necessity to all men. The first part of the proposition (that machine-industry produces ugliness) I cannot argue with these persons, because they neither know, nor care for, the difference between beauty and ugliness; and with those who do understand what beauty means I need not argue it, as they are but too familiar with the fact that the produce of all modern industrialism is ugly, and that whenever anything which is old disappears, its place is taken by something inferior to it in beauty; and that even out in the very fields and open country. The art of

making beautifully all kinds of ordinary things, carts, gates, fences, boats, bowls, and so forth, let alone houses and public buildings, unconsciously and without effort, has gone; when anything has to be renewed among these simple things the only question asked is how little it can be done for, so as to tide us over our responsibility and shift its mending on to the next generation.

It may be said, and indeed I have heard it said, that since there is some beauty still left in the world and some people who admire it, there is a certain gain in the acknowledged eclecticism of the present day, since the ugliness which is so common affords a contrast whereby the beauty, which is so rare, may be appreciated. This I suspect to be only another form of the maxim which is the sheet-anchor of the laziest and most cowardly group of our cultivated classes, that it is good for the many to suffer for the few; but if any one puts forward in good faith the fear that we may be too happy in the possession of pleasant surroundings, so that we shall not be able to enjoy them, I must answer that this seems to me a very remote terror. Even when the tide at last turns in the direction of sweeping away modern squalor and vulgarity, we shall have, I doubt, many generations of effort in perfecting the transformation, and when it is at last complete, there will be first the triumph of our success to exalt us, and next the history of the long wade through the putrid sea of ugliness which we shall have at last escaped from. But furthermore, the proper answer to this objection lies deeper than this. It is to my mind that very consciousness of the production of beauty for beauty's sake which we want to avoid; it is just what is apt to produce affectation and effeminacy amongst the artists and their following. In the great times of art conscious effort was used to produce great works for the glory of the City, the triumph of the Church, the exaltation of the citizens, the quickening of the devotion of the faithful; even in the higher art, the record of history, the instruction of men alive and to live hereafter, was the aim rather than beauty; and the lesser art was unconscious and spontaneous, and did not in any way interfere with the rougher business of life, while it enabled men in general to understand and sympathize with the nobler forms of art. But unconscious as these producers of ordinary beauty may be, they will not and cannot fail to receive pleasure from the exercise of their work under these conditions, and this above all things is that which influences me

most in my hope for the recovery of handicraft. I have said it often enough, but I must say it once again, since it is so much a part of my case for handicraft, that so long as man allows his daily work to be mere unrelieved drudgery he will seek happiness in vain. I say further that the worst tyrants of the days of violence were but feeble tormentors compared with those Captains of Industry who have taken the pleasure of work away from the workmen. Furthermore I feel absolutely certain that handicraft joined to certain other conditions, of which more presently, would produce the beauty and the pleasure in work above mentioned; and if that be so, and this double pleasure of lovely surroundings and happy work could take the place of the double torment of squalid surroundings and wretched drudgery, have we not good reason for wishing, if it might be, that handicraft should once more step into the place of machine-production?

I am not blind to the tremendous change which this revolution would mean. The maxim of modern civilization to a well-to-do man is, Avoid taking trouble! Get as many of the functions of your life as you can performed by others for you! Vicarious life is the watchword of our civilization, and we well-to-do and cultivated people live smoothly enough while it lasts. But, in the first place, how about the vicars, who do more for us than the singing of mass for our behoof for a scanty stipend? Will they go on with it for ever? For indeed the shuffling off of responsibilities from one to the other has to stop at last, and somebody has to bear the burden in the end. But let that pass, since I am not writing politics, and let us consider another aspect of the matter. What wretched lop-sided creatures we are being made by the excess of the division of labour in the occupations of life! What on earth are we going to do with our time when we have brought the art of vicarious life to perfection, having first complicated the question by the ceaseless creation of artificial wants which we refuse to supply for ourselves? Are all of us (we of the great middle class I mean) going to turn philosophers, poets, essayists—men of genius, in a word, when we have come to look down on the ordinary functions of life with the same kind of contempt wherewith persons of good breeding look down upon a good dinner, eating it sedulously however? I shudder when I think of how we shall bore each other when we have reached that perfection. Nay, I think we have already got in all branches of culture rather more geniuses than we can comfortably bear, and

that we lack, so to say, audiences rather than preachers. I must ask pardon of my readers; but our case is at once so grievous and so absurd that one can scarcely help laughing out of bitterness of soul. In the very midst of our pessimism we are boastful of our wisdom, yet we are helpless in the face of the necessities we have created, and which, in spite of our anxiety about art, are at present driving us into luxury unredeemed by beauty on the one hand, and squalor unrelieved by incident or romance on the other, and will one day drive us into mere ruin.

Yes, we do sorely need a system of production which will give us beautiful surroundings and pleasant occupation, and which will tend to make us good human animals, able to do something for ourselves, so that we may be generally intelligent instead of dividing ourselves into dull drudges or duller pleasure-seekers according to our class, on the one hand, or hapless pessimistic intellectual personages, and pretenders to that dignity, on the other. We do most certainly need happiness in our daily work, content in our daily rest; and all this cannot be if we hand over the whole responsibility of the details of our daily life to machines and their drivers. We are right to long for intelligent handicraft to come back to the world which it once made tolerable amidst war and turmoil and uncertainty of life, and which it should, one would think, make happy now we have grown so peaceful, so considerate of each other's temporal welfare.

Then comes the question, How can the change be made? And here at once we are met by the difficulty that the sickness and death of handicraft is, it seems, a natural expression of the tendency of the age. We willed the end, and therefore the means also. Since the last days of the Middle Ages the creation of an intellectual aristocracy has been, so to say, the spiritual purpose of civilization side by side with its material purpose of supplanting the aristocracy of status by the aristocracy of wealth. Part of the price it has had to pay for its success in that purpose (and some would say it is comparatively an insignificant part) is that this new aristocracy of intellect has been compelled to forgo the lively interest in the beauty and romance of life, which was once the portion of every artificer at least, if not of every workman, and to live surrounded by an ugly vulgarity which the world amidst all its changes has not known till modern times. It is not strange that until recently it has not been conscious of this degradation; but it may seem strange to many that it has now grown

partially conscious of it. It is common now to hear people say of such and such a piece of country or suburb: 'Ah! it was so beautiful a year or so ago, but it has been quite spoilt by the building'. Forty years back the building would have been looked on as a vast improvement; now we have grown conscious of the hideousness we are creating, and we go on creating it. We see the price we have paid for our aristocracy of intellect, and even that aristocracy itself is more than half regretful of the bargain and would be glad if it could keep the gain and not pay the full price for it. Hence not only the empty grumbling about the continuous march of machinery over dying handicraft, but also various elegant little schemes for trying to withdraw ourselves, some of us, from the consequences (in this direction) of our being superior persons; none of which can have more than a temporary and very limited success. The great wave of commercial necessity will sweep away all these well meant attempts to stem it, and think little of what it has done, or whither it is going.

Yet after all even these feeble manifestations of discontent with the tyranny of commerce are tokens of a revolutionary epoch, and to me it is inconceivable that machine-production will develop into mere infinity of machinery, or life wholly lapse into a disregard of life as it passes. It is true indeed that powerful as the cultivated middle class is, it has not the power of re-creating the beauty and romance of life; but that will be the work of the new society which the blind progress of commercialism will create, nay, is creating. The cultivated middle class is a class of slave-holders, and its power of living according to its choice is limited by the necessity of finding constant livelihood and employment for the slaves who keep it alive. It is only a society of equals which can choose the life it will live, which can choose to forgo gross luxury and base utilitarianism in return for the unwearying pleasure of tasting the fulness of life. It is my firm belief that we shall in the end realize this society of equals, and also that when it is realized it will not endure a vicarious life by means of machinery; that it will in short be the master of its machinery and not the servant, as our age is.

Meantime, since we shall have to go through a long series of social and political events before we shall be free to choose how we shall live, we should welcome even the feeble protest which is now being made against the vulgarization of all life: first because it is one token amongst others of the sickness of modern

civilization; and next, because it may help to keep alive memories of the past which are necessary elements of the life of the future, and methods of work which no society could afford to lose. In short, it may be said that though the movement towards the revival of handicraft is contemptible on the surface in face of the gigantic fabric of commercialism; yet, taken in conjunction with the general movement towards freedom of life for all, on which we are now surely embarked, as a protest against intellectual tyranny, and a token of the change which is transforming civilization into socialism, it is both noteworthy and encouraging.

# ✒ *Eight* ✒

# *Gothic Architecture*

BY the word Architecture is, I suppose, commonly understood the art of ornamental building, and in this sense I shall often have to use it here. Yet I would not like you to think of its productions merely as well constructed and well proportioned buildings, each one of which is handed over by the architect to other artists to finish, after his designs have been carried out (as we say) by a number of mechanical workers, who are not artists. A true architectural work rather is a building duly provided with all necessary furniture, decorated with all due ornament, according to the use, quality, and dignity of the building, from mere mouldings or abstract lines, to the great epical works of sculpture and painting, which, except as decorations of the nobler form of such buildings, cannot be produced at all. So looked on, a work of architecture is a harmonious co-operative work of art, inclusive of all the serious arts, all those which are not engaged in the production of mere toys, or of ephemeral prettinesses.

Now these works of art are man's expression of the value of life, and also the production of them makes his life of value: and since they can only be produced by the general good-will and help of the public, their continuous production, or the existence of the true Art of Architecture, betokens a society which, whatever elements of change it may bear within it, may be called stable, since it is founded on the happy exercise of the energies of the most useful part of its population.

What the absence of this Art of Architecture may betoken in the long run it is not easy for us to say: because that lack belongs only to these later times of the world's history, which as yet we cannot fairly see, because they are too near to us; but clearly in the present it indicates a transference of the interest of civilized men from the development of the human and intellectual ener-

gies of the race to the development of its mechanical energies. If
this tendency is to go along the logical road of development, it
must be said that it will destroy the arts of design and all that is
analogous to them in literature; but the logical outcome of obvi-
ous tendencies is often thwarted by the historical development;
that is, by what I can call by no better name than the collective
will of mankind; and unless my hopes deceive me, I should say
that this process has already begun, that there is a revolt on foot
against the utilitarianism which threatens to destroy the Arts; and
that it is deeper rooted than a mere passing fashion. For myself
I do not indeed believe that this revolt can effect much, so long
as the present state of society lasts; but as I am sure that great
changes which will bring about a new state of society are rapidly
advancing upon us, I think it a matter of much importance that
these two revolts should join hands, or at least should learn to
understand one another. If the New society when it comes (itself
the result of the ceaseless evolution of countless years of tradi-
tion) should find the world cut off from all tradition of art, all
aspiration towards the beauty which man has proved that he can
create, much time will be lost in running hither and thither after
the new thread of art; many lives will be barren of a manly pleas-
ure which the world can ill afford to lose even for a short time.
I ask you, therefore, to accept what follows as a contribution
toward the revolt against utilitarianism, toward the attempt at
catching-up the slender thread of tradition before it be too late.

Now, that Harmonious Architectural unit, inclusive of the arts
in general, is no mere dream. I have said that it is only in these
later times that it has become extinct: until the rise of modern
society, no Civilization, no Barbarism has been without it in
some form; but it reached its fullest development in the Middle
Ages, an epoch really more remote from our modern habits of
life and thought than the older civilizations were, though an im-
portant part of its life was carried on in our own country by men
of our own blood. Nevertheless, remote as those times are from
ours, if we are ever to have architecture at all, we must take up
the thread of tradition there and nowhere else, because that
Gothic Architecture is the most completely organic form of the
Art which the world has seen; the break in the thread of tradition
could only occur there: all the former developments tended thith-
erward, and to ignore this fact and attempt to catch up the thread
before that point was reached, would be a mere piece of artifici-

ality, betokening, not new birth, but a corruption into mere whim of the ancient traditions.

In order to illustrate this position of mine, I must ask you to allow me to run very briefly over the historical sequence of events which led to Gothic Architecture and its fall, and to pardon me for stating familiar and elementary facts which are necessary for my purpose. I must admit also that in doing this I must mostly take my illustrations from works that appear on the face of them to belong to the category of ornamental building, rather than that of those complete and inclusive works of which I have spoken. But this incompleteness is only on the surface; to those who study them they appear as belonging to the class of complete architectural works; they are lacking in completeness only through the consequences of the lapse of time and the folly of men, who did not know what they were, who, pretending to use them, marred their real use as works of art; or in a similar spirit abused them by making them serve their turn as instruments to express their passing passion and spite of the hour.

We may divide the history of the Art of Architecture into two periods, the Ancient and the Mediæval: the Ancient again may be divided into two styles, the barbarian (in the Greek sense) and the classical. We have, then, three great styles to consider — the Barbarian, the Classical, and the Mediæval. The two former, however, were partly synchronous, and at least overlapped somewhat. When the curtain of the stage of definite history first draws up, we find the small exclusive circle of the highest civilization, which was dominated by Hellenic thought and science, fitted with a very distinctive and orderly architectural style. That style appears to us to be, within its limits, one of extreme refinement, and perhaps seemed so to those who originally practised it. Moreover, it is ornamented with figure-sculpture far advanced towards perfection even at an early period of its existence, and swiftly growing in technical excellence; yet for all that, it is, after all, a part of the general style of architecture of the Barbarian world, and only outgoes it in the excellence of its figure-sculpture and its refinement. The bones of it, its merely architectural part, are little changed from the Barbarian or primal building, which is a mere piling or jointing together of material, giving one no sense of growth in the building itself and no sense of the possibility of growth in the style.

The one Greek form of building with which we are really familiar, the columnar temple, though always built with blocks of stone, is clearly a deduction from the wooden god's-house or shrine, which was a necessary part of the equipment of the not very remote ancestors of the Periclean Greeks; nor had this god's-house changed so much as the city had changed from the Tribe, or the Worship of the City (the true religion of the Greeks) from the Worship of the Ancestors of the Tribe. In fact, rigid conservatism of form is an essential part of Greek architecture as we know it. From this conservatism of form there resulted a jostling between the building and its higher ornament. In early days, indeed, when some healthy barbarism yet clung to the sculpture, the discrepancy is not felt; but as increasing civilization demands from the sculptors more naturalism and less restraint, it becomes more and more obvious, and more and more painful; till at last it becomes clear that sculpture has ceased to be a part of architecture and has become an extraneous art bound to the building by habit or superstition. The form of the ornamental building of the Greeks, then, was very limited, had no capacity in it for development, and tended to divorce from its higher or epical ornament. What is to be said about the spirit of it which ruled that form? This I think; that the narrow superstition of the form of the Greek temple was not a matter of accident, but was the due expression of the exclusiveness and aristocratic arrogance of the ancient Greek mind, a natural result of which was a demand for pedantic perfection in all the parts and details of a building; so that the inferior parts of the ornament are so slavishly subordinated to the superior, that no invention or individuality is possible in them, whence comes a kind of bareness and blankness, a rejection in short of all romance, which does not indeed destroy their interest as relics of past history, but which puts the style of them aside as any possible foundation for the style of the future architecture of the world. It must be remembered also that this attempt at absolute perfection soon proved a snare to Greek architecture; for it could not be kept up long. It was easy indeed to ensure the perfect execution of a fret or a dentil; not so easy to ensure the perfection of the higher ornament: so that as Greek energy began to fall back from its high-water mark, the demand for absolute perfection became rather a demand for absolute plausibility, which speedily dragged the architectural arts into mere Academicism.

But long before classical art reached the last depths of that degradation, it had brought to birth another style of architecture, the Roman style, which to start with was differentiated from the Greek by having the habitual use of the arch forced upon it. To my mind, organic Architecture, Architecture which must necessarily grow, dates from the habitual use of the arch, which, taking into consideration its combined utility and beauty, must be pronounced to be the greatest invention of the human race. Until the time when man not only had invented the arch, but had gathered boldness to use it habitually, architecture was necessarily so limited, that strong growth was impossible to it. It was quite natural that a people should crystallize the first convenient form of building they might happen upon, or, like the Greeks, accept a traditional form without aspiration towards anything more complex or interesting. Till the arch came into use, building men were the slaves of conditions of climate, materials, kind of labour available, and so forth. But once furnished with the arch, man has conquered Nature in the matter of building; he can defy the rigours of all climates under which men can live with fair comfort: splendid materials are not necessary to him; he can attain a good result from shabby and scrappy materials. When he wants size and span he does not need a horde of war-captured slaves to work for him; the free citizens (if there be any such) can do all that is needed without grinding their lives out before their time. The arch can do all that architecture needs, and in turn from the time when the arch comes into habitual use, the main artistic business of architecture is the decoration of the arch; the only satisfactory style is that which never disguises its office, but adorns and glorifies it. This the Roman architecture, the first style that used the arch, did not do. It used the arch frankly and simply indeed, in one part of its work, but did not adorn it; this part of the Roman building must, however, be called engineering rather than architecture, though its massive and simple dignity is a wonderful contrast to the horrible and restless nightmare of modern engineering. In the other side of its work, the ornamental side, Roman building used the arch and adorned it, but disguised its office, and pretended that the structure of its buildings was still that of the lintel, and that the arch bore no weight worth speaking of. For the Romans had no ornamental building of their own (perhaps we should say no art of their own) and therefore fitted their ideas of the ideas of the Greek sculpture-architect on

to their own massive building; and as the Greek plastered his
energetic and capable civilized sculpture on to the magnified
shrine of his forefathers, so the Roman plastered sculpture,
shrine, and all, on to his magnificent engineer's work. In fact,
this kind of front-building or veneering was the main resource of
Roman ornament; the construction and ornament did not inter-
penetrate; and to us at this date its seems doubtful if he gained
by hiding with marble veneer the solid and beautiful construction
of his wall of brick or concrete; since others have used marble
far better than he did, but none have built a wall or turned an
arch better. As to the Roman ornament, it is not in itself worth
much sacrifice of interest in the construction: the Greek orna-
ment was cruelly limited and conventional; but everything about
it was in its place, and there was a reason for everything, even
though that reason were founded on superstition. But the Roman
ornament has no more freedom than the Greek, while it has lost
the logic of the latter: it is rich and handsome, and that is all the
reason it can give for its existence; nor does its execution and its
design interpenetrate. One cannot conceive of the Greek orna-
ment existing apart from the precision of its execution; but well
as the Roman ornament is executed in all important works, one
almost wishes it were less well executed, so that some mystery
might be added to its florid handsomeness. Once again, it is a
piece of necessary history, and to criticize it from the point of
view of work of to-day would be like finding fault with a geo-
logical epoch: and who can help feeling touched by its remnants
which show crumbling and battered amidst the incongruous mass
of modern houses, amidst the disorder, vulgarity and squalor of
some modern town? If I have ventured to call your attention to
what it was as architecture, it is because of the abuse of it which
took place in later times and has even lasted into our own anti-
architectural days; and because it is necessary to point out that it
has not got the qualities essential to making it a foundation for
any possible new-birth of the arts. In its own time it was for
centuries the only thing that redeemed the academical period of
classical art from mere nothingness, and though it may almost be
said to have perished before the change came, yet in perishing it
gave some token of the coming change, which indeed was as
slow as the decay of imperial Rome herself. It was in the height
of the taxgathering period of the Roman Peace, in the last days
of Diocletian (died 313) in the palace of Spalato which he built

himself to rest in after he was satiated with rule, that the rebel, Change, first showed in Roman art, and that the builders admitted that their false lintel was false, and that the arch could do without it.

This was the first obscure beginning of Gothic or organic Architecture; henceforth till the beginning of the modern epoch all is growth, uninterrupted, however slow. Indeed, it is slow enough at first: Organic Architecture took two centuries to free itself from the fetters which the Academical ages had cast over it, and the Peace of Rome had vanished before it was free. But the full change came at last, and the architecture was born which logically should have supplanted the primitive lintel-architecture, of which the civilized style of Greece was the last development. Architecture was become organic; henceforth no academical period was possible to it, nothing but death could stop its growth.

The first expression of this freedom is called Byzantine Art, and there is nothing to object to in the name. For centuries Byzantium was the centre of it, and its first great work in that city (the Church of the Holy Wisdom, built by Justinian in the year 540) remains its greatest work. The style leaps into sudden completeness in this most lovely building: for there are few works extant of much importance of earlier days. As to its origin, of course buildings were raised all through the sickness of classical art, and traditional forms and ways of work were still in use, and these traditions, which by this time included the forms of Roman building, were now in the hands of the Greeks. This Romano-Greek building in Greek hands met with traditions drawn from many sources. In Syria, the borderland of so many races and customs, the East mingled with the West, and Byzantine art was born. Its characteristics are simplicity of structure and outline of mass; amazing delicacy of ornament combined with abhorrence of vagueness: it is bright and clear in colour, pure in line, hating barrenness as much as vagueness; redundant, but not florid, the very opposite of Roman architecture in spirit, though it took so many of its forms and revivified them. Nothing more beautiful than its best works has ever been produced by man, but in spite of its stately loveliness and quietude, it was the mother of fierce vigour in the days to come, for from its first days in St. Sophia, Gothic architecture has still one thousand years of life before it. East and West it overran the world wherever men built with his-

tory behind them. In the East it mingled with the traditions of the
native populations, especially with Persia of the Sassanian pe-
riod, and produced the whole body of what we, very erroneously,
call Arab Art (for the Arabs never had any art) from Isphahan to
Granada. In the West it settled itself in the parts of Italy that
Justinian had conquered, notably Ravenna, and thence came to
Venice. From Italy, or perhaps even from Byzantium itself, it
was carried into Germany and pre-Norman England, touching
even Ireland and Scandinavia. Rome adopted it, and sent it an-
other road through the south of France, where it fell under the
influence of provincial Roman architecture, and produced a very
strong orderly and logical substyle, just what one imagines the
ancient Romans might have built, if they had been able to resist
the conquered Greeks who took them captive. Thence it spread
all over France, the first development of the architecture of the
most architectural of peoples, and in the north of that country fell
under the influence of the Scandinavian and Teutonic tribes, and
produced the last of the round-arched Gothic styles, (named by
us Norman) which those energetic warriors carried into Sicily,
where it mingled with the Saracenic Byzantine and produced
lovely works. But we know it best in our own country; for Duke
William's intrusive monks used it everywhere, and it drove out
the native English style derived from Byzantium through Ger-
many.

Here on the verge of a new change, a change of form impor-
tant enough (though not a change of essence), we may pause to
consider once more what its essential qualities were. It was the
first style since the invention of the arch that did due honour to
it, and instead of concealing it decorated it in a logical manner.
This was much; but the complete freedom that it had won, which
indeed was the source of its ingenuousness, was more. It had
shaken off the fetters of Greek superstition and aristocracy, and
Roman pedantry, and though it must needs have had laws to
be a style at all, it followed them of free will, and yet uncon-
sciously. The cant of the beauty of simplicity (i.e., bareness and
barrenness) did not afflict it; it was not ashamed of redundancy
of material, or super-abundance of ornament, any more than na-
ture is. Slim elegance it could produce, or sturdy solidity, as its
moods went. Material was not its master, but its servant: marble
was not necessary to its beauty; stone would do, or brick, or
timber. In default of carving it would set together cubes of glass

or whatsoever was shining and fair-hued, and cover every por-
tion of its interiors with a fairy coat of splendour; or would
mould mere plaster into intricacy of work scarce to be followed,
but never wearying the eyes with its delicacy and expressiveness
of line. Smoothness it loves, the utmost finish that the hand can
give; but if material or skill fail, the rougher work shall so be
wrought that it also shall please us with its inventive suggestion.
For the iron rule of the classical period, the acknowledged slav-
ery of every one but the great man, was gone, and freedom had
taken its place: but harmonious freedom. Subordination there is,
but subordination of effect, not uniformity of detail; true and
necessary subordination, not pedantic.

The full measure of this freedom Gothic Architecture did not
gain until it was in the hands of the workmen of Europe, the
gildsmen of the Free Cities, who on many a bloody field proved
how dearly they valued their corporate life by the generous val-
our with which they risked their individual lives in its defence.
But from the first, the tendency was towards this freedom of
hand and mind subordinated to the co-operative harmony which
made the freedom possible. That is the spirit of Gothic Architec-
ture.

Let us go on a while with our history: up to this point the
progress had always been from East to West, i.e., the East car-
ried the West with it; the West must now go to the East to fetch
new gain thence. A revival of religion was one of the moving
causes of energy in the early Middle Ages in Europe, and this
religion (with its enthusiasm for visible tokens of the objects of
worship) impelled people to visit the East, which held the centre
of that worship. Thence arose the warlike pilgrimages of the cru-
sades amongst races by no means prepared to turn their cheeks
to the smiter. True it is that the tendency of the extreme West to
seek East did not begin with the days just before the crusades.
There was a thin stream of pilgrims setting eastward long before,
and the Scandinavians had found their way to Byzantium, not as
pilgrims but as soldiers, and under the name of Voerings a body-
guard of their blood upheld the throne of the Greek Kaiser, and
many of them, returning home, bore with them ideas of art which
were not lost on their scanty but energetic populations. But the
crusades brought gain from the East in a far more wholesale
manner; and I think it is clear that part of that gain was the idea
of art that brought about the change from round-arched to

pointed Gothic. In those days (perhaps in ours also) it was the rule for conquerors settling in any country to assume that there could be no other system of society save that into which they had been born; and accordingly conquered Syria received a due feudal government, with the King of Jerusalem for Suzerain, the one person allowed by the heralds to bear metal on metal in his coat-armour. Nevertheless, the Westerners who settled in this new realm, few in number as they were, readily received impressions from the art which they saw around them, the Saracenic Byzantine Art, which was, after all, sympathetic with their own minds: and these impressions produced the change. For it is not to be thought that there was any direct borrowing of forms from the East in the gradual change from the round-arched to the pointed Gothic: there was nothing more obvious at work than the influence of a kindred style, whose superior lightness and elegance gave a hint of the road which development might take.

Certainly this change in form, when it came, was a startling one: the pointed-arched Gothic, when it had grown out of its brief and most beautiful transition, was a vigorous youth indeed. It carried combined strength and elegance almost as far as it could be carried: indeed, sometimes one might think it overdid the lightness of effect, as e.g., in the interior of Salisbury Cathedral. If some abbot or monk of the eleventh century could have been brought back to his rebuilt church of the thirteenth, he might almost have thought that some miracle had taken place: the huge cylindrical or square piers transformed into clusters of slim, elegant shafts; the narrow round-headed windows supplanted by tall wide lancets showing the germs of the elaborate traceries of the next century, and elegantly glazed with pattern and subject; the bold vault spanning the wide nave instead of the flat wooden ceiling of past days; the extreme richness of the mouldings with which every member is treated; the elegance and order of the floral sculpture, the grace and good drawing of the imagery: in short, a complete and logical style with no longer anything to apologize for, claiming homage from the intellect, as well as the imagination of men; the developed Gothic Architecture which has shaken off the trammels of Byzantium as well as of Rome, but which has, nevertheless, reached its glorious position step by step with no break and no conscious effort after novelty from the wall of Tiryns and the Treasury of Mycenæ.

This point of development was attained amidst a period of social conflict, the facts and tendencies of which, ignored by the historians of the eighteenth century, have been laid open to our view by our modern school of evolutionary historians. In the twelfth century the actual handicraftsmen found themselves at last face to face with the development of the earlier associations of freemen which were the survivals from the tribal society of Europe: in the teeth of these exclusive and aristocratic munici-palities the handicraftsmen had associated themselves into guilds of craft, and were claiming their freedom from legal and arbi-trary oppression, and a share in the government of the towns; by the end of the thirteenth century they had conquered the position everywhere and within the next fifty or sixty years the governors of the free towns were the delegates of the craft-guilds, and all handicraft was included in their associations. This period of their triumph, marked amidst other events by the Battle of Courtray, where the chivalry of France turned their backs in flight before the Flemish weavers, was the period during which Gothic Archi-tecture reached its zenith. It must be admitted, I think, that during this epoch, as far as the art of beautiful building is con-cerned, France and England were the architectural countries par excellence; but all over the intelligent world was spread this bright, glittering, joyous art, which had now reached its acme of elegance and beauty: and moreover in its furniture, of which I have spoken above, the excellence was shared in various meas-ure betwixt the countries of Europe. And let me note in passing that the necessarily ordinary conception of a Gothic interior as being a colourless whitey-grey place dependent on nothing but the architectural forms, is about as far from the fact as the corre-sponding idea of a Greek temple standing in all the chastity of white marble. We must remember, on the contrary, that both buildings were clad, and that the noblest part of their raiment was their share of a great epic, a story appealing to the hearts and minds of men. And in the Gothic building, especially in the half century we now have before us, every part of it, walls, windows, floor, was all looked on as space for the representation of inci-dents of the great story of mankind, as it had presented itself to the minds of men then living; and this space was used with the greatest frankness of prodigality, and one may fairly say that wherever a picture could be painted there it was painted.

For now Gothic Architecture had completed its furniture: Dante, Chaucer, Petrarch; the German hero ballad-epics, the French Romances, the English Forest-ballads, that epic of revolt, as it has been called, the Icelandic Sagas, Froissart and the Chroniclers, represent its literature. Its painting embraces a host of names (of Italy and Flanders chiefly), the two great realists Giotto and Van Eyck at their head: but every village has its painter, its carvers, its actors even; every man who produces works of handicraft is an artist. The few pieces of household goods left of its wreckage are marvels of beauty; its woven cloths and embroideries are worthy of its loveliest building, its pictures and ornamented books would be enough in themselves to make a great period of art, so excellent as they are in epic intention, in completeness of unerring decoration, and in marvellous skill of hand. In short, those masterpieces of noble building, those specimens of architecture, as we call them, the sight of which makes the holiday of our lives to-day, are the standard of the whole art of those times, and tell the story of all the completeness of art in the heyday of life, as well as that of the sad story which follows. For when anything human has arrived at quasi-completion there remains for it decay and death, in order that the new thing may be born from it: and this wonderful, joyous art of the Middle Ages could by no means escape its fate.

In the middle of the fourteenth century Europe was scourged by that mysterious terror the Black Death (a similar terror to which perhaps waylays the modern world), and, along with it, the no less mysterious pests of Commercialism and Bureaucracy attacked us. This misfortune was the turning-point of the Middle Ages; once again a great change was at hand.

The birth and growth of the coming change was marked by art with all fidelity. Gothic Architecture began to alter its character in the years that immediately followed on the Great Pest; it began to lose its exaltation of style and to suffer a diminution in the generous wealth of beauty which it gave us in its heyday. In some places, e.g., England, it grew more crabbed, and even sometimes more commonplace; in others, as in France, it lost order, virility, and purity of line. But for a long time yet it was alive and vigorous, and showed even greater capacity than before for adapting itself to the needs of a developing society: nor did the change of style affect all its furniture injuriously; some of the

subsidiary arts as, e.g., Flemish tapestry and English wood-carving, rather gained than lost for many years.

At last, with the close of the Fifteenth century, the Great Change became obvious; and we must remember that it was no superficial change of form, but a change of spirit affecting every form inevitably. This change we have somewhat boastfully, and as regards the arts quite untruthfully, called the New Birth. But let us see what it means.

Society was preparing for a complete recasting of its elements: the Mediæval Society of Status was in process of transition into the modern Society of Contract. New classes were being formed to fit the new system of production which was at the bottom of this; political life began again with the new birth of bureaucracy; and political, as distinguished from natural, nationalities were being hammered together for the use of that bureaucracy, which was itself a necessity to the new system. And withal a new religion was being fashioned to fit the new theory of life: in short, the Age of Commercialism was being born.

Now some of us think that all this was a source of misery and degradation to the world at the time, that it is still causing misery and degradation, and that as a system it is bound to give place to a better one. Yet we admit that it had a beneficent function to perform; that amidst all the ugliness and confusion which it brought with it, it was a necessary instrument for the development of freedom of thought and the capacities of man; for the subjugation of nature to his material needs. This Great Change, I say, was necessary and inevitable, and on this side, the side of commerce and commercial science and politics, was a genuine new birth. On this side it did not look backward but forward: there had been nothing like it in past history; it was founded on no pedantic model; necessity, not whim, was its crafts-master.

But, strange to say, to this living body of social, political, religious, scientific New Birth was bound the dead corpse of a past art. On every other side it bade men look forward to some change or other, were it good or bad: on the side of art, with the sternest pedagogic utterance, it bade men look backward across the days of the 'Fathers and famous men that begat them', and in scorn of them, to an art that had been dead a thousand years before. Hitherto from the very beginning the past was past, all of it that was not alive in the present, unconsciously to the men of the present. Henceforth the past was to be our present, and the

blankness of its dead wall was to shut out the future from us. There are many artists at present who do not sufficiently estimate the enormity, the portentousness of this change, and how closely it is connected with the Victorian Architecture of the brick box and the slate lid, which helps to make us the dullards that we are. How on earth could people's ideas of beauty change so? you may say. Well, was it their ideas of beauty that changed? Was it not rather that beauty, however unconsciously, was no longer an object of attainment with the men of that epoch?

This used once to puzzle me in the presence of one of the so-called masterpieces of the New Birth, the revived classical style, such a building as St. Paul's in London, for example. I have found it difficult to put myself in the frame of mind which could accept such a work as a substitute for even the latest and worst Gothic building. Such taste seemed to me like the taste of a man who should prefer his lady-love bald. But now I know that it was not a matter of choice on the part of any one then alive who had an eye for beauty: if the change had been made on the grounds of beauty it would be wholly inexplicable; but it was not so. In the early days of the Renaissance there were artists possessed of the highest qualities; but those great men (whose greatness, mind you, was only in work not carried out by co-operation, painting and sculpture for the most part) were really but the fruit of the blossoming-time, the Gothic period; as was abundantly proved by the succeeding periods of the Renaissance, which produced nothing but inanity and plausibility in all the arts. A few individual artists were great truly; but artists were no longer the masters of art, because the people had ceased to be artists: its masters were pedants. St. Peter's in Rome, St. Paul's in London, were not built to be beautiful, or to be beautiful and convenient. They were not built to be homes of the citizens in their moments of exaltation, their supreme grief or supreme hope, but to be proper, respectable, and therefore to show the due amount of cultivation and knowledge of the only peoples and times that in the minds of their ignorant builders were not ignorant barbarians. They were built to be the homes of a decent unenthusiastic ecclesiasticism, of those whom we sometimes call Dons now-a-days. Beauty and romance were outside the aspirations of their builders. Nor could it have been otherwise in those days; for, once again, architectural beauty is the result of the harmonious and intelligent co-operation of the whole body of

people engaged in producing the work of the workman; and by the time that the changeling New Birth was grown to be a vigorous imp, such workmen no longer existed. By that time Europe had begun to transform the great army of artist-craftsmen, who had produced the beauty of her cities, her churches, manor-houses and cottages, into an enormous stock of human machines, who had little chance of earning a bare livelihood if they lingered over their toil to think of what they were doing: who were not asked to think, paid to think, or allowed to think. That invention we have, I should hope, about perfected by this time, and it must soon give place to a new one. Which is happy; for as long as the invention is in use you need not trouble yourselves about architecture, since you will not get it, as the common expression of our life, that is as a genuine thing.

But at present I am not going to say anything about direct remedies for the miseries of the New Birth; I can only tell you what you ought to do if you can. I want you to see that from the brief historic review of the progress of the Arts it results that to-day there is only one style of Architecture on which it is possible to found a true living art, which is free to adapt itself to the varying conditions of social life, climate, and so forth, and that that style is Gothic architecture. The greater part of what we now call architecture is but an imitation of an imitation of an imitation, the result of a tradition of dull respectability, or of foolish whims without root or growth in them.

Let us look at an instance of pedantic retrospection employed in the service of art. A Greek columnar temple, when it was a real thing, was a kind of holy railing built round a shrine: these things the people of that day wanted, and they naturally took the form of a Greek Temple under the climate of Greece and given the mood of its people. But do we want those things? If so, I should like to know what for. And if we pretend we do and so force a Greek Temple on a modern city, we produce such a gross piece of ugly absurdity as you may see spanning the Lochs at Edinburgh. In these islands we want a roof and walls with windows cut in them; and these things a Greek Temple does not pretend to give us.

Will a Roman building allow us to have these necessaries? Well, only on the terms that we are to be ashamed of wall, roof, and windows, and pretend that we haven't got either of them, but rather a whimsical attempt at the imitation of a Greek Temple.

Will a neo-classical building allow us these necessities? Pretty much on the same terms as the Roman one; except when it is rather more than half Gothic. It will force us to pretend that we have neither roof, walls, nor windows, nothing but an imitation of the Roman travesty of a Greek Temple.

Now a Gothic building has walls that it is not ashamed of; and in those walls you may cut windows wherever you please; and, if you please may decorate them to show that you are not ashamed of them; your windows, which you must have, become one of the great beauties of your house, and you have no longer to make a lesion in logic in order not to sit in pitchy darkness in your own house, as in the sham sham-Roman style; your window, I say, is no longer a concession to human weakness, an ugly necessity (generally ugly enough in all conscience) but a glory of the Art of Building. As for the roof in the sham style: unless the building is infected with Gothic common sense, you must pretend that you are living in a hot country which needs nothing but an awning, and that it never rains or snows in these islands. Whereas in a Gothic building the roof both within and without (especially within, as is most meet) is the crown of its beauties, the abiding place of its brain.

Again, consider the exterior of our buildings, that part of them that is common to all passers-by, and that no man can turn into private property unless he builds amidst an inaccessible park. The original of our neo-classic architecture was designed for marble in a bright dry climate, which only weathers it to a golden tone. Do we really like a neo-classic building weather-beaten by the roughness of hundreds of English winters from October to June? And on the other hand, can any of us fail to be touched by the weathered surface of a Gothic building which has escaped the restorers' hands? Do we not clearly know the latter to be a piece of nature, that more excellent mood of nature that uses the hands and wills of men as instruments of creation?

Indeed time would fail me to go into the many sides of the contrast between the Architecture which is a mere pedantic imitation of what was once alive, and that which after a development of long centuries has still in it, as I think, capacities for fresh developments, since its life was cut short by an arbitrary recurrence to a style which had long lost all elements of life and growth. Once for all, then, when the modern world finds that the eclecticism of the present is barren and fruitless, and that it needs

and will have a style of architecture which, I must tell you once more, can only be as part of a change as wide and deep as that which destroyed Feudalism; when it has come to that conclusion, the style of architecture will have to be historic in the true sense; it will not be able to dispense with tradition; it cannot begin at least with doing something quite different from anything that has been done before; yet whatever the form of it may be, the spirit of it will be sympathy with the needs and aspirations of its own time, not simulation of needs and aspirations passed away. Thus it will remember the history of the past, make history in the present, and teach history in the future. As to the form of it, I see nothing for it but that the form, as well as the spirit, must be Gothic; an organic style cannot spring out of an eclectic one, but only from an organic one. In the future, therefore, our style of architecture must be Gothic Architecture.

And meanwhile of the world demanding architecture, what are we to do? Meanwhile? After all, is there any meanwhile? Are we not now demanding Gothic Architecture and crying for the fresh New Birth? To me it seems so. It is true that the world is uglier now than it was fifty years ago; but then people thought that ugliness a desirable thing, and looked at it with complacency as a sign of civilization, which no doubt it is. Now we are no longer complacent, but are grumbling in a dim unorganized manner. We feel a loss, and unless we are very unreal and helpless we shall presently begin to try to supply that loss. Art cannot be dead so long as we feel the lack of it, I say: and though we shall probably try many roundabout ways for filling up the lack; yet we shall at last be driven into the one right way of concluding that in spite of all risks, and all losses, unhappy and slavish work must come to an end. In that day we shall take Gothic Architecture by the hand, and know it for what it was and what it is.

# Art and Industry
# in the Fourteenth Century

I N England, at least, if not on the Continent of Europe, there
are some towns and cities which have indeed a name that
recalls associations with the past, but have no other trace left
them of the course of that history which has made them what
they are. Besides these, there are many more which have but a
trace or two left; sometimes, indeed, this link with the past is so
beautiful and majestic in itself that it compels us when we come
across it to forget for a few moments the life of to-day with
which we are so familiar that we do not mark its wonders or its
meannesses, its follies or its tragedies. It compels us to turn
away from our life of habit which is all about us on our right
hand and our left, and which therefore we cannot see, and forces
on us the consideration of past times which we can picture to
ourselves as a whole, rightly or wrongly, because they are so far
off. Sometimes, as we have been passing through the shabby
streets of ill burnt bricks, we have come on one of these links
with the past and wondered. Before the eyes of my mind is such
a place now. You travel by railway, get to your dull hotel by
night, get up in the morning and breakfast in company with one
or two men of the usual middle-class types, who even as they
drink their tea and eat their eggs and glance at the sheet of lies,
inanity, and ignorance, called a newspaper, by their sides, are
obviously doing their business to come, in a vision. You go out
into the street and wander up it; all about the station, and stretch-
ing away to the left, is a wilderness of small, dull houses built of
a sickly coloured yellow brick pretending to look like stone, and
not even able to blush a faint brown blush at the imposture, and
roofed with thin, cold, purple-coloured slates. They cry out at
you at the first glance, workmen's houses; and a kind of instinct

of information whispers to you: railway workmen and engineers. Bright as the spring morning is, a kind of sick feeling of hopeless disgust comes over you, and you go on further, sure at any rate that you cannot fare worse. The street betters a little as you go on; shabbyish shops indeed, and mean houses of the bourgeoisie of a dull market town, exhibiting in their shop fronts a show of goods a trifle below the London standard, and looking 'flash' at the best; and above them dull houses, greyish and reddish, recalling some associations of the stage-coach days and Mr. Pickwick and Sam Weller, which would cheer you a little if you didn't see so many gaps in their lines filled up with the sickly yellow-white brick and blue slate, and with a sigh remember that even the romance surrounding Mr. Winkle is fast vanishing from the world. You let your eyes fall to the pavement and stop and stare a little, revolving many things, at a green grocer's shop whose country produce probably comes mostly from Covent Garden, but looks fresh and green as a relief from the jerry building. Then you take a step or two onward and raise your eyes, and stand transfixed with wonder, and a wave of pleasure and exultation sweeps away the memory of the squalidness of to-day and the shabby primness of yesterday; such a feeling as takes hold of the city-dweller when, after a night journey, he wakes and sees through his windows some range of great and noble mountains. And indeed this at the street's end is a mountain also; but wrought by the hand and the brain of man, and bearing the impress of his will and his aspirations; for there heaves itself up above the meanness of the street and its petty commercialism a mass of grey stone traceried and carved and moulded into a great triple portico beset with pinnacles and spires, so orderly in its intricacy, so elegant amidst its hugeness, that even without any thought of its history or meaning it fills your whole soul with satisfaction. You walk on a little and see before you at last an ancient gate that leads into the close of the great church, but as if dreading that when you come nearer you may find some piece of modern pettiness or incongruity which will mar it, you turn away down a cross street from which the huge front is no longer visible, though its image is still in your mind's eye. The street leads you in no long while to a slow-flowing river crossed by an ugly modern iron bridge, and you are presently out in the fields, and going down a long causeway with a hint of Roman work in it. It runs along the river through a dead flat of black, peaty-look-

ing country where long rows of men and women are working with an overlooker near them, giving us uncomfortable suggestions of the land on the other side of the Atlantic as it was; and you half expect as you get near some of these groups to find them black and woolly haired; but they are white as we call it, burned and grimed to dirty brown though; fair-sized and strong-looking enough, both men and women; but the women roughened and spoilt, with no remains of gracefulness, or softness of face or figure; the men heavy and depressed-looking; all that are not young, bent and beaten, and twisted and starved and weathered out of shape; in short, English field-labourers. You turn your face away with a sigh toward the town again, and see towering over its mean houses and the sluggish river and the endless reclaimed fen the flank of that huge building, whose front you saw just now, plainer and severer than the front, but harmonious and majestic still. A long roof tops it and a low, square tower rises from its midst. The day is getting on now, and the wind setting from the north-west is driving the smoke from the railway-works round the long roof and besmirching it somewhat; but still it looks out over the huddle of houses and the black fen with its bent rows of potato-hoers, like some relic of another world. What does it mean? Over there the railway-works with their monotonous hideousness of dwelling-houses for the artisans; here the gangs of the field-labourers; twelve shillings a week for ever and ever, and the workhouse for all day of judgment, of rewards and punishments; on each side and all around the nineteenth century, and rising solemnly in the midst of it, that token of the 'dark ages', their hope in the past, grown now a warning for our future.

A thousand years ago our forefathers called the place Medehamstead, the abode of the meadows. They used the Roman works and doubtless knew little who wrought them, as by the side of the river Nene they drew together some stockaded collection of wooden and wattled houses. Then came the monks and built a church, which they dedicated to St. Peter; a much smaller and ruder building than that whose beauty has outlasted so many hundred years of waste and neglect and folly, but which seemed grand to them; so grand, that what for its building, what for the richness of its shrines, Medehamstead got to be called the Golden Burg. Doubtless that long stretching water there knew more than the monks' barges and the coracles of the fenmen, and the

oars of the Norsemen have often beaten it white; but records of the sacking of the Golden Burg I have not got till the time when a valiant man of the country, in desperate contest with Duke William, the man of Blood and Iron of the day, led on the host of the Danes to those rich shrines, and between them they stripped the Golden Burg down to its stone and timber. Hereward, that valiant man, was conquered and died, and what was left of the old tribal freedom of East England sank lower and lower into the Romanized feudality that crossed the Channel with the Frenchmen. But the country grew richer, and the craftsmen defter, and some three generations after that sacking of the Golden Burg, St. Peter's Church rose again, a great and noble pile, the most part of which we have seen to-day.

Time passed again; the feudal system had grown to its full height, and the cloud as big as a man's hand was rising up to overshadow it in the end. Doubtless this town played its part in this change: had a great gild changing to a commune, federating the craft-gilds under it; and was no longer called Medehamstead or the Golden Burg, but after its patron saint, Peterborough. And as a visible token of those times, the gilds built for the monks in the thirteenth century that wonderful piece of ordered beauty which you saw just now rising from out the grubby little streets of the early nineteenth century. They added to the great Church here and there in the fourteenth century, traceried windows to the aisles, two spirelets to the front, that low tower in the midst. The fifteenth century added certain fringes and trimmings, so to say, to the building; and so it was left to bear as best it could the successive waves of degradation, the blindness of middle-class puritanism, the brutality of the eighteenth-century squirearchy, and the stark idealless stupidity of the early nineteenth century; and there it stands now, with the foul sea of modern civilization washing against it; a token, as I said, of the hopes that were, and which civilization has destroyed. Might it but give a lesson to the hopes that are, and which shall some day destroy civilization!

For what was the world so utterly different from ours of this day, the world that completed the glories of the Golden Burg, which to-day is called Peterborough, and is chiefly known, I fear, as the depôt of the Great Northern Railway? This glorious building is a remnant of the feudal system, which even yet is not so well understood amongst us as it should be; and especially, people scarcely understand how great a gulf lies between the life

of that day and the life of ours. The hypocrisy of so-called constitutional development has blinded us to the greatness of the change which has taken place; we use the words King, Parliament, Commerce, and so on, as if their connotation was the same as in that past time. Let us very briefly see, for the sake of a better understanding of the art and industry embodied in such works as Peterborough Cathedral, what was the relation of the complete feudal system with its two tribes, the one the unproductive masters, the other the productive servants, to the older incomplete feudality which it superseded; or in other words, what the Middle Ages came to before the development of the seeds of decay in them became obvious.

On the surface, the change from the serf and baron society of the earlier Middle Ages to the later Gild and Parliament Middle Ages was brought about by the necessities of feudalism. The necessities of the conquering or unproductive tribe gave opportunities to the progressive part of the conquered or productive tribe to raise its head out of the mere serfdom which in earlier times had been all it could look to. At bottom, this process of the rise of the towns under feudalism was the result of economical causes. The poor remains of the old tribal liberties, the folkmotes, the meetings round the shire-oak, the trial by compurgation, all these customs which imply the equality of freemen, would have faded into mere symbols and traditions of the past if it had not been for the irrepressible life and labour of the people, of those who really did the work of society in the teeth of the arbitrary authority of the feudal hierarchy. For you must remember that its very arbitrariness made the latter helpless before the progress of the productive part of that society. The upper classes had not got hold of those material means of production which enable them now to make needs in order to satisfy them for the sake of profit; the miracle of the world-market had not yet been exhibited. Commerce, in our sense of the word, did not exist: people produced for their own consumption, and only exchanged the overplus of what they did not consume. A man would then sell the results of his labour in order to buy wherewithal to live upon or to live better; whereas at present he buys other people's labour in order to sell its results, that he may buy yet more labour, and so on to the end of the chapter; the mediæval man began with production, the modern begins with money. That is, there was no capital in our sense of the word; nay, it was a main

care of the crafts, as we shall see later on, that there should be none. The money lent at usury was not lent for the purposes of production, but as spending-money for the proprietors of land: and their land was not capitalizable as it now is; they had to eat its produce from day to day, and used to travel about the country doing this like bands of an invading army, which was indeed what they were; but they could not, while the system lasted, drive their now tenants, erewhile serfs, off their lands, or fleece them beyond what the custom of the manor allowed, unless by sheer violence or illegal swindling; and also every free man had at least the use of some portion of the soil on which he was born. All this means that there was no profit to be made out of anything but the land; and profit out of that was confined to the lords of the soil, the superior tribe, the invading army, as represented in earlier times by Duke William and his hirelings. But even they could not accumulate their profit: the very serfdom that enabled them to live as an unproductive class forbade them to act as land capitalists: the serfs had to perform the customary services and nothing more, and thereby got a share of the produce over and above the economic rent, which surplus would to-day certainly not go to the cultivators of the soil. Now since all the class-robbery that there was was carried on by means of the land, and that not by any means closely or carefully, in spite of distinct arbitrary laws directed against the workers, which again were never fully carried out, it follows that it was easy for the productive class to live. Poor men's money was good, says one historian; necessaries were very cheap, that is, ordinary food (not the cagmag of to-day), ordinary clothing and housing; but luxuries were dear. Spices from the East, foreign fruits, cloth of gold, gold and silver plate, silk, velvet, Arras tapestries, Iceland gerfalcons, Turkish dogs, lions, and the like, doubtless cost far more than they do to-day. For the rest, men's desires keep pace with their power over nature, and in those days their desires were comparatively few; the upper class did not live so much more comfortably then than the lower; so there were not the same grounds or room for discontent as there are now-a-days. A workman then might have liked to possess a canopy of cloth of gold or a big cupboard of plate; whereas now the contrast is no longer between splendour and simplicity, but between ease and anxiety, refinement and sordidness.

The ordinary life of the workman then was easy; what he suffered from was either the accidents of nature, which the society of the day had not yet learned to conquer, or the violence of his masters, the business of whose life was then open war, as it is now veiled war. Storm, plague, famine and battle, were his foes then; scarcity and the difficulty of bringing goods from one place to another were what pinched him, not as now, superabundance and the swiftness of carriage. Yet, in some respects even here, the contrast was not so violent as it is now-a-days between rich and poor; for, if the artisan was apt to find himself in a besieged city, and had to battle at all adventure for his decent life and easy work, there were vicissitudes enough in the life of the lord also, and the great prince who sat in his hall like a god one day, surrounded by his gentlemen and men-at-arms, might find himself presently as the result of some luckless battle riding barefoot and bareheaded to the gallows-tree: distinguished politicians risked more then than they do now. A change of government was apt to take heads off shoulders.

What was briefly the process that led to this condition of things, a condition certainly not intended by the iron feudalism which aimed at embracing all life in its rigid grasp, and would not, if it had not been forced to it, have suffered the serf to escape from serfdom, the artisan to have any status except that of a serf, the gild to organize labour, or the town to become free? The necessities of the feudal lord were the opportunities of the towns: the former not being able to squeeze his serf-tenants beyond a certain point, and having no means of making his money grow, had to keep paying for his main position by yielding up what he thought he could spare of it to the producing classes. Of course, that is clear enough to see in reading mediæval history; but what gave the men of the towns the desire to sacrifice their hard earnings for the sake of position, for the sake of obtaining a status alongside that of the baron and the bishop? The answer to my mind is clear: the spirit of association which had never died out of the peoples of Europe, and which in Northern Europe at least had been kept alive by the gilds which in turn it developed; the strong organization that feudalism could not crush.

The tale of the origin and development of the gilds is as long as it is interesting, and it can only be touched on here; for the history of the gilds is practically the history of the people in the Middle Ages, and what follows must be familiar to most of my

readers. And I must begin by saying that it was not, as some would think (speaking always of Northern Europe), the towns that made the gilds, but the gilds that made the towns. These latter, you must remember once more, important as they grew to be before the Middle Ages ended, did not start with being organized centres of life political and intellectual, with tracts of country whose business it was just to feed and nourish them; in other words, they did not start with being mere second-rate imitations of the Greek and Roman cities. They were simply places on the face of the country where the population drawn together by convenience was thicker than in the ordinary country, a collection of neighbours associating themselves together for the ordinary business of life, finding it convenient in those disturbed times to palisade the houses and closes which they inhabited and lived by. But even before this took place, and while the unit of habitation was not even a village, but a homestead (or tun), our Teutonic and Scandinavian forefathers, while yet heathens, were used to band themselves together for feasts and sacrifices and for mutual defence and relief against accident and violence into what would now be called benefit societies, but which they called gilds. The change of religion from heathenism to Christianity did not make any difference to these associations; but as society grew firmer and more peaceful, as the commerce of our forefathers became something more than the selling to one town what the traders had plundered from another, these gilds developed in one direction into associations for the defence of the carriers and sellers of goods (who you must remember in passing had little in common with our merchants and commercial people); and on the other side began to grow into associations for the regulation of the special crafts, amongst which the building and clothing crafts were naturally pre-eminent. The development of these two sides of the gilds went on together, but at first the progress of the trading gilds, being administrative or political, was more marked than that of the craft-gilds, and their status was recognized much more readily by the princes of the feudal hierarchy; though I should say once for all that the direct development of the gilds did not flourish except in those countries where the undercurrent of the customs of the free tribes was too strong to be quite merged in the main stream of Romanized feudality. Popes, bishops, emperors, and kings in their early days fulminated against them; for instance, an association in Northern

France for resistance to the Norse sea-robbers was condemned under ferocious penalties. In England, at any rate, where the king was always carrying on a struggle with his baronage, he was generally glad to acknowledge the claims of the towns or communes to a free administration as a make-weight to the power of the great feudatories; and here as well as in Flanders, Denmark, and North Germany, the merchant-gild was ready to form that administrative power, and so slid insensibly into the government of the growing towns under the name of the Great Gild, the Porte, the Lineage, and so on. These Great Gilds, the corporations of the towns, were from the first aristocratic and exclusive, even to the extent of excluding manual workmen; in the true spirit of Romanized feudalism, so diametrically opposed to that of the earlier tribal communities, in the tales of which the great chiefs are shown smithying armour, building houses and ships, and sowing their fields, just as the heroes of the Iliad and the Odyssey do. They were also exclusive in another way, membership in them being in the main an hereditary privilege, and they became at last very harsh and oppressive. But these bodies, divorced from labour and being nothing but governors, or at most administrators, on the one hand, and on the other not being an integral portion of the true feudal hierarchy, could not long hold their own against the gilds of craft, who all this while were producing and organizing production. There was a continuous and fierce struggle between the aristocratic and democratic elements in the towns, and plenty of downright fighting, bitter and cruel enough after the fashion of the times; besides a gradual progress of the crafts in getting hold of the power in the communes or municipalities. This went on all through the thirteenth century, and in the early part of the fourteenth the artisans had everywhere succeeded, and the affairs of the towns were administered by the federated craft-gilds. This brings us to the culminating period of the Middle Ages, the period to which my remarks on the condition of labourers apply most completely; though you must remember that the spirit which finally won the victory for the craft-gilds had been at work from the first, contending not only against the mere tyranny and violence incidental to those rough times, but also against the hierarchical system, the essential spirit of feudality. The progress of the gilds, which from the first were social, was the form which the class-struggle took in the Middle Ages.

I will now try to go a little more in detail into the conditions of art and industry in those days, conditions which it is clear, even from the scattered hints given above, are very different from those of to-day; so different indeed, that many people cannot conceive of them. The rules of the crafts in the great towns of Flanders will give us as typical examples as can be got at; since the mechanical arts, especially of weaving, were there farther advanced than anywhere else in Northern Europe. Let us take then the cloth-weavers of Flanders, and see under what rules they worked. No master to employ more than three journeymen in his workshop: no one under any pretence to have more than one workshop: the wages fixed per day, and the number of hours also: no work to be done on holidays. If piecework (which was allowed), the price per yard fixed: but only so much and no more to be done in a day. No one allowed to buy wool privately, but at open sales duly announced. No mixing of wools allowed; the man who uses English wool (the best) not to have any other on his premises. English and other foreign cloth not allowed to be sold. Workmen not belonging to the commune not admitted unless hands fell short. Most of these rules and many others may be considered to have been made in the direct interest of the workmen. Now for safeguards for the public: the workman must prove that he knows his craft duly: he serves as apprentice first, then as journeyman, after which he is a master if he can manage capital enough to set up three looms besides his own, which, of course, he generally could do. Width of web is settled; colour of list according to quality; no work to be done in a frost, or in a bad light. All cloth must be 'walked' or fulled a certain time, and to a certain width; and so on, and so on. And finally every piece of cloth must stand the test of examination, and if it fall short, goes back to the maker, who is fined; if it come up to the due standard it is marked as satisfactory.

Now you will see that the accumulation of capital is impossible under such regulations as this, and it was meant to be impossible. The theory of industry among these communes was something like this. There is a certain demand for the goods which we can make, and a certain settled population to make them: if the goods are not thoroughly satisfactory we shall lose our market for them and be ruined: we must therefore keep up their quality to the utmost. Furthermore, the work to be done must be shared amongst the whole of those who can do it, who

must be sure of work always as long as they are well behaved and industrious, and also must have a fair livelihood and plenty of leisure; as why should they not?

We shall find plenty of people to-day to cry out on this as slavery; but to begin with, history tells us that these workmen did not fight like slaves at any rate; and certainly a condition of slavery in which the slaves were well fed, and clothed, and housed, and had abundance of holidays, has not often been realized in the world's history. Yes, some will say, but their minds were enslaved. Were they? Their thoughts moved in the narrow circle maybe; and yet I can't say that a man is of slavish mind who is free to express his thoughts, such as they are; still less if he habitually expresses them; least of all if he expresses them in a definite form which gives pleasure to other people, what we call producing works of art; and these workmen of the communes did habitually produce works of art.

I have told you that the chief contrast between the upper and lower classes of those days was that the latter lacked the showy pomp and circumstance of life, and that the contrast rather lay there than in refinement and non-refinement. It is possible that some readers might judge from our own conditions that this lack involved the lack of art; but here, indeed, there was little cause for discontent on the part of he lower classes in those days; it was splendour rather than art in which they could feel any lack. It is, I know, so difficult to conceive of this now-a-days that many people don't try to do so, but simply deny this fact; which is, however, undeniable by any one who had studied closely the art of the Middle Ages and its relation to the workers. I must say what I have often said before, that in those times there was no such thing as a piece of handicraft being ugly; that everything made had a due and befitting form; that most commonly, however ordinary its use might be, it was elaborately ornamented; such ornament was always both beautiful and inventive, and the mind of the workman was allowed full play and freedom in producing it; and also that for such art there was no extra charge made; it was a matter of course that such and such things should be ornamented, and the ornament was given and not sold. And this condition of the ordinary handicrafts with reference to the arts was the foundation of all that nobility of beauty which we were considering in a building like Peterborough Cathedral, and without that its beauty would never have existed. As it was, it

was no great task to rear a building that should fill men's minds with awe and admiration when people fell to doing so of set purpose, in days when every cup and plate and knife-handle was beautiful.

When I had the Golden Burg in my eye just now, it was by no means only on account of its external beauty that I was so impressed by it, and wanted my readers to share my admiration, but it was also on account of the history embodied in it. To me it & its like are tokens of the aspirations of the workers five centuries ago; aspirations of which time alone seemed to promise fulfilment, & which were definitely social in character. If the leading element of association in the life of the mediæval workman could have cleared itself of certain drawbacks, and have developed logically along the road that seemed to be leading it onward, it seems to me it could scarcely have stopped short of forming a true society founded on the equality of labour: the Middle Ages, so to say, saw the promised land of Socialism from afar, like the Israelites, and like them had to turn back again into the desert. For the workers of that time, like us, suffered heavily from their masters: the upper classes who lived on their labour, finding themselves barred from progress by their lack of relation to the productive part of society, and at the same time holding all political power, turned towards aggrandizing themselves by perpetual war and shuffling of the political positions, and so opened the door to the advance of bureaucracy, and the growth of that thrice-accursed spirit of nationality which so hampers us even now in all attempts towards the realization of a true society. Furthermore, the association of the time, instinct as it was with hopes of something better, was exclusive. The commune of the Middle Ages, like the classical city, was unhappily only too often at strife with its sisters, and so became a fitting instrument for the greedy noble or bureaucratic king to play on. The gildsman's duties were bounded on the one hand by the limits of his craft, and on the other by the boundaries of the liberties of his city or town. The instinct of union was there, otherwise the course of the progress of association would not have had the unity which it did have: but the means of intercourse were lacking, and men were forced to defend the interests of small bodies against all comers, even those whom they should have received as brothers.

But, after all, these were but tokens of the real causes that checked the development of the Middle Ages towards Communism; that development can be traced from the survival of the primitive Communism which yet lived in the early days of the Middle Ages. The birth of tradition, strong in instinct, was weak in knowledge, and depended for its existence on its checking the desire of mankind for knowledge and the conquest of material nature: its own success in developing the resources of labour ruined it; it opened chances to men of growing rich and powerful if they could succeed in breaking down the artificial restrictions imposed by the gilds for the sake of the welfare of their members. The temptation was too much for the craving ignorance of the times, that were yet not so ignorant as not to have an instinct of what boundless stores of knowledge lay before the bold adventurer. As the need for the social and political organization of Europe blotted out the religious feeling of the early Middle Ages which produced the Crusades, so the need for knowledge and the power over material nature swept away the communistic aspirations of the fourteenth century, and it was not long before people had forgotten that they had ever existed.

The world had to learn another lesson; it had to gain power, and not be able to use it; to gain riches, and starve upon them like Midas on his gold; to gain knowledge, and then have newspapers for its teachers; in a word, to be so eager to gather the results of the deeds of the life of man that it must forget the life of man itself. Whether the price of the lesson was worth the lesson we can scarcely tell yet; but one comfort is that we are fast getting perfect in it; we shall, at any rate, not have to begin at the beginning of it again. The hope of the renaissance of the time when Europe first opened its mouth wide to fill its belly with the east wind of commercialism, that hope is passing away, and the ancient hope of the workmen of Europe is coming to life again. Times troublous and rough enough we shall have, doubtless, but not that dull time over again during which labour lay hopeless and voiceless under the muddle of self-satisfied competition.

It is not so hard now to picture to oneself those grey masses of stone, which our forefathers raised in their hope, standing no longer lost and melancholy over the ghastly misery of the fields and the squalor of the towns, but smiling rather on their newborn sisters the houses and halls of the free citizens of the new

Communes, and the garden-like fields about them where there will be labour still, but the labour of the happy people who have shaken off the curse of labour and kept its blessing only. Between the time when the hope of the workman disappeared in the fifteenth century and our own times, there is a great gap indeed, but we know now that it will be filled up before long, and that our own lives from day to day may help to fill it. That is no little thing and is well worth living for, whatever else may fail us.

# ঌ Bibliography ঌ

## Collections of Writings by Morris

Briggs, Asa, ed.; *William Morris: Selected Writings and Designs* (Harmondsworth: 1962).

Cockerell, Sydney C. and Proctor, G.C., ed.; *Architecture, Industry, and Wealth: Collected Papers by William Morris* (London: 1902).

Cole, G.D.H., ed.; *William Morris: Selected Writings* (London: 1934).

Henderson, Philip, ed.; *The Letters of William Morris to His Family and Friends* (London: 1950).

Jackson, Holbrook, ed.; *William Morris on Art and Socialism* (London: 1947).

Lemire, E.D., ed.; *The Unpublished Lectures of William Morris* (Detroit: 1969).

Morris, May, ed.; *The Collected Works of William Morris*, 24 vols. (London: 1910-1915).

Morris, May, ed.; *William Morris: Artist, Writer, Socialist*, 2 vols. (Oxford: 1936).

Morton, A.L., ed.; *Political Writings of William Morris* (London: 1973).

Morton, A.L., ed.; *Three Works by William Morris: News from Nowhere, The Pilgrims of Hope, A Dream of John Ball* (New York: 1968).

## Works about Morris

Aymer, Vallance; *The Art of William Morris* (London: 1897).

Banham, Joanna and Harris, Jenifer; *William Morris and the Middle Ages* (Manchester: 1984).

Boris, Eileen; *Art and Labor: Ruskin, Morris, and the Craftsman Ideal in America* (Philadelphia: 1986).

Calhoun, B.; *The Pastoral Vision of William Morris: 'The Earthly Paradise'* (Athens, Georgia: 1975).

Cole, G.D.H.; *William Morris as a Socialist* (London: 1960).

Coleman, Stephen and O'Sullivan, Paddy, ed.; *Morris and News from Nowhere: A Vision for Our Time* (Devon: 1990).

Crow, G.M.; *William Morris, Designer* (London: 1934).

The Design Council; *William Morris & Kelmscott* (London: 1981).

Duncan, Robinson; *William Morris, Edward Burne-Jones and the Kelmscott Chaucer* (London: 1982).

Faulkner, Peter; *Against the Age: An Introduction to William Morris* (London: 1980).

Furneaux Jordan, R.; *The Medieval Vision of William Morris* (London: 1960).

Glaiser, J. Bruce; *William Morris and the Early Days of the Socialist Movement* (London: 1921).

Grennan, M.R.; *William Morris, Medievalist and Revolutionary* (London: 1945).

Mackrail, J.W.; *The Life of William Morris*, 2 vols. (London: 1898).

Mackrail, J.W.; *William Morris and His Circle* (London: 1902).

Marshall, R.; *William Morris and His Earthly Paradises* (London: 1979).

Meier, Paul; *William Morris, The Marxist Dreamer*, 2 vols. (Brighton: 1978).

Naylor, Gillian; *William Morris by Himself* (London: 1988).

Parry, Linda; *William Morris and the Arts and Crafts Movement — A Sourcebook* (London: 1989).

Pevsner, Nikolaus; *Pioneers of Modern Design* (London: 1986).

Pevsner, Nikolaus; *Pioneers of the Modern Movement, from William Morris to Walter Gropius* (London: 1936).

Poulson, Christine; *William Morris* (London: 1989).

Simon, Roger; *William Morris Now* (London: 1984).

Stansky, Peter; *Redesigning the World: William Morris, the 1880's, and the Arts and Crafts* (Princeton: 1985).

Thompson, E.P.; *William Morris, Romantic to Revolutionary* (London: 1977).

Watkinson, Roy; *William Morris as Designer* (London: 1967).

## Radical Works on Art and Aesthetics

Adorno, T.W., et. al.; *Aesthetics and Politics*, Ronald Taylor, tr. (London: 1977).

Adorno, T.W.; *Aesthetic Theory*, C. Lenhardt, tr. (London: 1984).

Arvon, Henri; *Marxist Aesthetics*, Helen Lane, tr. (London: 1973).

Baxandall, Lee, and Stefan Morawski, eds.; *Marx and Engels on Literature and Art: A Selection of Writings* (St. Louis: 1973).

Benjamin, Walter; *Charles Baudelaire: A Lyric Poet in the Era of High Capitalism*, Harry Zohn, tr. (London: 1973).

Benjamin, Walter; *Illuminations*, Harry Zohn, tr. (New York: 1968).

Benjamin, Walter; *The Origin of German Tragic Drama*, John Osborne, tr. (London: 1977).

Benjamin, Walter; *Reflections*, Edmund Jephcott, tr. (New York: 1978).

Bloch, Ernst; *Essays on the Philosophy of Music*, Peter Palmer, tr. (Cambridge, England: 1985).

Bloch, Ernst; *The Utopian Function of Art and Literature: Selected Essays*, Jack Zipes and Frank Mecklenburg, tr. (Cambridge, Massachusetts: 1988).

Berger, John; *Permanent Red* (London: 1960).

Berger, John; *Ways of Seeing* (London: 1972).

Bürger, Peter; *Theory of the Avant-Garde*, Michael Shaw, tr. (Minneapolis: 1984).

Eagleton, Terry; *The Function of Criticism: From the Spectator to Post-Structuralism* (London: 1984).

Eagleton, Terry; *The Ideology of the Aesthetic* (Oxford: 1990).

Goldmann, Lucien; *Cultural Creation in Modern Society*, Bart Grahl, tr. (St. Louis: 1976).

Hadjinicolaou, Nicos; *Art History and Class Struggle*, Louise Asmal, tr. (London: 1978).

Haug, W.F.; *Critique of Commodity Aesthetics*, Robert Bock, tr. (Minneapolis:1986).

Hauser, Arnold; *The Sociology of Art*, Kenneth J. Northcott, tr. (Chicago: 1982).

Home, Stewart; *The Assault on Culture: Utopian Currents from Lettrism to Class War* (Stirling: 1991).

James, C.L.R.; *Mariners, Renegades, and Castaways: The Story of Herman Melville and the World We Live In* (London: 1985).

Jameson, Fredric; *Marxism and Form* (Princeton: 1971).

Jameson, Fredric; *Postmodernism or the Cultural Logic of Late Capitalism* (Durham: 1991).

Lifshitz, Mikhail; *The Philosophy of Art of Karl Marx*, Ralph B. Winn, tr. (London: 1973).

Lukács, Georg; *The Historical Novel*, Hannah and Stanley Mitchell, tr. (London: 1962).

Lukács, Georg; *Realism in Our Time: Literature and the Class Struggle*, John and Necke Mander, tr. (New York: 1971).

Lukács, Georg; *Studies in European Realism* (New York: 1964).

Lunn, Eugene; *Marxism and Modernism: a Historical Study of Lukács, Brecht, Benjamin and Adorno* (Berkeley: 1982).

Marcuse, Herbert; *The Aesthetic Dimension: Toward a Critique of Marxist Aesthetics* (Boston: 1978).

Milner, John; *Vladimir Tatlin and the Russian Avant-Garde* (New Haven: 1983).

Read, Herbert; *Art and Industry* (Indiana: 1961).

Read, Herbert, *The Grassroots of Art: Lectures on the Social Aspects of Art in an Industrial Age* (Cleveland: 1961).

Rose, Margaret A.; *Marx's Lost Aesthetic: Karl Marx and the Visual Arts* (Cambridge, England: 1984).

Sartre, Jean-Paul; *What is Literature?*, Bernard Frechtman, tr. (New York: 1949).

Solomon, Maynard, ed.; *Marxism and Art: Essays Classic and Contemporary* (New York: 1973).

Trotsky, Leon; *On Literature and Art* (New York: 1970).

Williams, Raymond; *Marxism and Literature* (Oxford: 1977).

Williams, Raymond; *Modern Tragedy* (Stanford: 1966).

Williams, Raymond; *The Politics of Modernism: Against the New Conformists* (London: 1989).

Williams, Raymond; *Problems in Materialism and Culture* (London: 1980).

Williams, Raymond; *Writing in Society* (London: 1983).

Wolff, Janet; *The Social Production of Art* (New York: 1984).

Zipes, Jack; *Breaking the Magic Spell: Radical Theories of Folk and Fairy Tales* (Austin: 1979).

# ⁊ *Biography* ⁊

WILLIAM Morris was born on March 24, 1834 into a wealthy and respectable middle-class family in what was then the pleasant country village of Walthamstow, England. His father, a successful stockbroker, died when the boy was fifteen, but was able to leave the family a substantial fortune as the result of an investment in a Devonshire copper mine. The inheritance provided a sizeable annuity for William when he came of age, and it was this trust fund that enabled him to pursue creative work relatively free of financial worries. In 1853, Morris went to Exeter College, Oxford to study theology, but soon abandoned his plan to become a High Anglican cleric in favor of a life dedicated to the arts. At the university, he came under the influence of the Romantic poetic tradition, of John Ruskin's medievalist critique of Victorian capitalism, and, through his friend Edward Burne-Jones, of the Pre-Raphaelite Brotherhood of painters (including especially Dante Gabriel Rossetti). On graduating from Oxford in 1856, Morris apprenticed himself to a leading figure in the Gothic Revival, the architect G.E. Street, though, finding the work routine, he left before completing his apprenticeship. He tried his hand at painting, participating in Burne-Jones' commission to create frescos for the walls of the debating hall at the new Oxford Union. In 1858, Morris began his long and successful career as a poet by publishing *The Defence of Guenevere*, based in part on Arthurian themes. This literary activity was to lead thirty-four years later to an offer of the poet laureateship which Morris, however, refused on political grounds. In 1859, he married the Pre-Raphaelite model, Jane Burden, with whom he had two daughters, Jenny (born 1861) and May (born 1862). The year after they were married, Morris moved with Jane into Red House, which had been built on commission in southeast London by his friend and future collaborator, Philip Webb. It was in an attempt to provide Red House with beautiful furnishings that Morris founded Morris, Marshall, Faulkner & Company in 1861, which became simply Morris & Company thirteen years later.

The firm soon began to produce objects of decorative art for middle-class and aristocratic homes as well as churches, cathedrals, and other public and private institutions. It was the principal instrument through which Morris revived such fine crafts as stained glass work, embroidery, ceramics, furniture-making, carpet-weaving, and wallpaper design, initiating the Arts and Crafts Movement that later spread to the United States. In 1877, Morris founded the Society for the Preservation of Ancient Buildings, nicknamed 'Anti-Scrape'. Its purpose was to oppose insensitive restoration of medieval structures, and it remained a central passion until the end of Morris' life. In 1890, he founded the Kelmscott Press, which revived the art of fine printing with the creation of three new typefaces, and the publication of fifty-three exquisitely designed, decorated, and hand-printed books, including the famous Kelmscott *Chaucer*.

Morris' involvement in politics began in 1876 with his participation in a campaign against the Tory prime minister Disraeli's plan to take Britain to war against Russia in alliance with the Ottoman Empire so as to maintain British control of the Suez Canal. Morris spoke at public meetings, and published an open letter *To the Working Men of England* which was militantly anti-imperialist in content. His position on the 'Eastern Question', however, was limited by his membership in the Liberal Party and admiration for Gladstone, who was using the campaign to re-enter public life after an earlier political defeat. Still, the Eastern agitation gave Morris his first experience of political action. The experience was greatly deepened when, against the opposition of his wife and most of his friends, he joined the roughly two hundred-member socialist Democratic Federation (led by H.M. Hyndman) in January, 1883. He was immediately elected to the executive committee of the organization in the capacity of Treasurer. When the executive split in two in December, 1884, Morris left with the majority who opposed Hyndman's autocratic style of leadership, and formed the Socialist League. He became editor and chief financial supporter of the League's newspaper, *The Commonweal*, in which many of his most famous works appeared, including *The Pilgrims of Hope* (1885), *A Dream of John Ball* (1886), and *News from Nowhere* (1890). In 1890, as the result of more factional fighting, he left the League to form the Hammersmith Socialist Society.

In September, 1885, Morris brought international attention to 'The Cause' when he was arrested and brought before a magistrate on the charge of striking a policeman. The assault was alleged to have taken place in court during an uproar the previous summer when a socialist speaker had been sentenced to two month's hard labor for his role in unemployment agitation. Morris denied that the assault had taken place and was allowed to go free. Throughout his years as a socialist, Morris was a tireless public speaker, addressing on average three political meetings per week. He spoke to mainly working-class audiences in almost every part of the country, urging the construction of a socialist society by revolutionary means. Morris died peacefully in his bed on the morning of October 3, 1896. At the time, an eminent doctor wrote: 'I consider the case is this: the disease is simply being William Morris, and having done more work than most ten men'.